RUSSIA

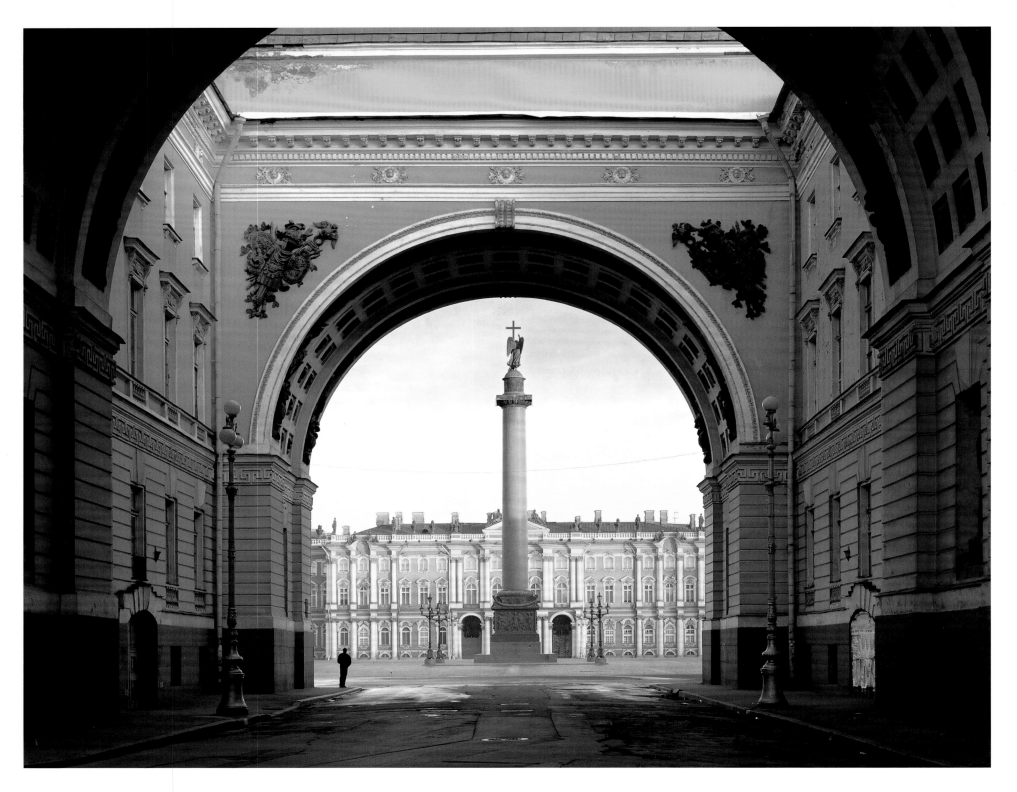

plate I **PALACE SQUARE**, ST. PETERSBURG

RUSSIA

Beyond Utopia

PHOTOGRAPHS *by* **ANDREW MOORE**

FOREWORD BY BORIS FISHMAN

CHRONICLE BOOKS

SAN FRANCISCO

PHOTOGRAPHS COPYRIGHT © 2005 BY **ANDREW MOORE**

AFTERWORD AND CAPTIONS COPYRIGHT © 2005 BY **ANDREW MOORE**

FOREWORD COPYRIGHT © 2005 BY **BORIS FISHMAN**

LIBRARY OF CONGRESS CATALOGING-IN-PUBLICATION DATA:

MOORE, ANDREW, 1957-

 RUSSIA : BEYOND UTOPIA / PHOTOGRAPHS BY ANDREW MOORE; FOREWORD

 BY BORIS FISHMAN.

 P. CM.

 ISBN 0-8118-4322-X (HARDCOVER)

1. RUSSIA (FEDERATION)–PICTORIAL WORKS. 2. RUSSIA (FEDERATION)–BUILD-

INGS, STRUCTURES, ETC.–PICTORIAL WORKS. I. TITLE.

 DK510.25.M66 2005

 914.7'0022'2--DC22

 2004025642

MANUFACTURED IN CHINA

DESIGN BY **SARA SCHNEIDER**

DISTRIBUTED IN CANADA BY RAINCOAST BOOKS
9050 SHAUGHNESSY STREET
VANCOUVER, BRITISH COLUMBIA V6P 6E5

10 9 8 7 6 5 4 3 2 1

CHRONICLE BOOKS LLC
85 SECOND STREET
SAN FRANCISCO, CALIFORNIA 94105
WWW.CHRONICLEBOOKS.COM

The stairway is built of plain, dark wood and the walls are an artless white, but the stained-glass window is a clamor of color and conviction. Instead of passively inviting us to gaze through, it marches toward us, steel-faced Bolsheviks clutching bayonets and brandishing rifles as they depart to conquer the world in a fury of red banners.

Like many of the photographs in Andrew Moore's *Russia: Beyond Utopia,* this image (plate #100) from a forgotten corner of the Siberian city of Irkutsk bittersweetly radiates a future that Soviet Communism promised and grievously failed to deliver. But the photograph is neither a dig at a discredited ideology nor an endorsement of the political system that succeeded it. Andrew has something broader in mind.

The stained-glass panel is an amalgam of Russia's multiple selves: the medium evokes piety and worship, the timeless tonic of the Russian people; the iconography—the severely angled shock troops of the proletarian revolt—channels the Communist struggle's martial predisposition and its cult of physical fitness; the fragmented style, known as constructivism, recalls the artistic avant-garde's experiments in the permissive early years of the Soviet Union, before the literalist earnestness of socialist realism was anointed as the nation's sole acceptable art form. To the eternal question of which Russia is the most authentic—the prerevolutionary monarchy? the socialist brotherhood? the emerging capitalist democracy?—Andrew's work answers, all of them.

You might receive a wholly different answer in Moscow or Vladivostok. Modern Russia cultivates amnesia. KGB archives have been pried open by the dictates of democratic disclosure, and survivors of Communist repression advertise testimonials of injustice, but there has been no state-sponsored reckoning with the Soviet past of Stalinist terror and corruption, and, more ruinously, the fantastic fraud of the Communist dream. Vladimir Putin, the current president, prefers stability to the turmoil of accountability; he has defended the Soviet period, reviving its anthem and rehabilitating its heroes. More damagingly, he is increasingly uninterested in having anyone propose doing otherwise; as Russia increasingly resembles a managed, authoritarian democracy, few citizens are willing to disagree. The newly prosperous elites prefer to look ahead, and the wanting masses romanticize what remains behind. The great nation of Dostoevsky's frantic fits of searching has closed its eyes to the truth.

How, then, to photograph a place that won't look itself in the mirror? How to obtain a foothold from a land whose history is made of ruptures and discontinuities? Books featuring Russian imagery usually keep to one of two perspectives: Either they gush over the grandeur of the monuments and architecture without acknowledging the seamier life down below, or they fetishize that underbelly without noticing the more dignified life that contextualizes them. Either they exalt the Kremlin at night, or they evoke pity for the Siberian trucker coaxing his sputtering engine back to life with a screw picked out of a side mirror. There is an implicit politics in these photographs that signals, respectively, either an approving awe of Russia's progress or socialist sympathy with the disenfranchised of capitalist democracy.

Andrew Moore's images, by contrast, transcend politics. He photographs Russia's extremes—the rich and the poor, the awesome and the pitiful—with equal curiosity and without partisanship. He does not rhapsodize over the excess and pomp of capitalist Russia, but neither does he dismiss it, its superficiality notwithstanding. In

demonstrating as much interest in facades as what's behind them, he considers modern Russia on its own terms, and the Soviet Union and the imperial Russia that preceded it on theirs. He interrogates the notion of Russia's otherness through the layers of history—the hip-hop rehearsal studio (plate #16) that was once a Soviet children's camp that was once a noble's estate—buried beneath riveting facades.

In this way, Andrew obtains a revolutionarily holistic and organic sense of a country that, for so many, derives its charm precisely from the feelings of artifice it provokes. In a sense, he frees Russia from so many of the myths with which it has been endowed, and he finds it no less enchanting and infuriating. At a time when Russia's government doggedly confines itself to the present, Andrew's photographs are monuments to the nation's other lives. They are silent witnesses testifying to a different history.

In eschewing political agenda, Andrew liberates his work to peer past Russia's politics—an unprecedented accomplishment in a place where every aspect of life is politicized—and discover its otherworldly aesthetic. The Western eye does not settle calmly on that aesthetic. By grounding Russia's otherness in its art and architecture, Andrew unravels some of the mystery of why.

No other artistic sensibility so cleaves to an idea at the expense of pragmatism, so elevates "what is just" above "what works." Utilitarianism has made limited inroads in Russia, where, historically, both in private and public life, feeling has been at least as important as utility. Many stereotypes have been forged from this generalization, but there is a nut of truth to them: Pure functionalism, with expediency as its sole raison d'être, fails to fulfill, because it leaves the soul unnourished. There is something base and dehumanizing about pure logic because it channels the mind and leaves the heart to atrophy, therefore lacking the inherent legitimacy supplied by feeling.

In its obsession with undoing the bourgeois order that elevated the few above the masses, Communism subordinated practical economic considerations to the ideology of egalitarianism. Certainly, uniform pay scales banished incentive and discouraged worker productivity—foremen received only several rubles more than ordinary workers; carpenters often pocketed more than doctors—but at least the socialist ideal was honored and the illusion of a brotherly utopia preserved.

For the same reason, Russians commute to work from metro stations encrusted with chandeliers and marble seemingly more appropriate for sumptuous balls (plate #15). (And they are: in 1941, because the war had made aboveground celebrations by party bigwigs risky, the Mayakovskaya metro station was cleared of traffic and outfitted with banquet tables for a celebration of the 24th anniversary of the October Revolution.) The metro museums manifested Stalin's commitment to investing architecture with ideological purpose and glorifying proletarian industry. That millions went without electricity while coffers were emptied to fund these vanities was an afterthought, if that. (Stalin was into the idea of the proletarian worker much more than he was into the workers themselves.)

But this idealism reaches farther back into Russian history than Stalin. The design of Moscow's extravagant Yeliseyevsky food emporium (plate #80), built in the last years of the nineteenth century, was concerned less with supermarket utilitarianism than with accommodating the refined taste and self-esteem of the capital's gentry as it selected its daily bread. The Soviets, in thrall to their idea, stripped away some of the glamour; Yeliseyevsky became Food Store No. 1, the source, for decades, of crumbly Romanian cookies, metallic Hungarian wine, and occasionally empty shelves. But these days, in keeping with the resurgent value of hierarchies, well-to-do Russians once again buy their toilet paper from a grocery store that should, by all appearances, stock Picasso and Magritte originals instead.

Andrew's images also challenge the Western commonplace about the grayness and pallor of the former Soviet Union. His photographs simmer with primary colors. Naturally, red predominates, often in the places and objects we'd expect—the bloodshot scarlet of the Ukrainian Pavilion at the Exhibition of the People's Economic Achievements (VDNKh) (plate #18), and that stained-glass panel in Irkutsk. But Andrew deftly shows us others—the communal home by the White Sea (plate #107), and a baby grand, appropriately labeled "Moskva" (plate #94), a transliteration from the Cyrillic "Mockba," the Russian word for Moscow—familiar only to the native Russian eye.

The aesthetic also feels foreign because of its relentless clash of iconoclasm and tradition, a legacy of the Soviet Union's quick passage from the radical inclinations of the postrevolutionary years to the traditionalist stasis of the Stalin era. For instance, the experimental, constructivist flourish of the bright peach half-arch leading into a St. Petersburg apartment building for tractor-factory workers (plate #88) and the futuristic, semicircular enclosure of the Red Gates metro-station entrance in Moscow (plate #50) aren't far from the Gothic traditionalism of Moscow's Stalinist skyscrapers or the VDNKh's grandiosely neoclassical Central Pavilion, though all of these edifices were built roughly in the same period.

Sometimes ideas collide within the same structure. At the Far Eastern State Technical University, in Vladivostok, a soldier taking an exam is surrounded by walls of rickety, cheap wooden paneling near an incongruous column of classical, ponderous iron (plate #33). The VDNKh Central Pavilion, built to commemorate the advances of Communism—an intemperately radical idea—is a monument to the most ancient of classical pasts (plate #115). The spare minimalism of a New Russian home cannot do without the rococo ceiling and chandelier beloved by the elite of a previous Russia (plate #110). Among these architectural centaurs, the richest irony

belongs to the constructivist Izvestia publishing house (plate #20), the erstwhile mouthpiece of the Communist Party, which stays in the black these days by publishing women's magazines.

Russia is, quite simply, the most conservative radical place on Earth.

If this dichotomy is dizzying for the American reader, how does it affect the Russian mind? The constant reinvention Andrew chronicles is the luxury of few in modern Russia, which is all the more painful in a land of such contrasts: the glass-factory watchman, who has remained at his post long after the factory's closing, surviving on favors and odd jobs (plate #105); the lighthouse keeper at the abandoned missile base in the Far East whose family subsists on illegally poached seafood (plate #109). How isolating, intimidating, and immoderate it must feel to live in a place that specializes in dimensions like those of the Ukrainian Pavilion (plate #18), the icebreaker *Academician Fedorov* (plate #2), and the Homeland Is Mother statue (plate #120).

Perhaps these images explain the apathy of a people that will have no more to do with politics and ideology and just wants to be left alone. Certainly, they wish never again to hear a politician—let alone a foreigner, especially an American—talk about which Russia is the most authentic. Most Russians are ambivalent toward Americans: They long for the quality of life common in the States, but they consider the emotionless self-interest that fosters such prosperity disgraceful and depraved. That Americans have frequently eschewed nuance in considering Russia—eternally projecting Western terms onto the nation and dividing Russians into authoritarians and democrats, with no regard for native context—has not helped their reputation.

But Andrew's photographs have had a unanimously warm reception among the Russians who have seen them. I imagine that it was Andrew's distance from politics that resonated most, that and

his candor in measuring both Russia's wealth and its want, both its pride and its shame, both its misery and its beauty. Andrew Moore has captured all of this complexity in the concise poetry of an individual image. Taken together, his photographs comprise an otherworldly calculus of a profoundly troubled nation eternally uncertain of its place in the world. They perceive a Russia beyond politics and ideology and beyond the polarities that define its relationship with the West. Enclosed you will find Russia's nuanced history of itself, as told to Andrew by its buildings and people. *Russia: Beyond Utopia* asks how a nation survives the epic humiliation brought on by the demise of the Communist paradise, and finds that there is much more to the story than that.

plates

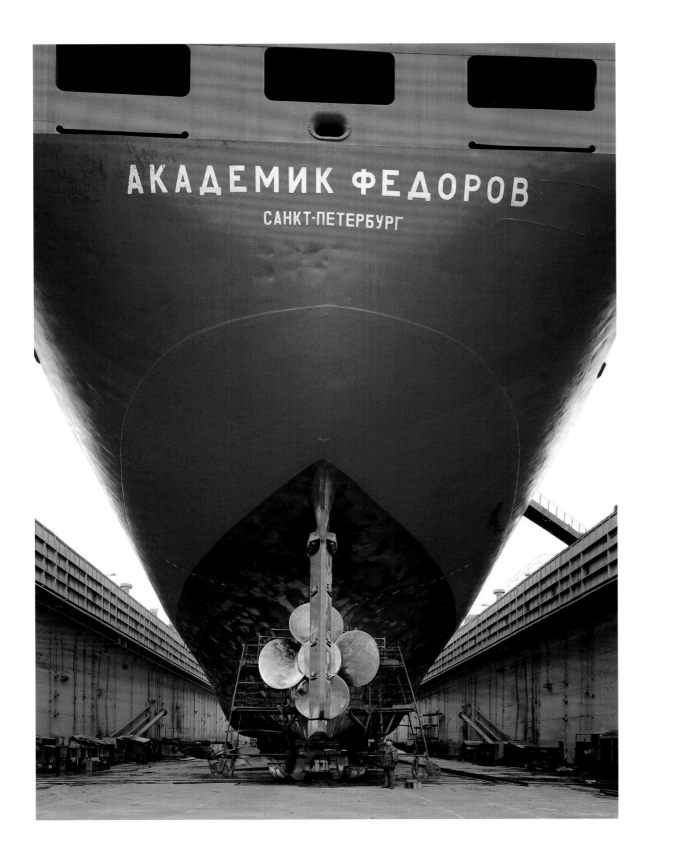

plate 3 **ABANDONED CHURCH,** VOLOGDA

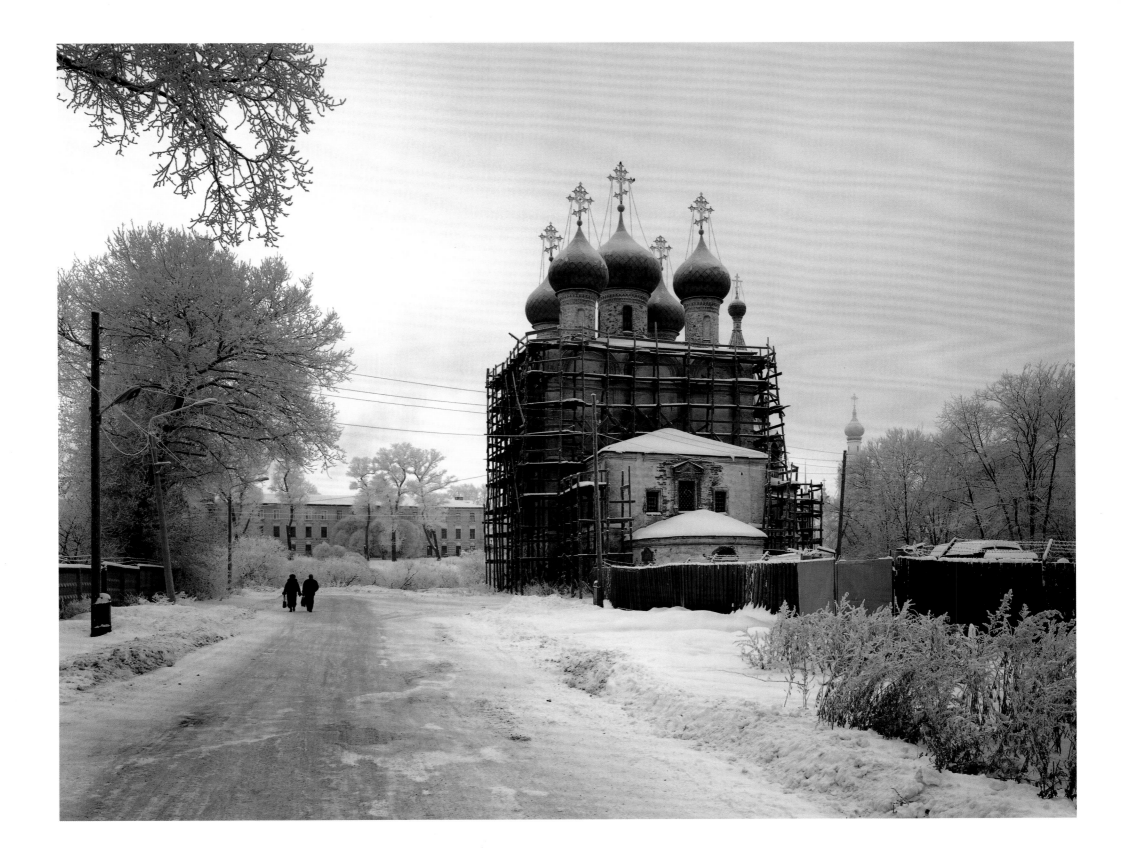

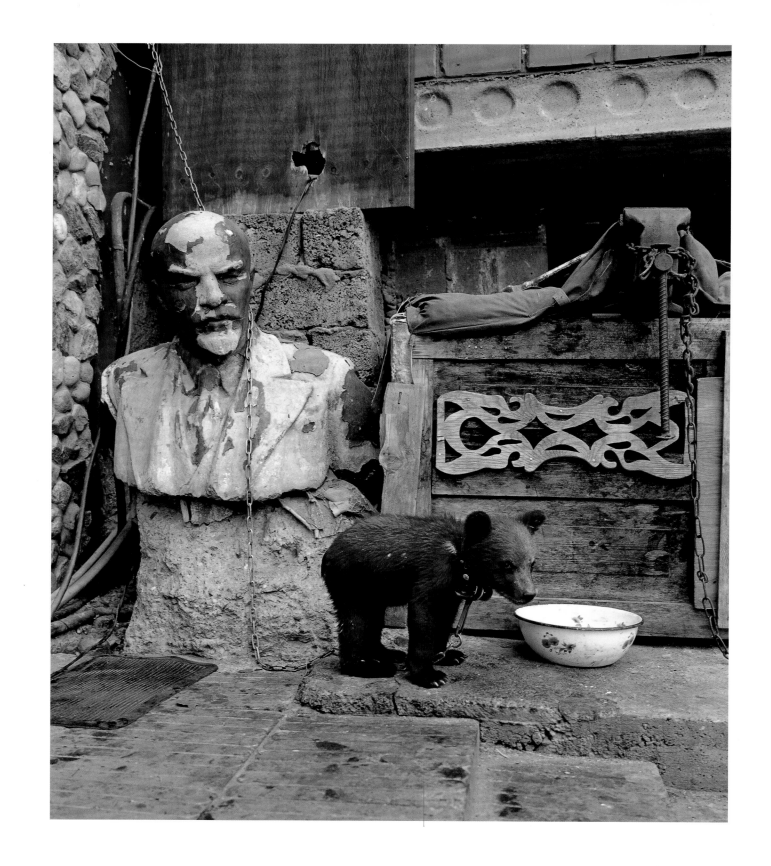

plate 4 **MISHA AND VLADIMIR,** LAKE BAIKAL

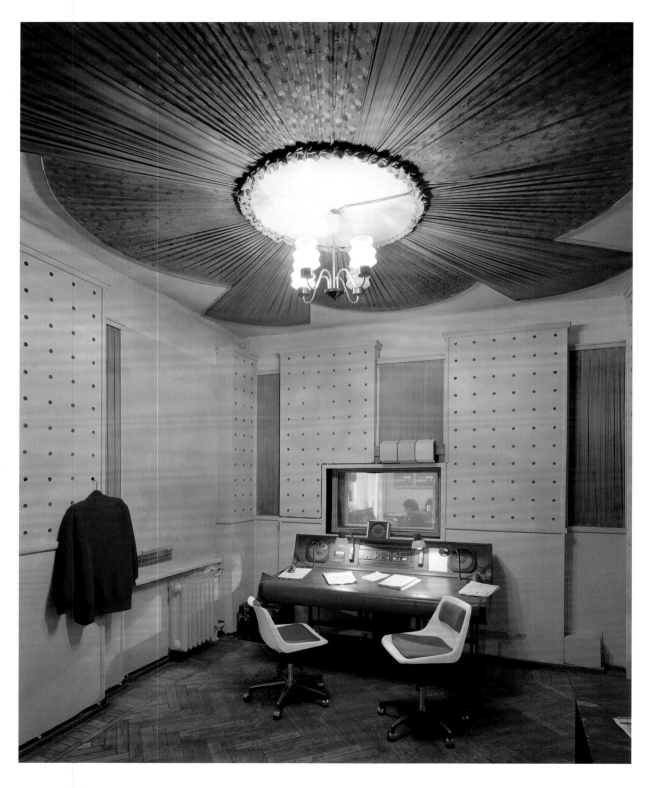

plate 5 **RADIO STATION,** SIMFEROPOL

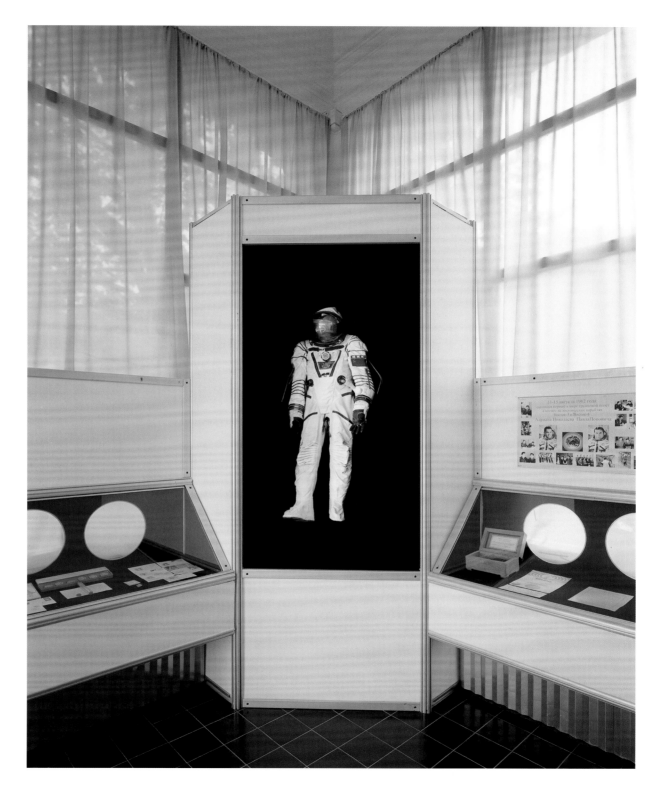

plate 6　**SPACE MUSEUM,** PIONEER CAMP ARTEK, YALTA

plate 7 **COSMOS PAVILION DOME,** MOSCOW

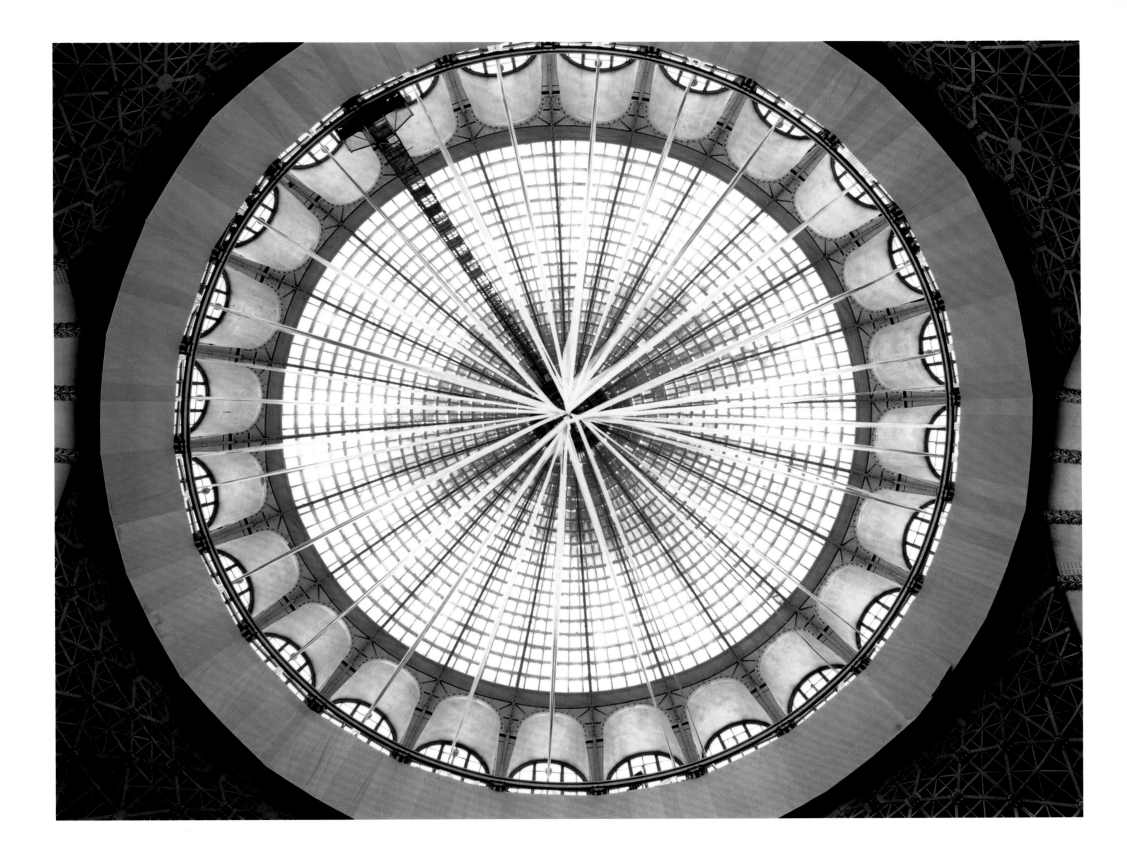

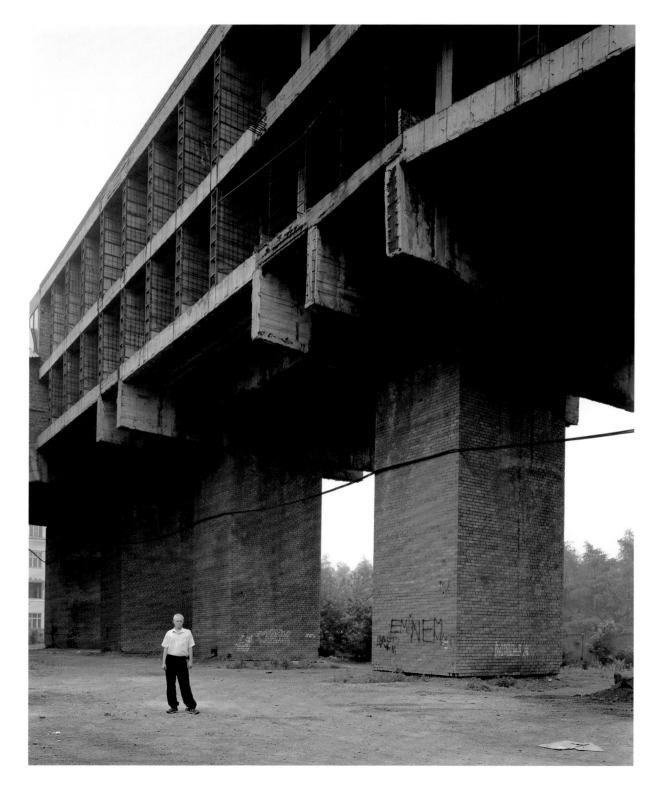

plate 8 **CHICKEN-LEGS BUILDING**, IRKUTSK

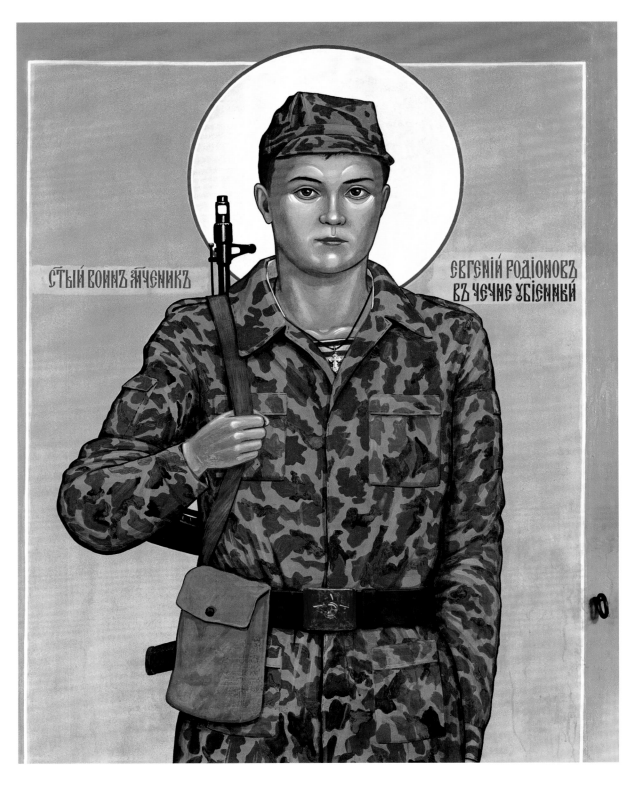

СТЫЙ ВОИНЪ МЧЕНИКЪ

ЕВГЕНІЙ РОДІОНОВЪ
ВЪ ЧЕЧНѢ УБІЕННЫЙ

plate 9 **WARRIOR-MARTYR,** ST. PETERSBURG

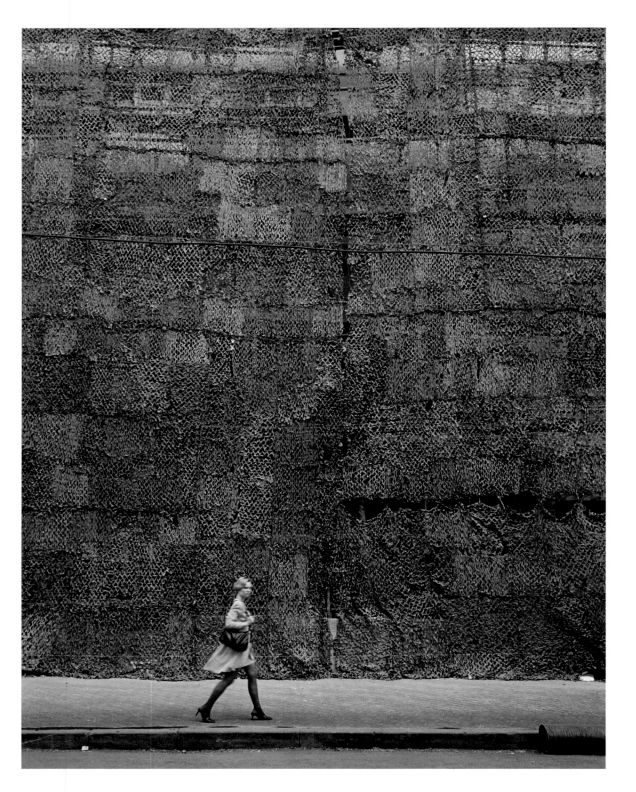

plate 10 **STREET SCENE,** IRKUTSK

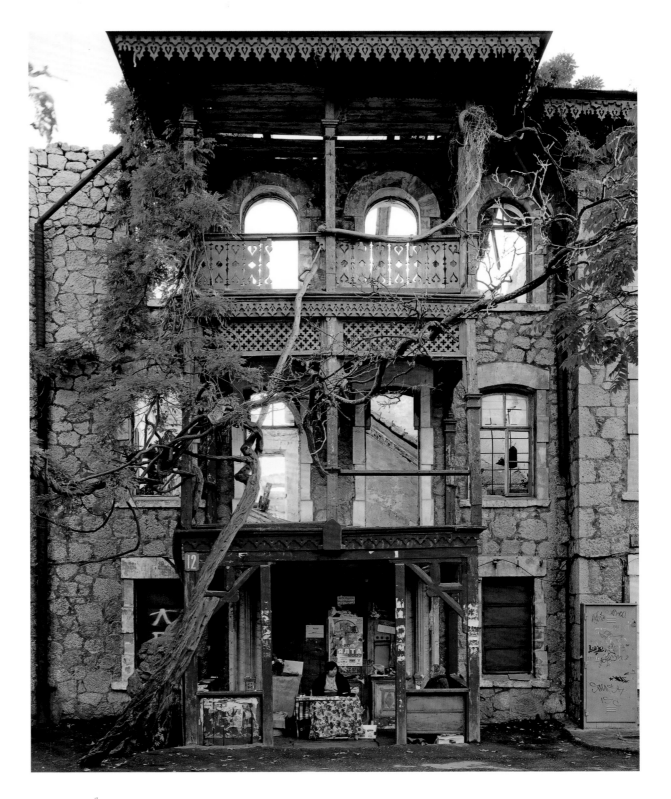

plate II **CIGARETTE SELLERS,** CHEKHOV STREET, YALTA

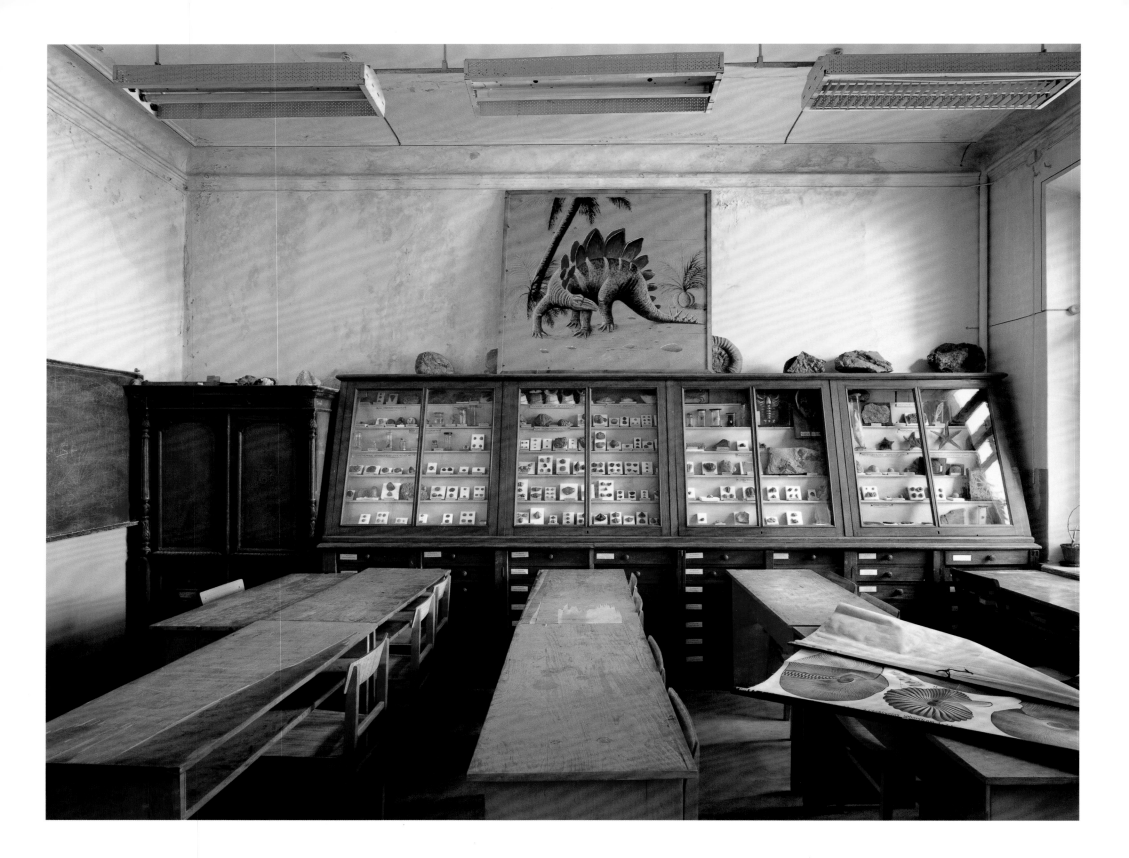

plate 12 **FOSSIL ROOM,** ST. PETERSBURG

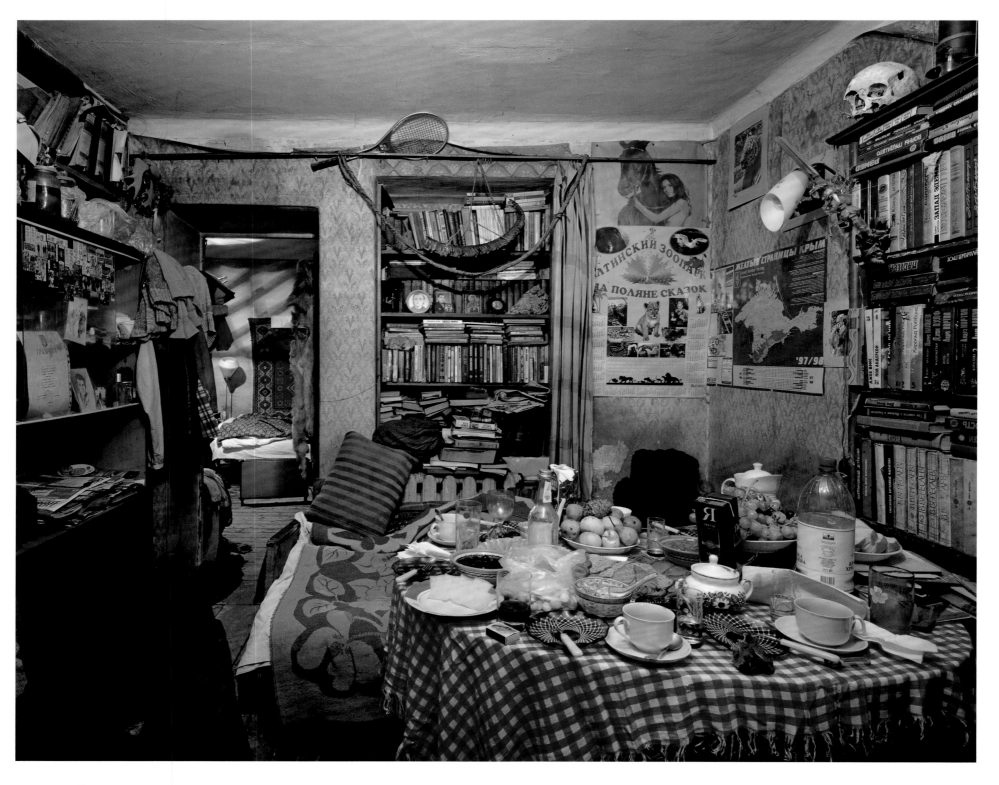

plate 13 **VOLODYA'S APARTMENT,** SIMFEROPOL

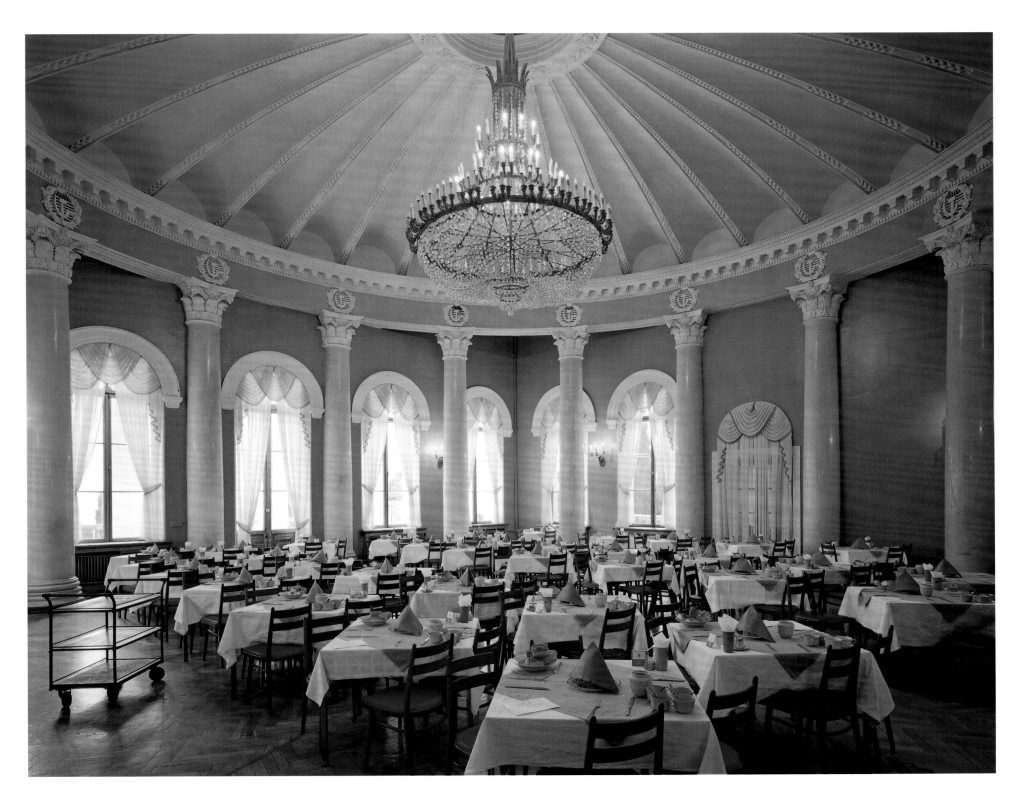

plate 14 **DINING ROOM,** UKRAINA SANATORIUM, YALTA

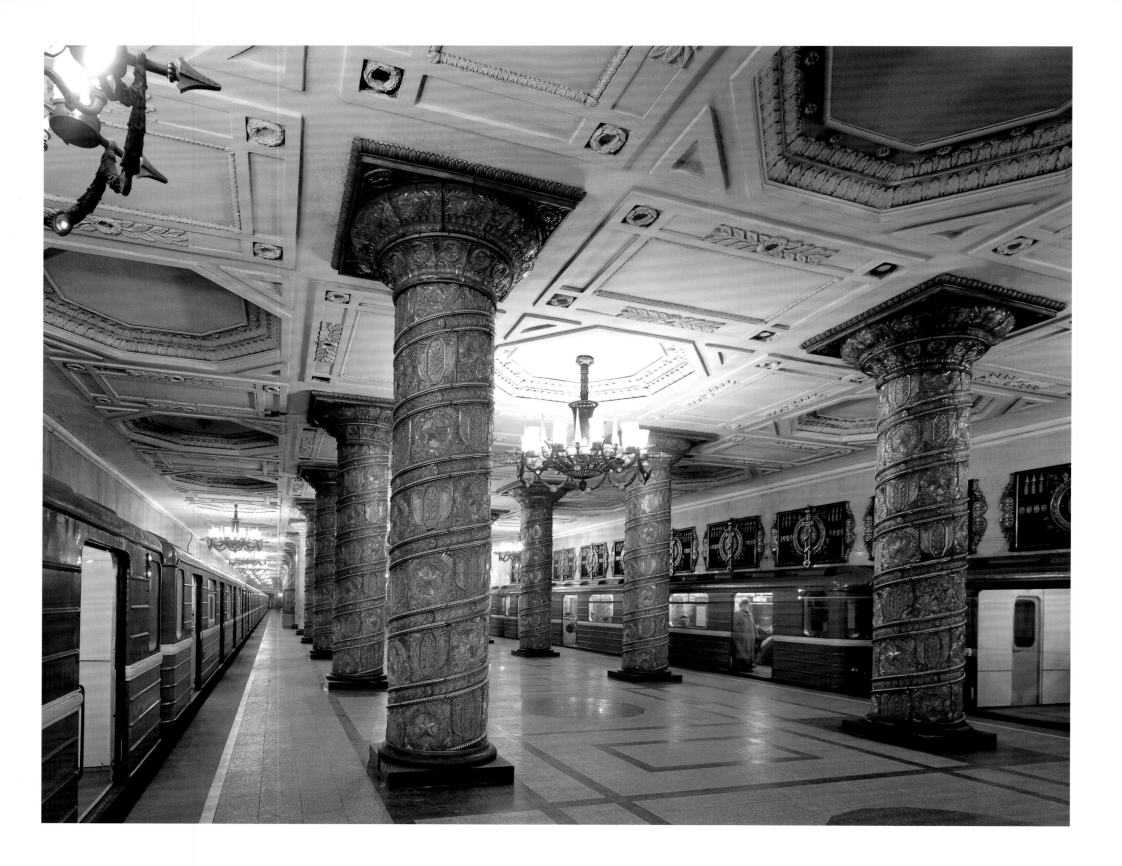

plate 15 **AVTOVO METRO STATION**, ST. PETERSBURG

plate 16 **TURKISH ENVOY'S ROOM,** ODESSA

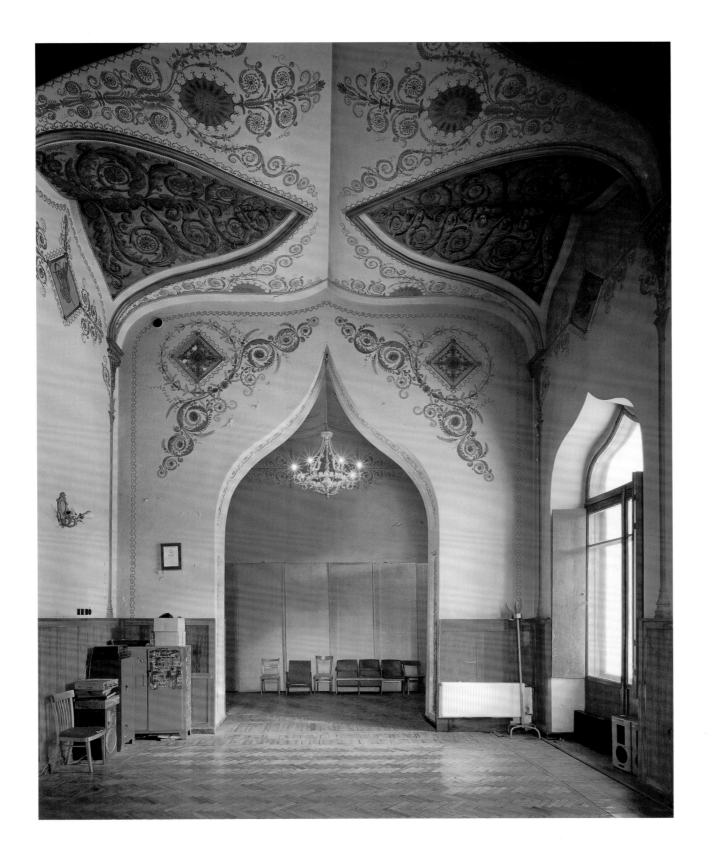

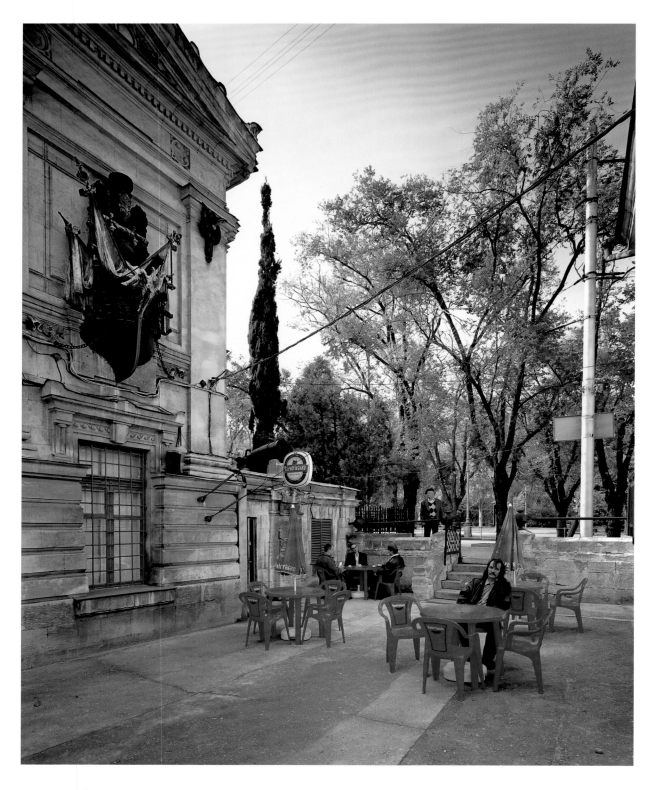

plate 17 **NAVAL-MUSEUM CAFÉ,** SEVASTOPOL

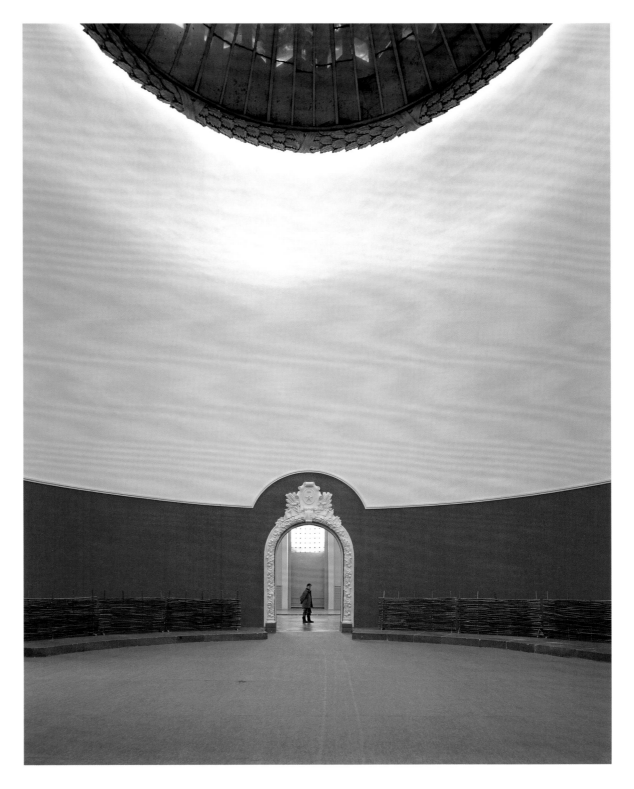

plate 18 **UKRAINIAN PAVILION,** VDNKH, MOSCOW

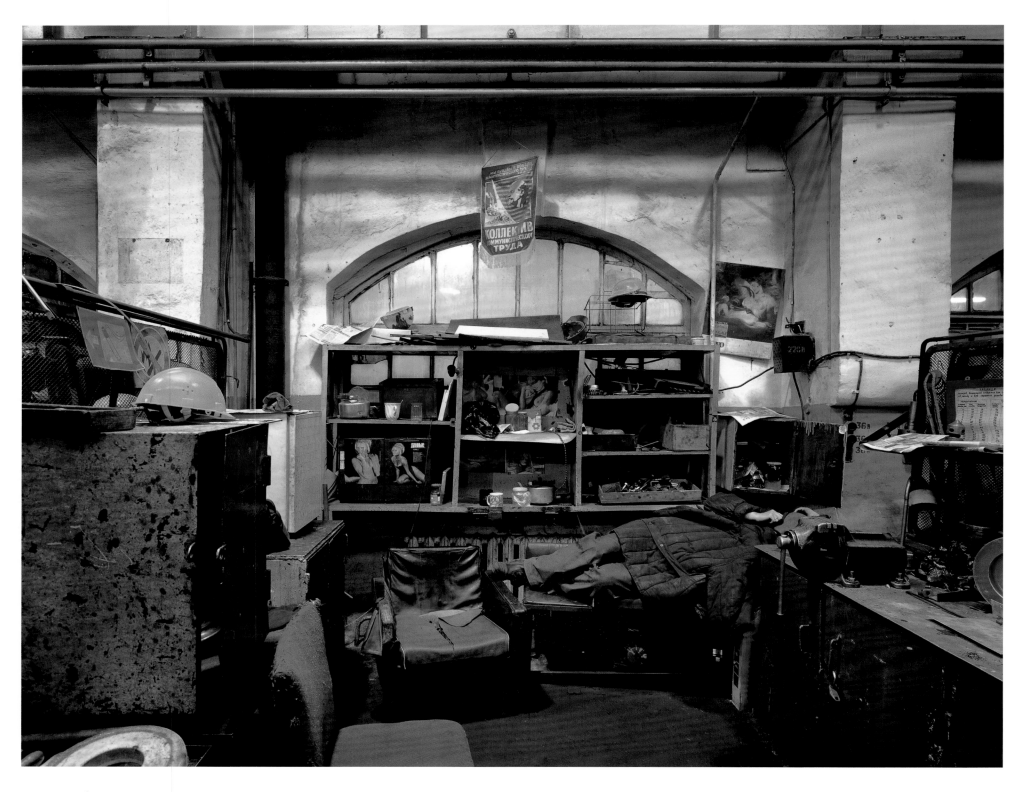

plate 19 **REPAIR SHOP,** ST. PETERSBURG

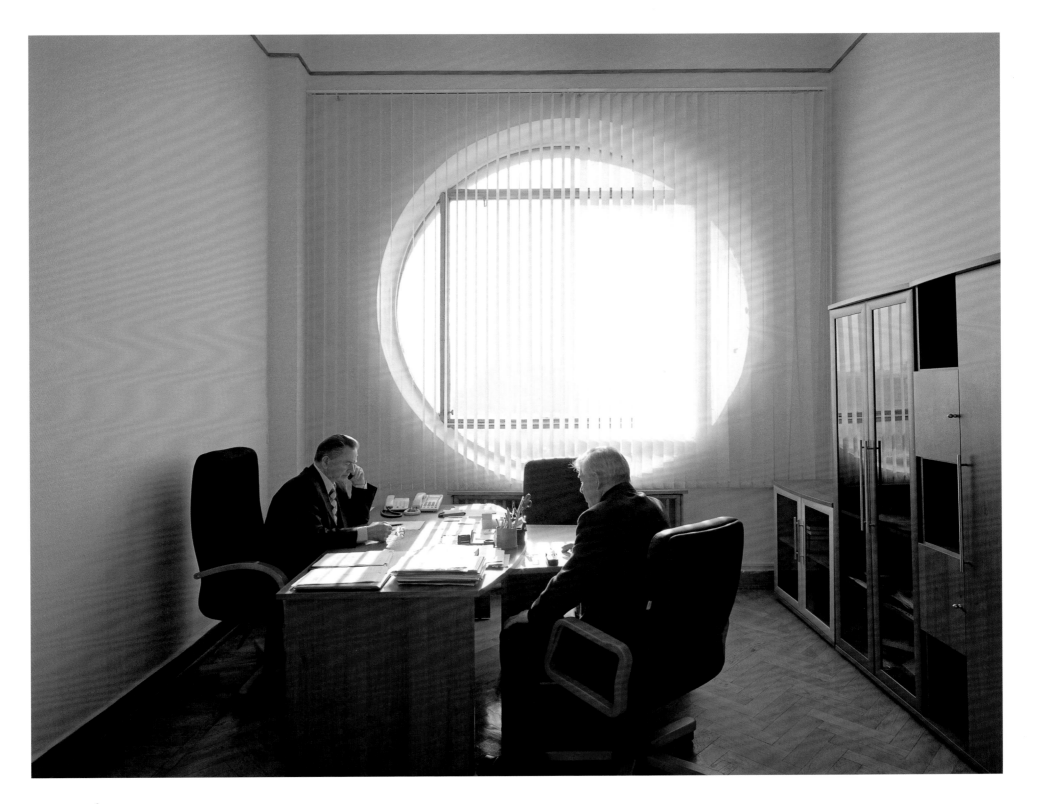

plate 20 **EXECUTIVE OFFICES,** IZVESTIA BUILDING, MOSCOW

plate 21　**GLORY TO THE WORKING CLASS,** KHABAROVSK

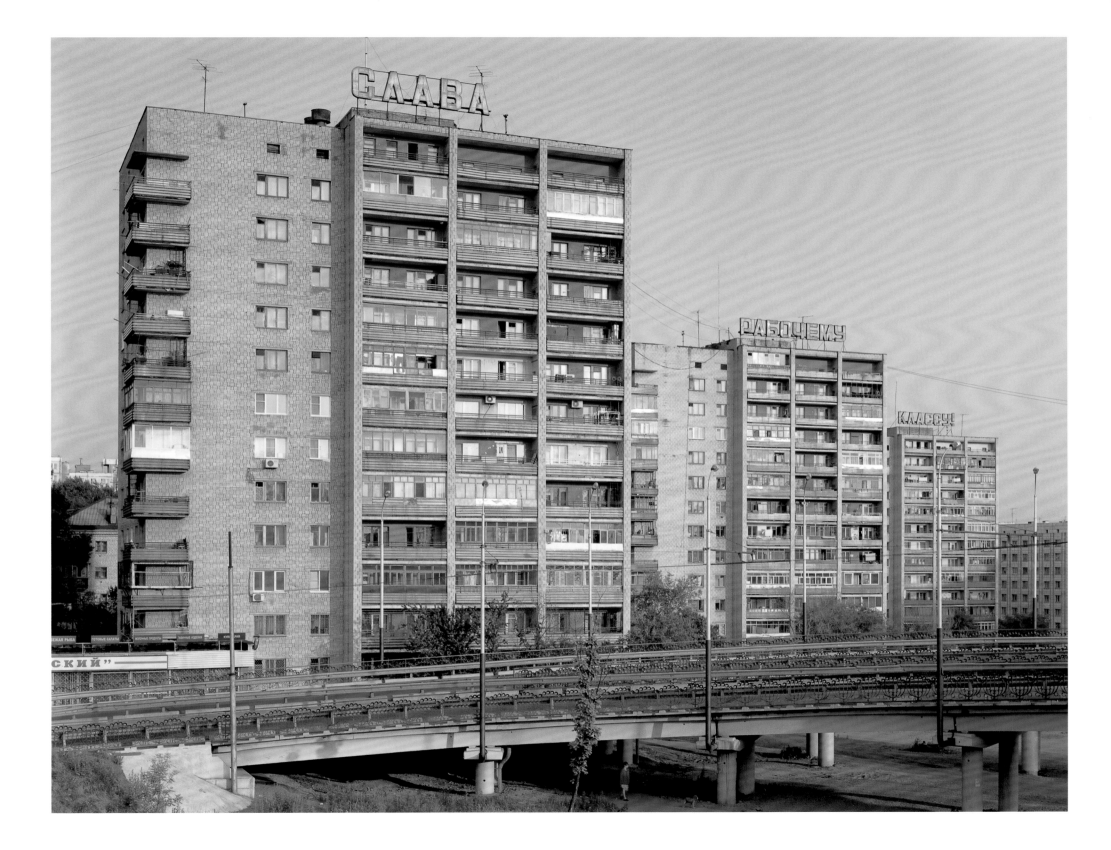

plate 22 **DISCOTHEQUE**, KRASNOYARSK

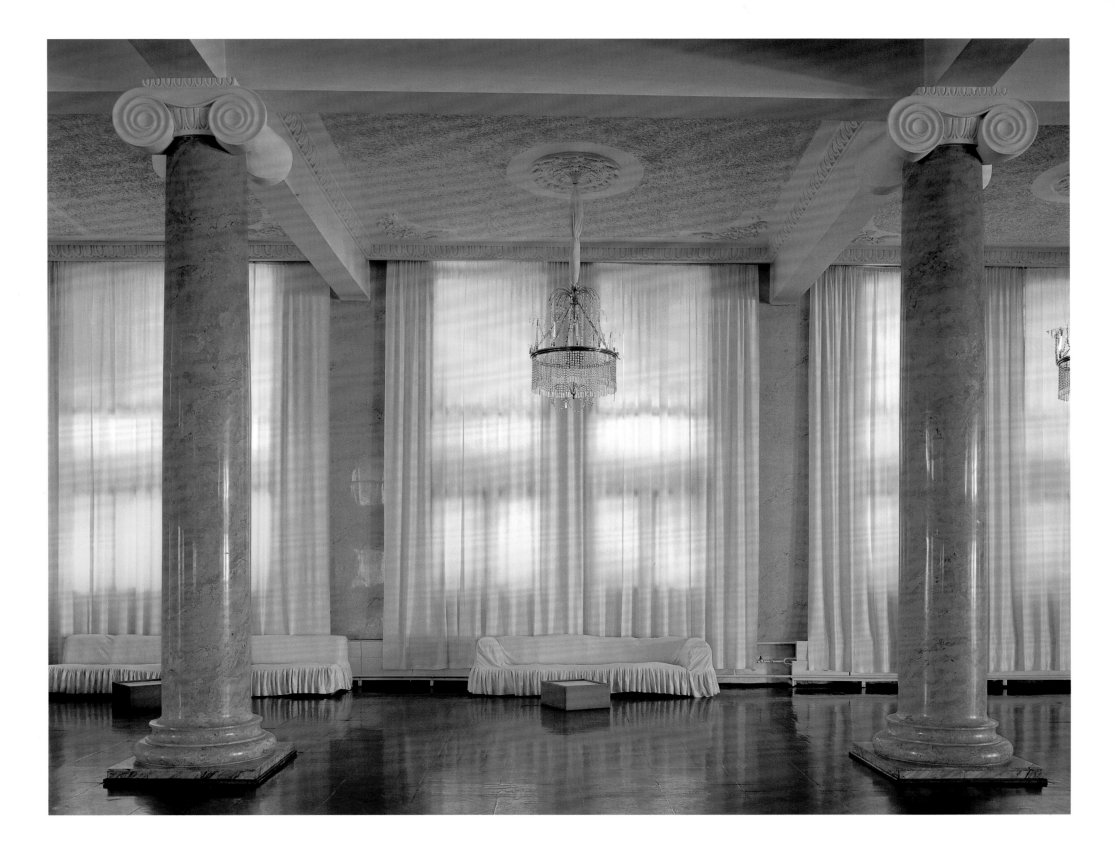

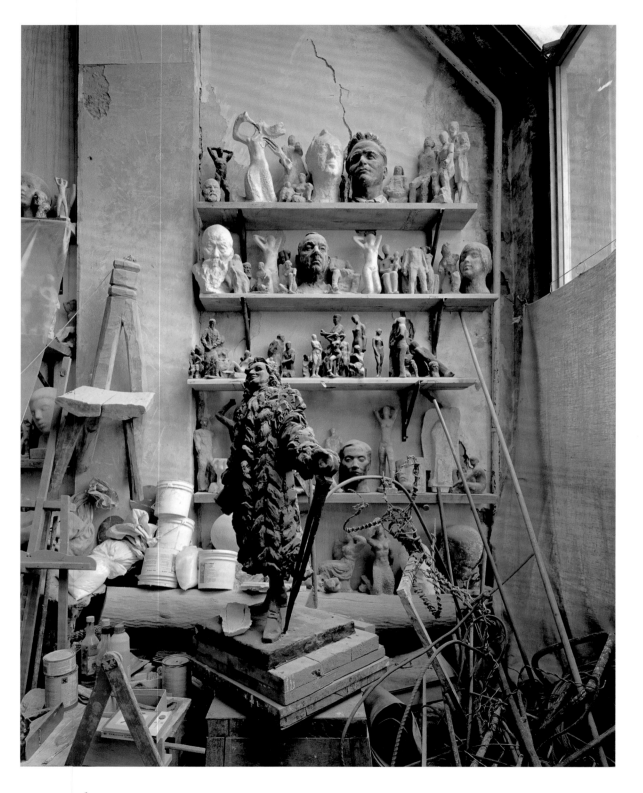

plate 23 **YOUNG SCULPTOR'S STUDIO,** ST. PETERSBURG

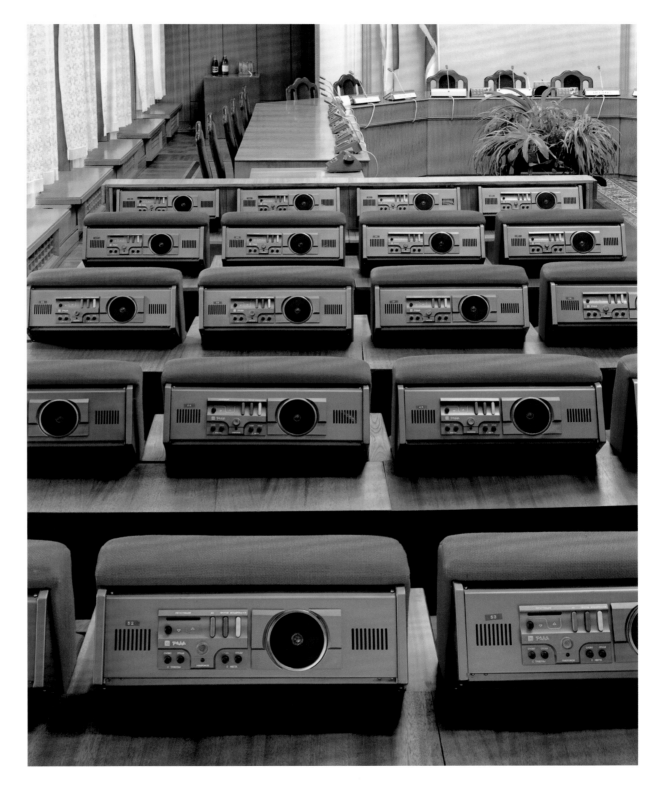

plate 24 **VOTING MACHINES,** SIMFEROPOL

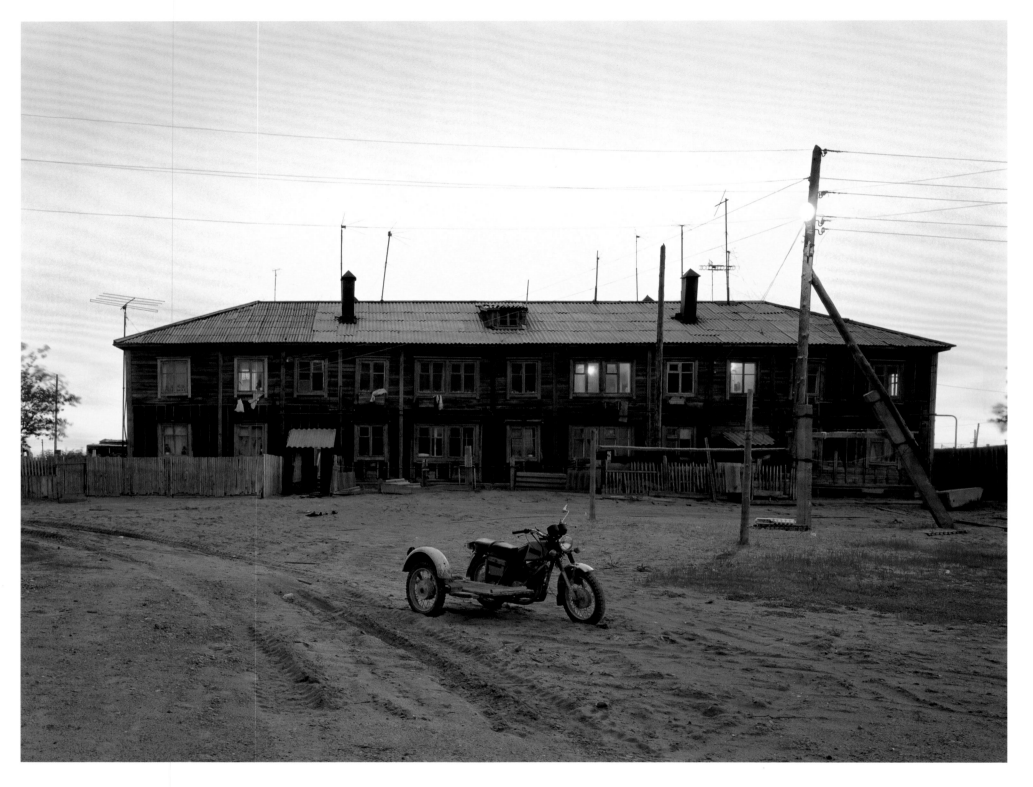

plate 25 **APARTMENT HOUSE NEAR SEA OF OKHOTSK,** FAR EAST

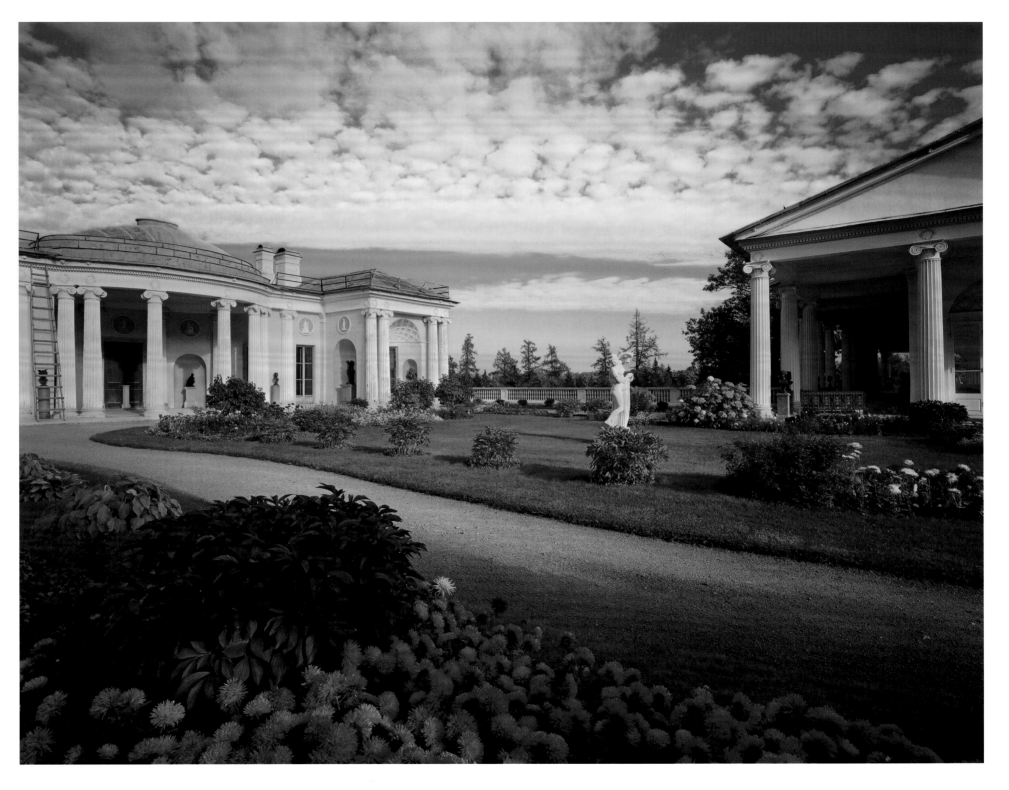

plate 26 **CAMERON GALLERY,** TSARSKOE SELO

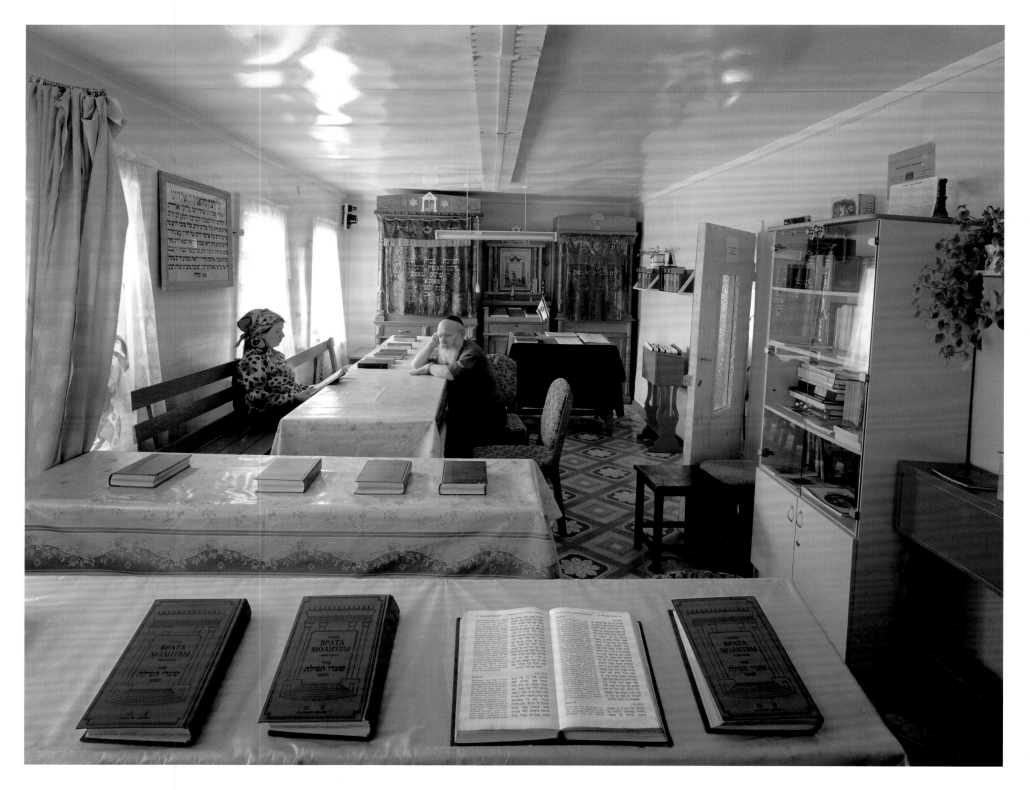

plate 27 **RABBI DOV AND WIFE NINA,** BIROBIDZHAN

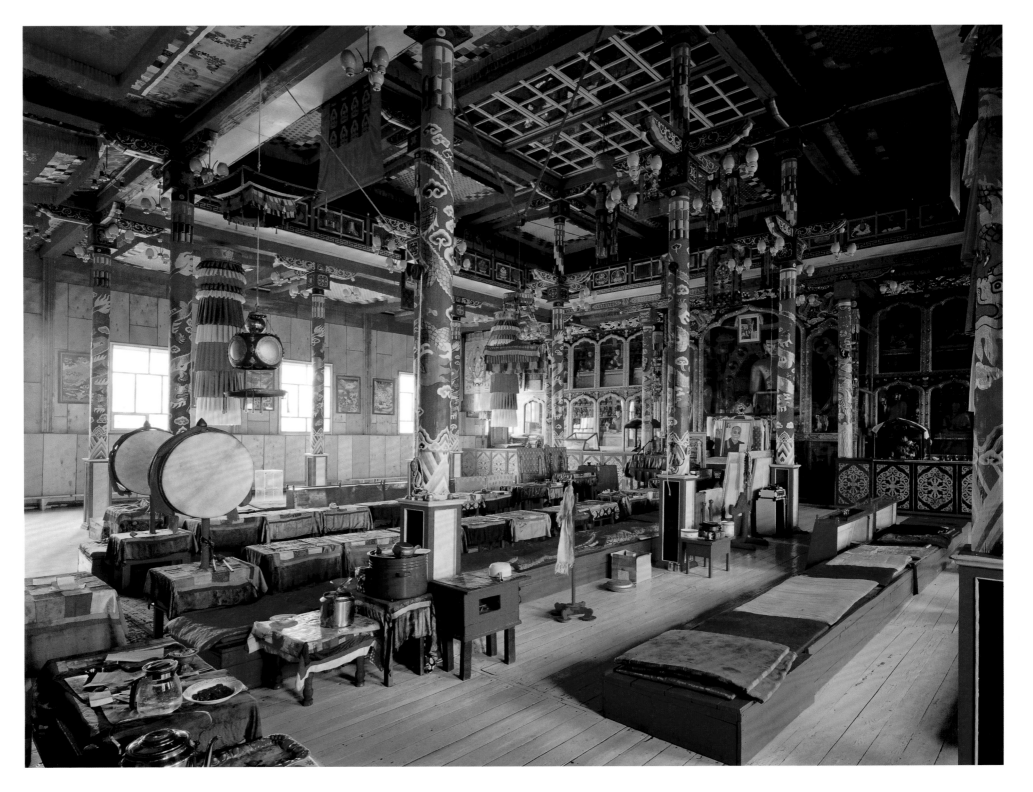

plate 28 **BUDDHIST MONASTERY INTERIOR,** DATSAN

plate 29 **WINTER WEDDING,** VOLOGDA

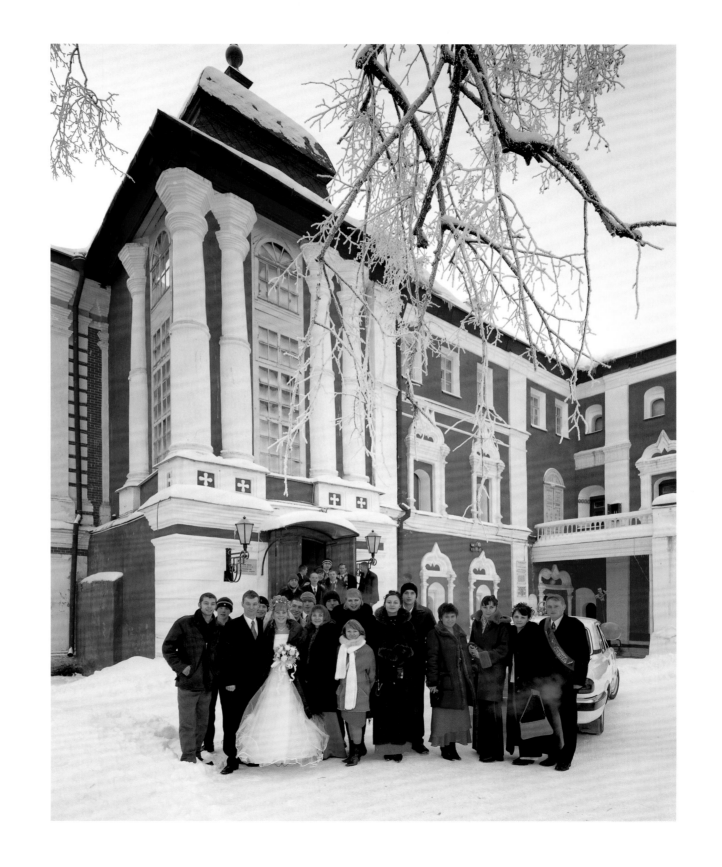

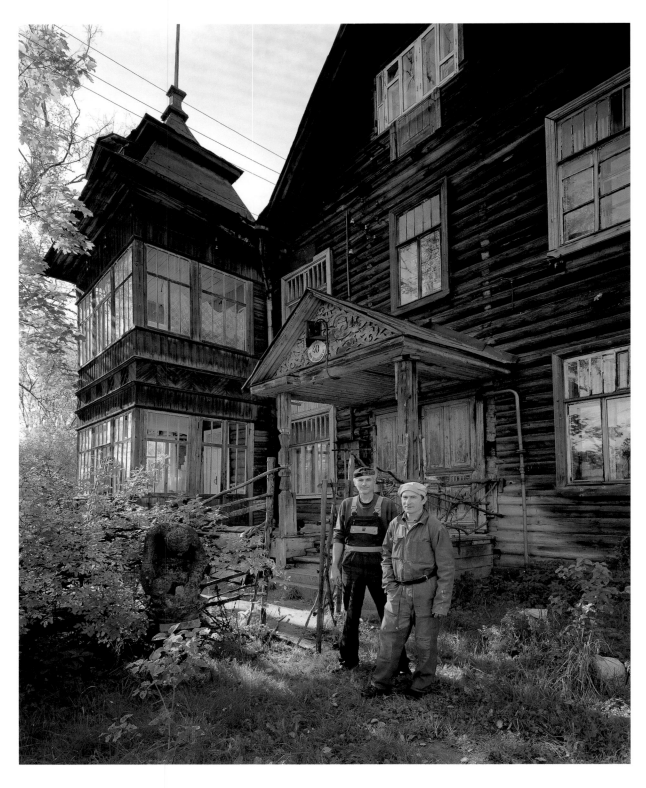

plate 30 **KAMINKER AND KOLIBADA,** ST. PETERSBURG

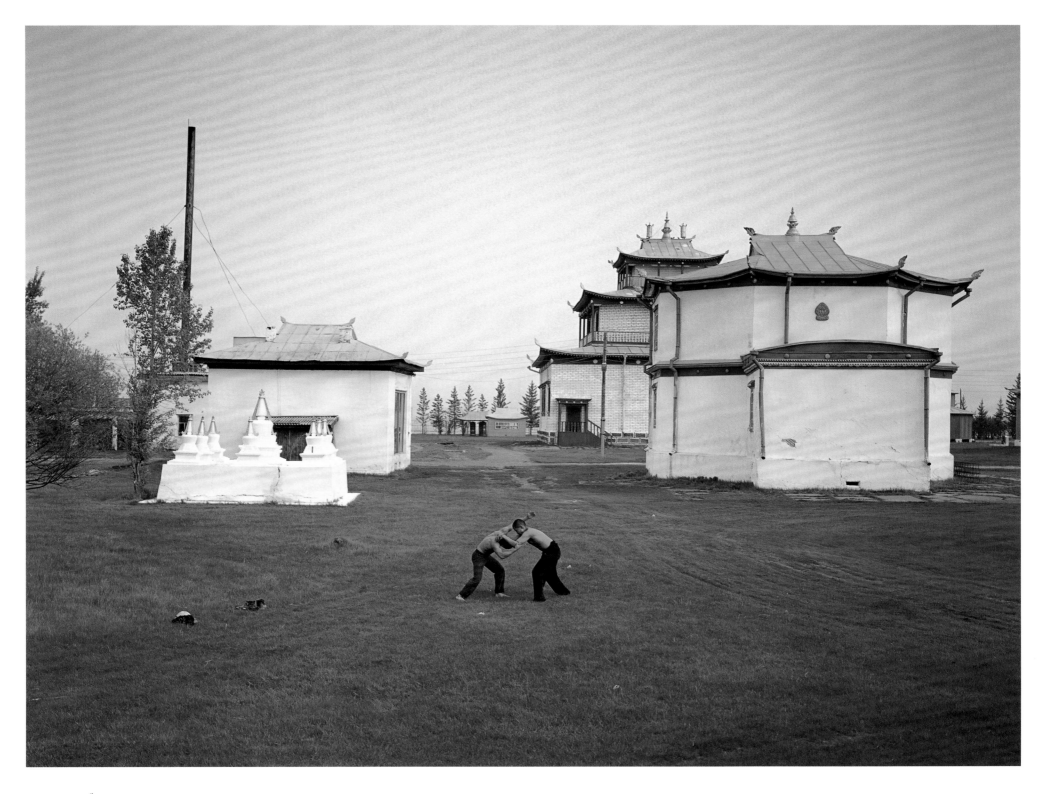

plate 31 **NOVICES WRESTLING,** DATSAN

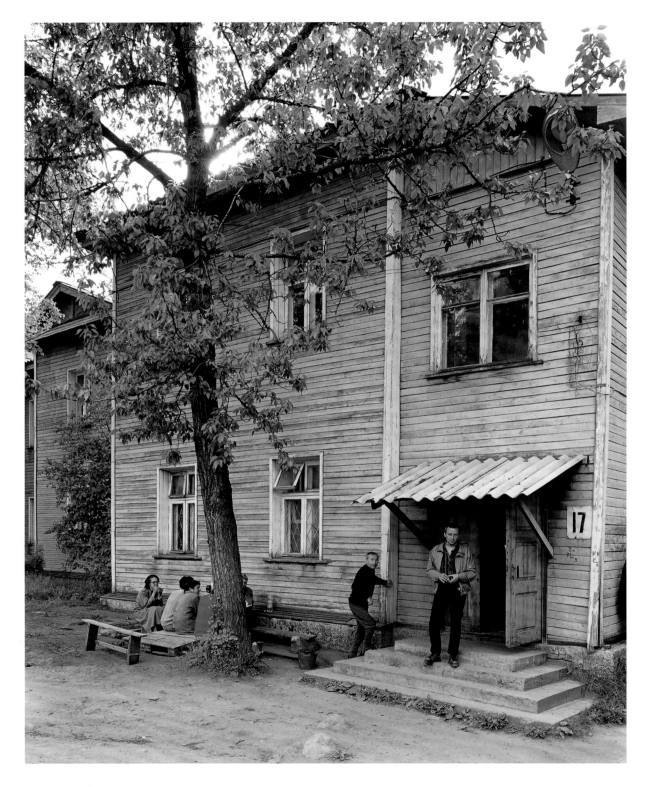

plate 32 **REHAB CENTER**, PETROZAVODSK

plate 33 **SOLDIER TAKING EXAM,** VLADIVOSTOK

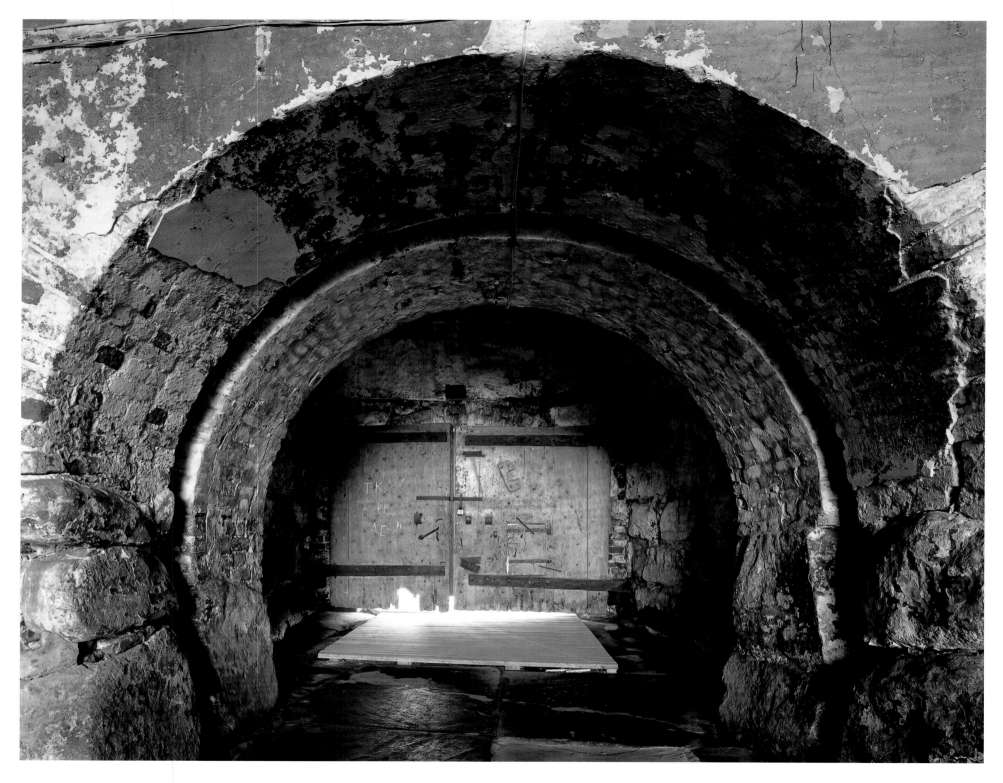

plate 34 **ENTRANCE GATE,** SOLOVKI

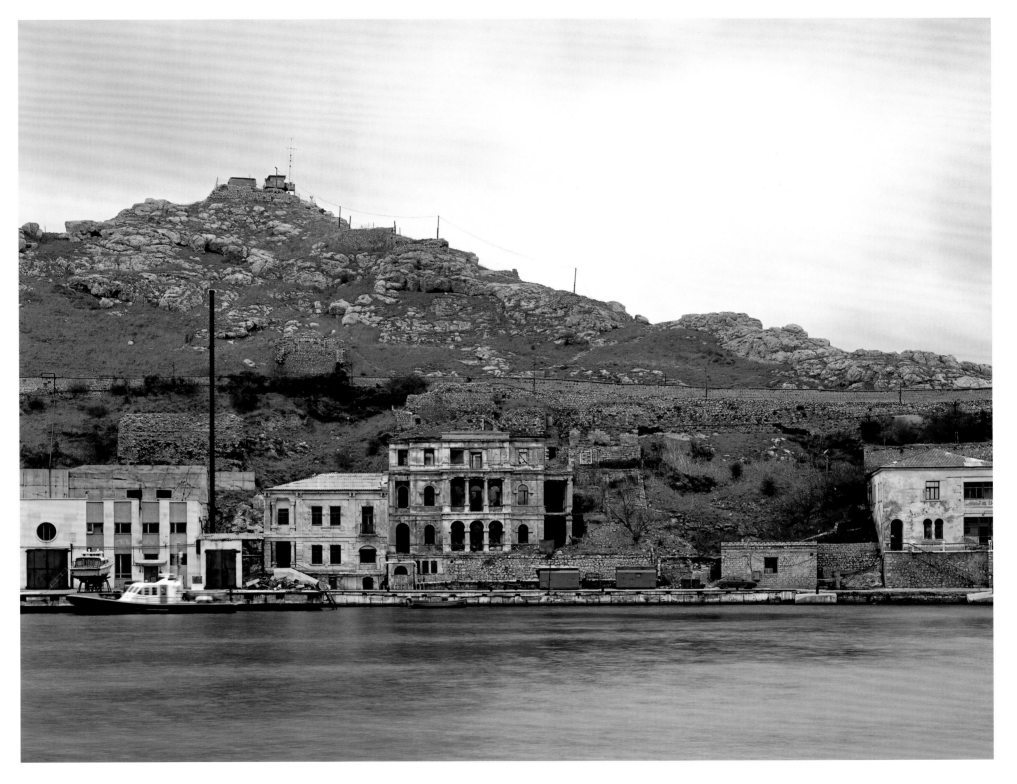

plate 35 **BALAKLAVA,** CRIMEA

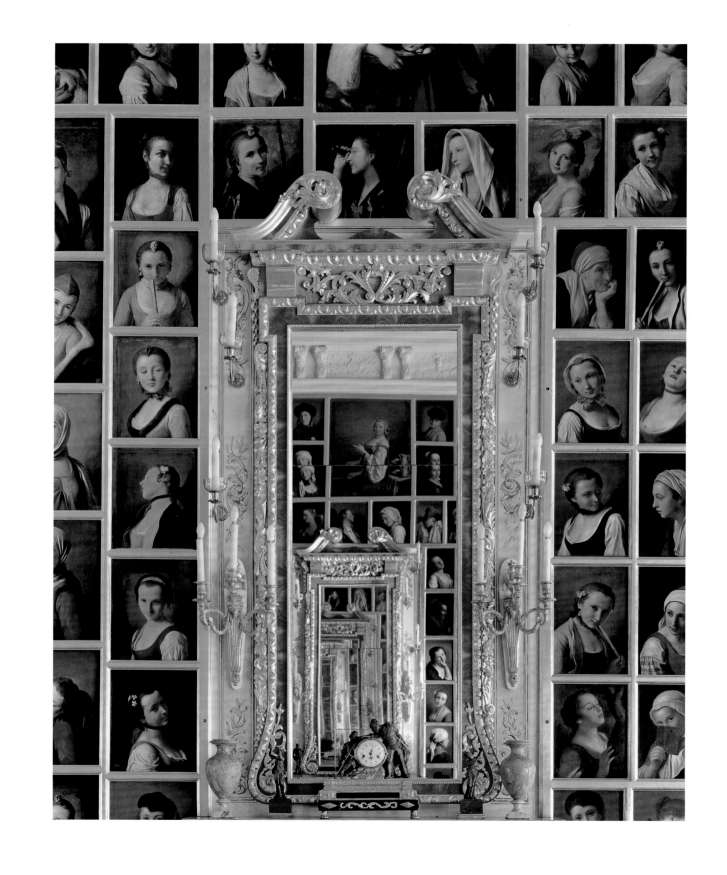

plate 36 **ROTARI'S GALLERY,** PETERHOF

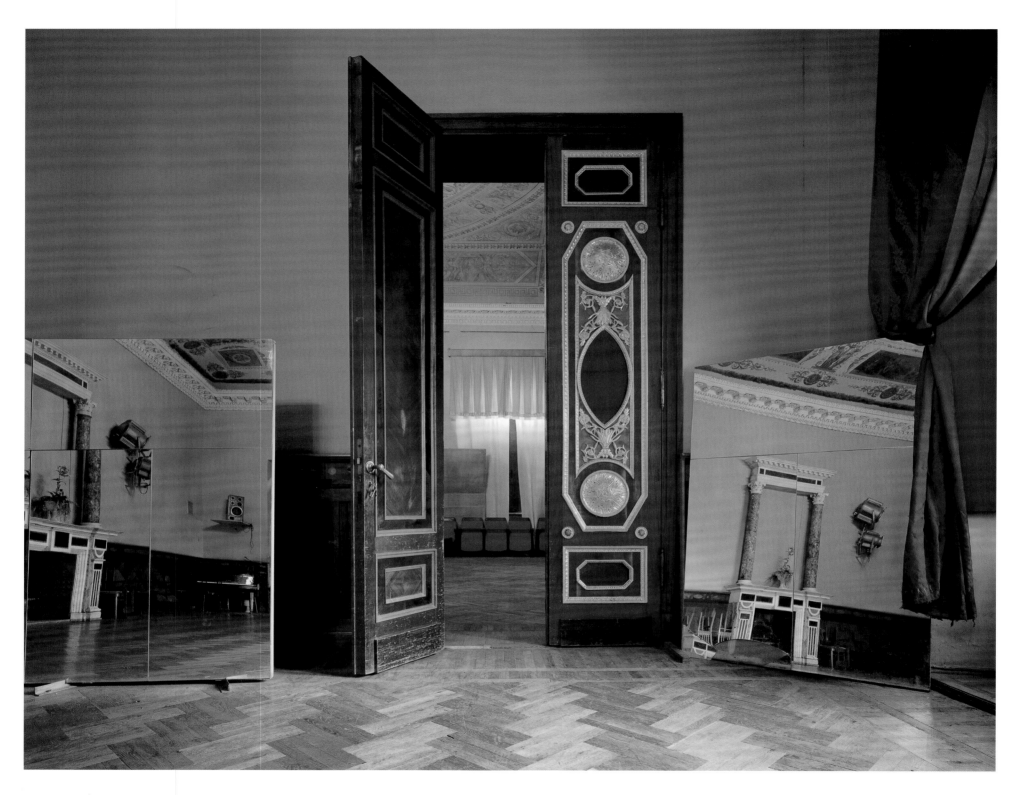

plate 37 **CHILDREN'S THEATER,** VORONTSOV'S PALACE, ODESSA

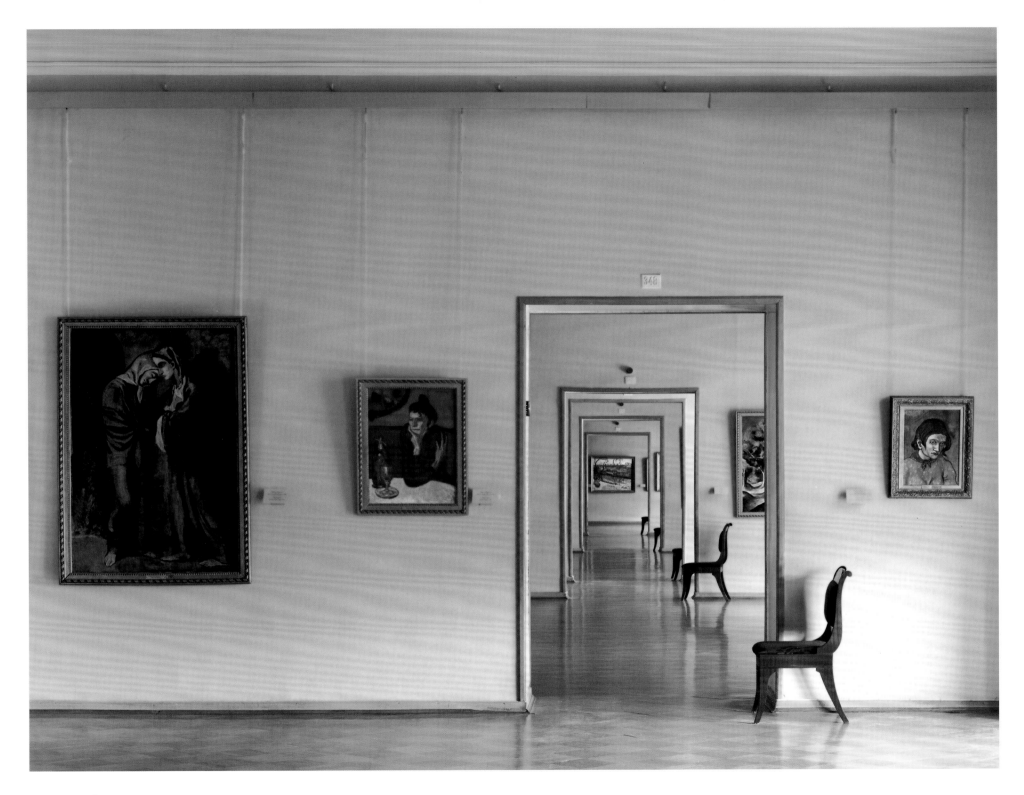

plate 38 **ROOM 348,** THE STATE HERMITAGE MUSEUM, ST. PETERSBURG

plate 39 **OPERA HOUSE,** IRKUTSK

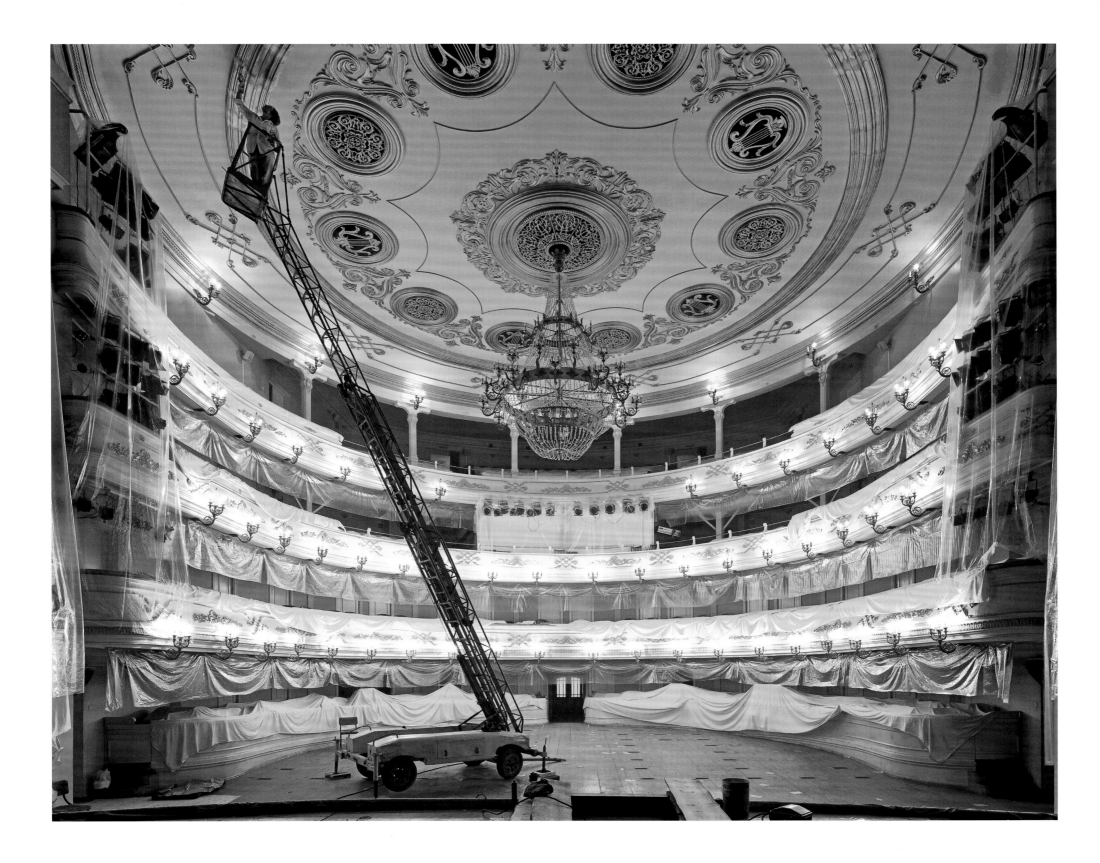

plate 40 **LOCOMOTIVE WORKERS' THEATRE,** ULAN UDE

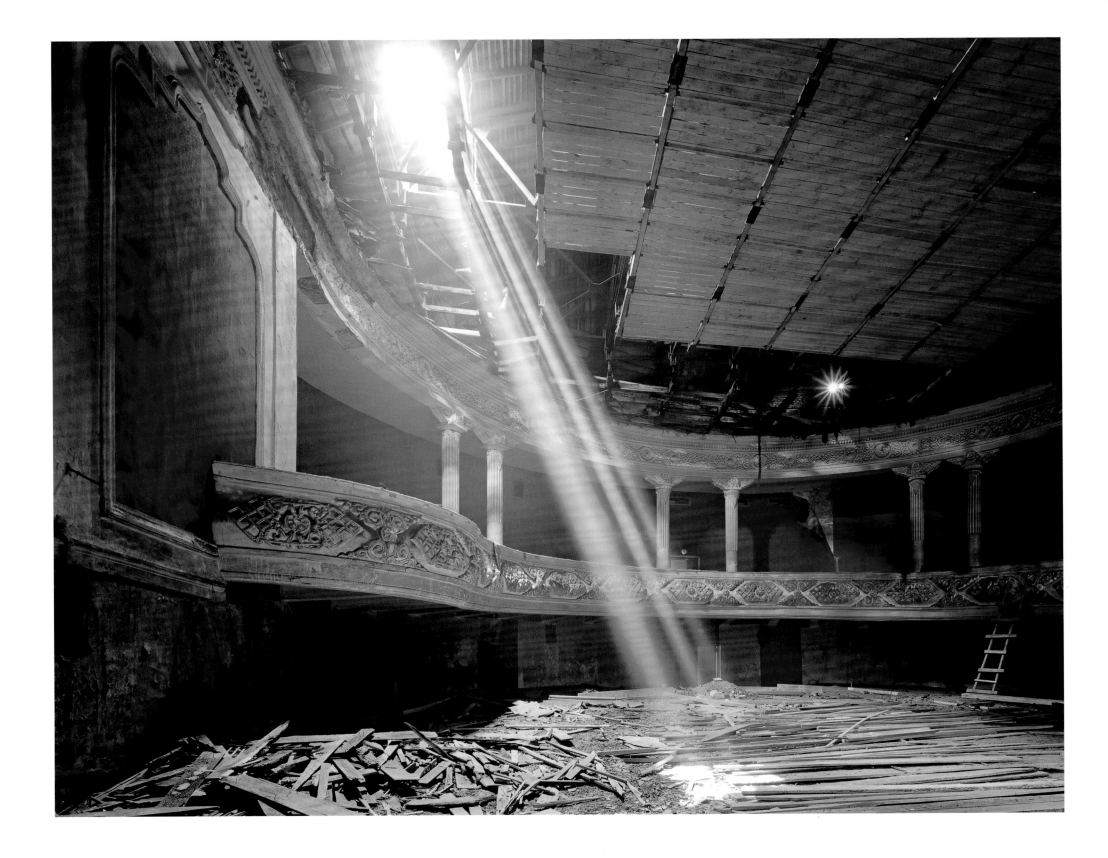

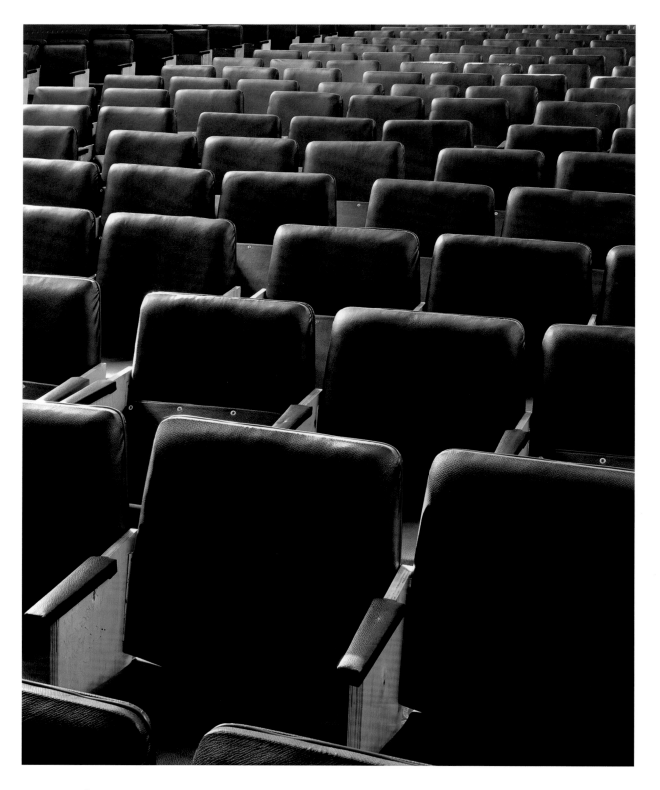

plate 41 **BLACK CHAIRS,** ODESSA

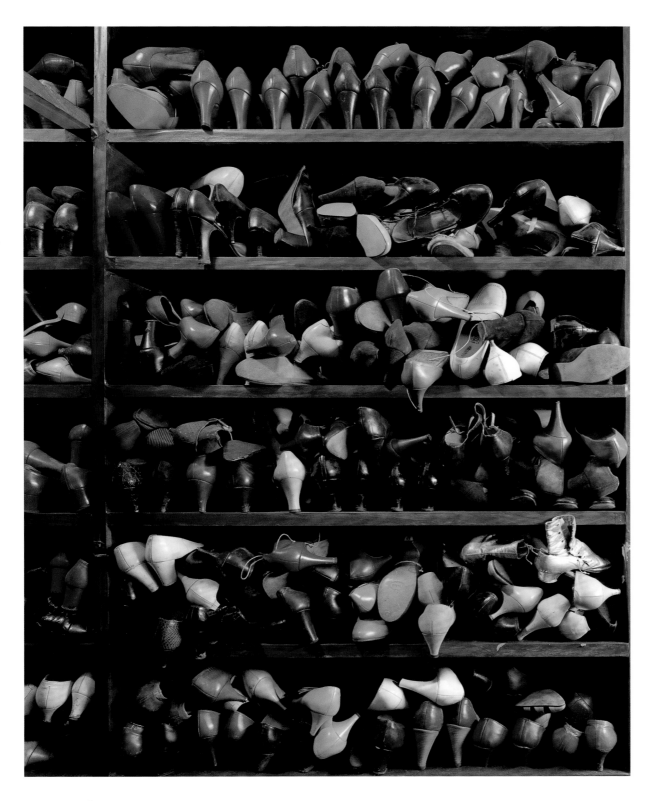

plate 42 **SHOES,** LENFILM, ST. PETERSBURG

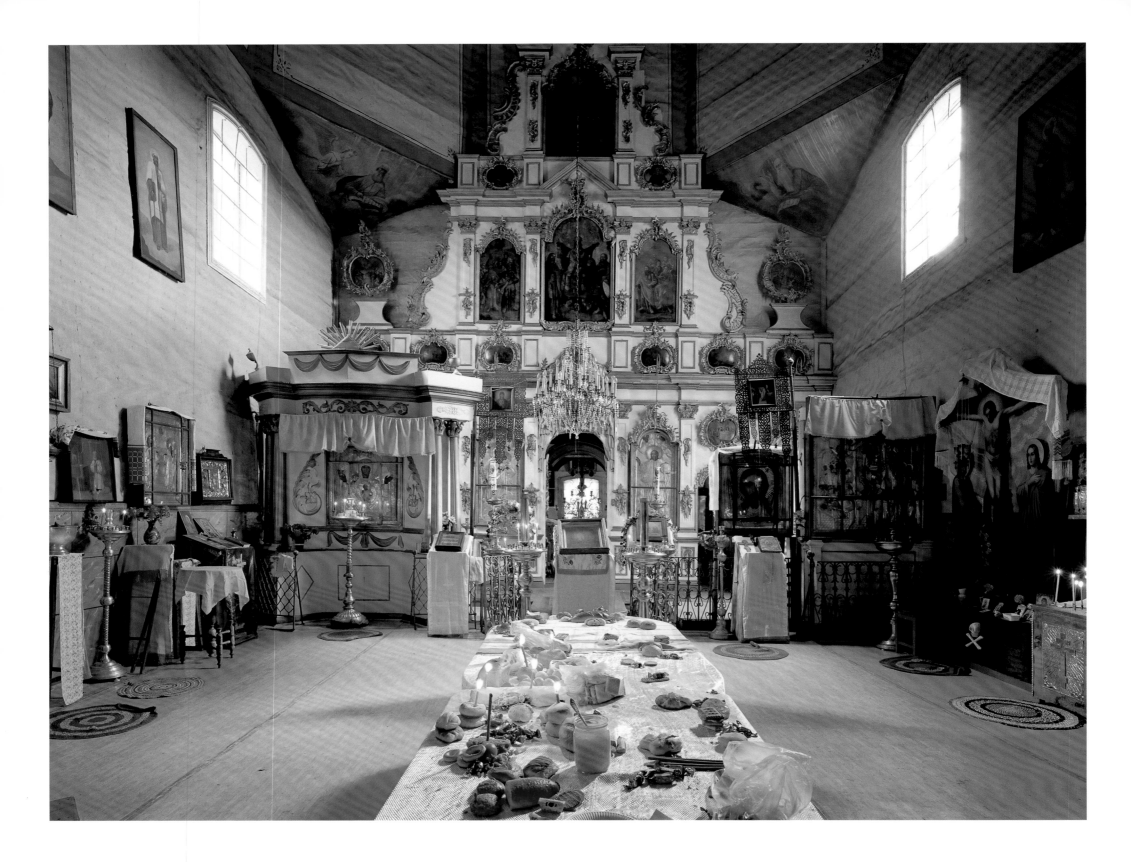

plate 43 **DAY OF THE TRINITY,** TEREBENI

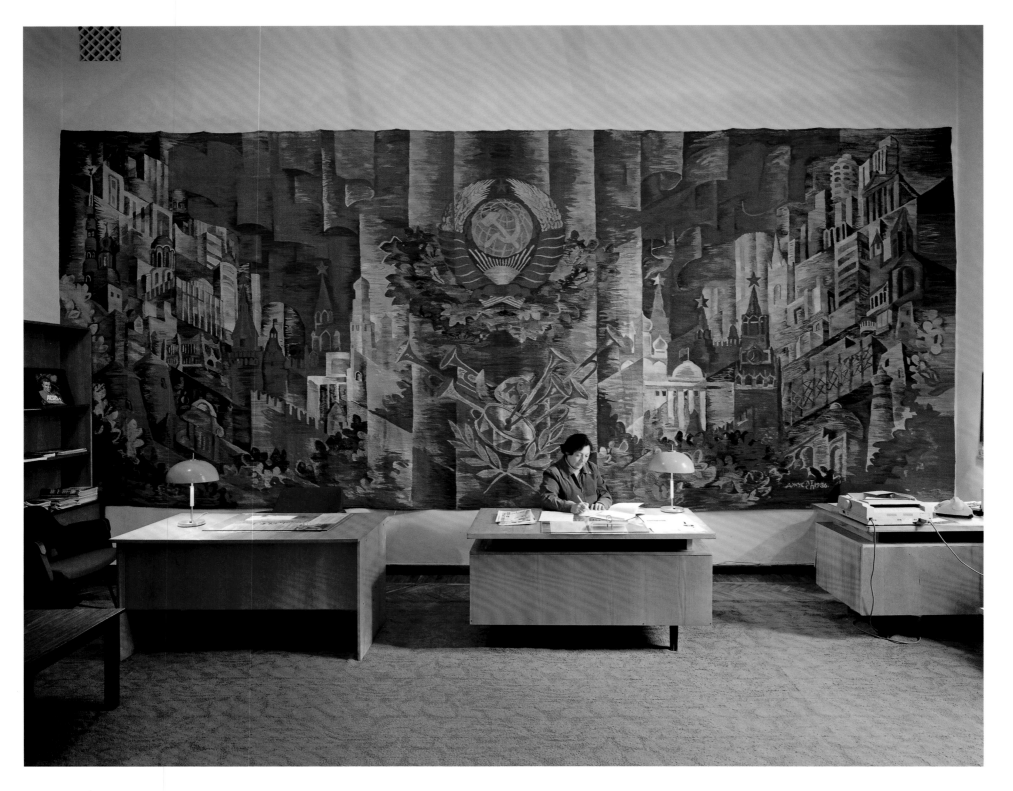

plate 44 **RECEPTION OFFICE,** PIONEER CAMP ARTEK, YALTA

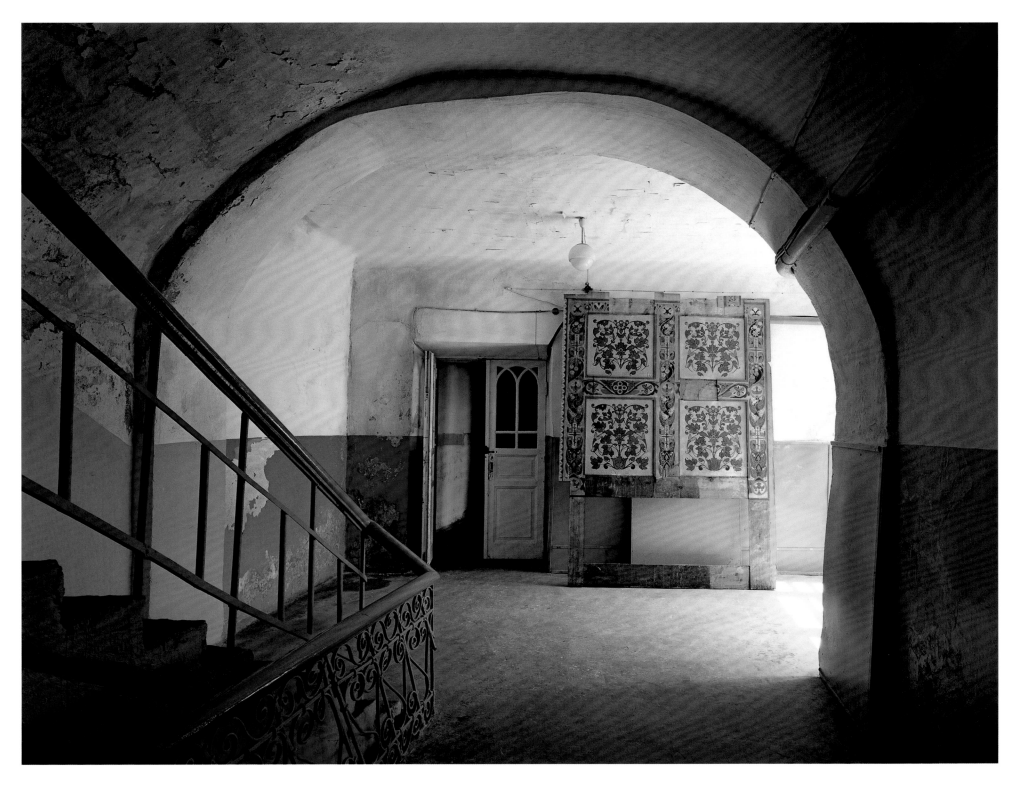

plate 45 **KREMLIN INTERIOR,** SOLOVKI

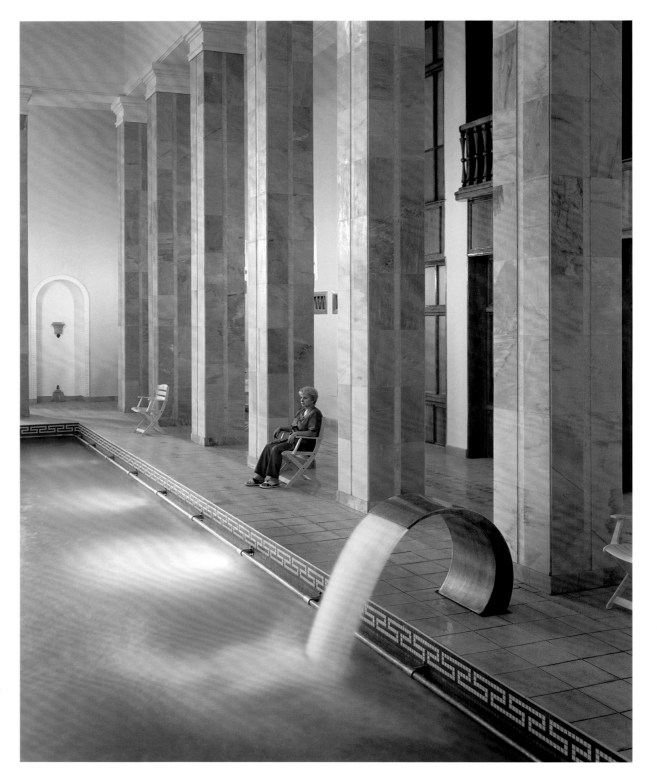

plate 46 **ARIANDA SANATORIUM**, YALTA

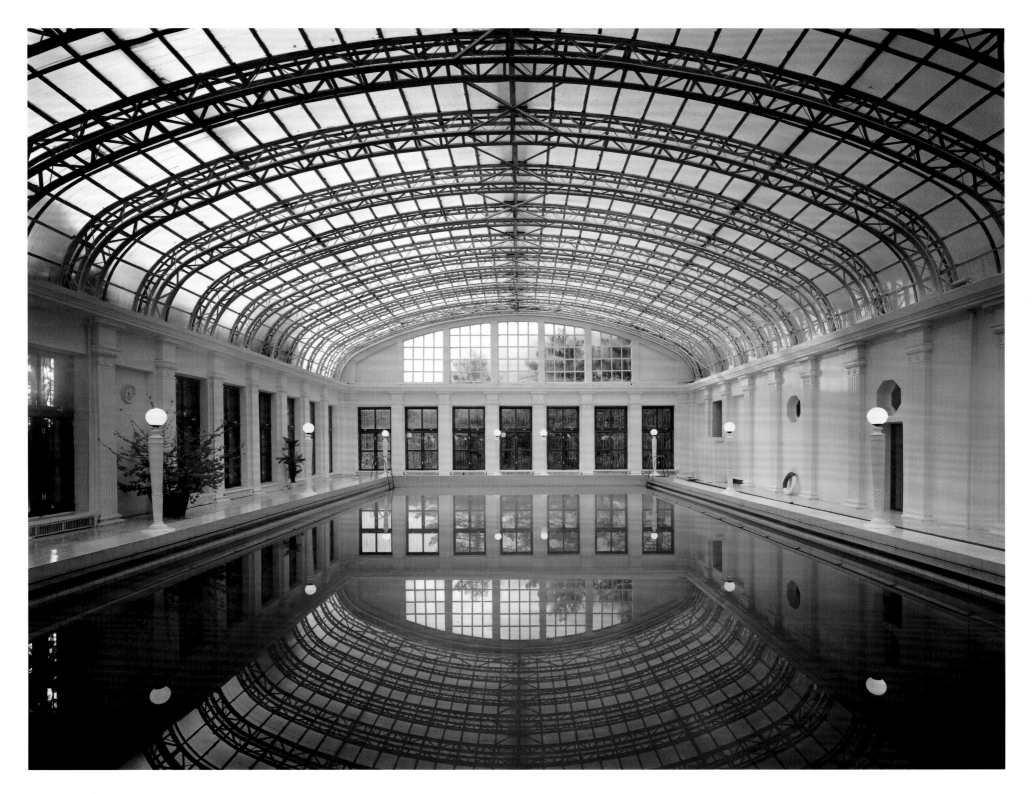

plate 47 **SWIMMING POOL,** UKRAINA SANATORIUM, YALTA

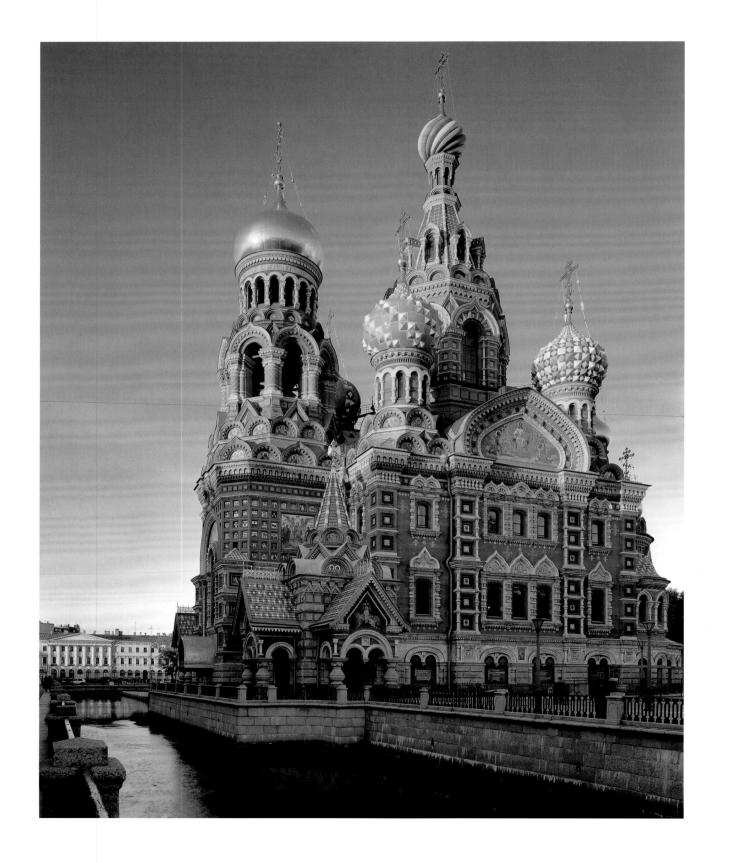

plate 49 **FOUR TREES,** NEAR FERAPONTOVO MONASTERY, FERAPONTOVO

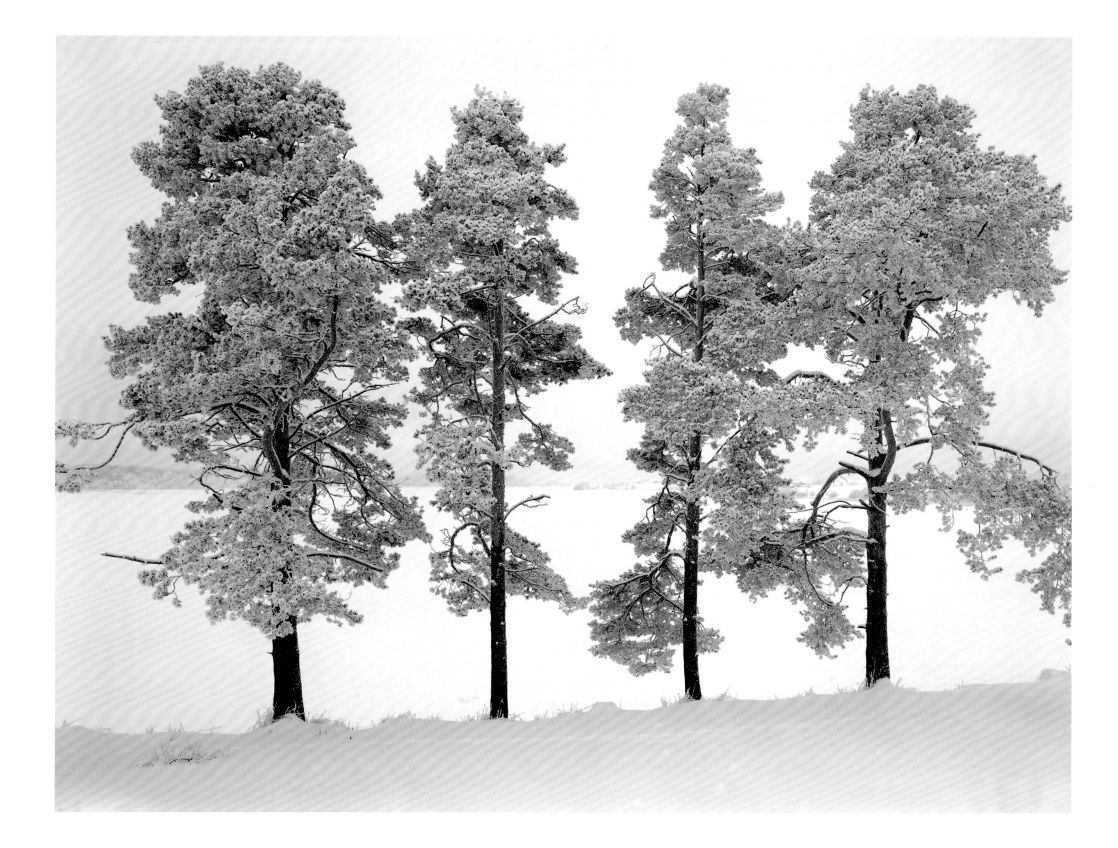

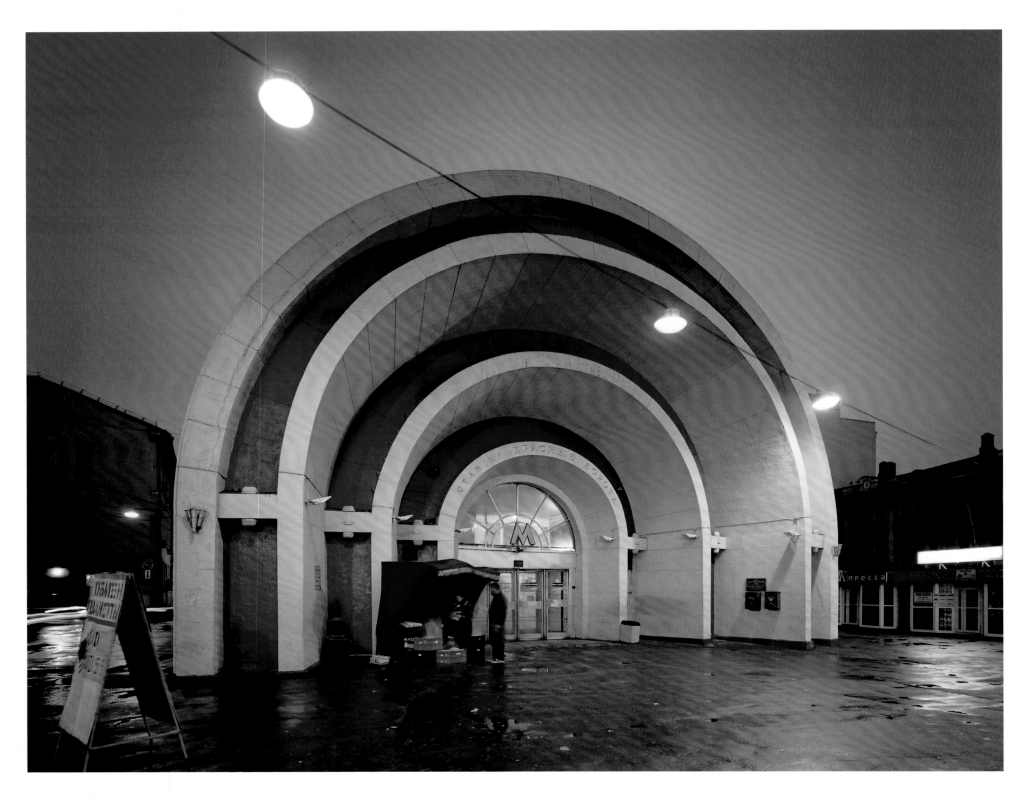

plate 50 **KRASNYE VOROTA STATION**, MOSCOW

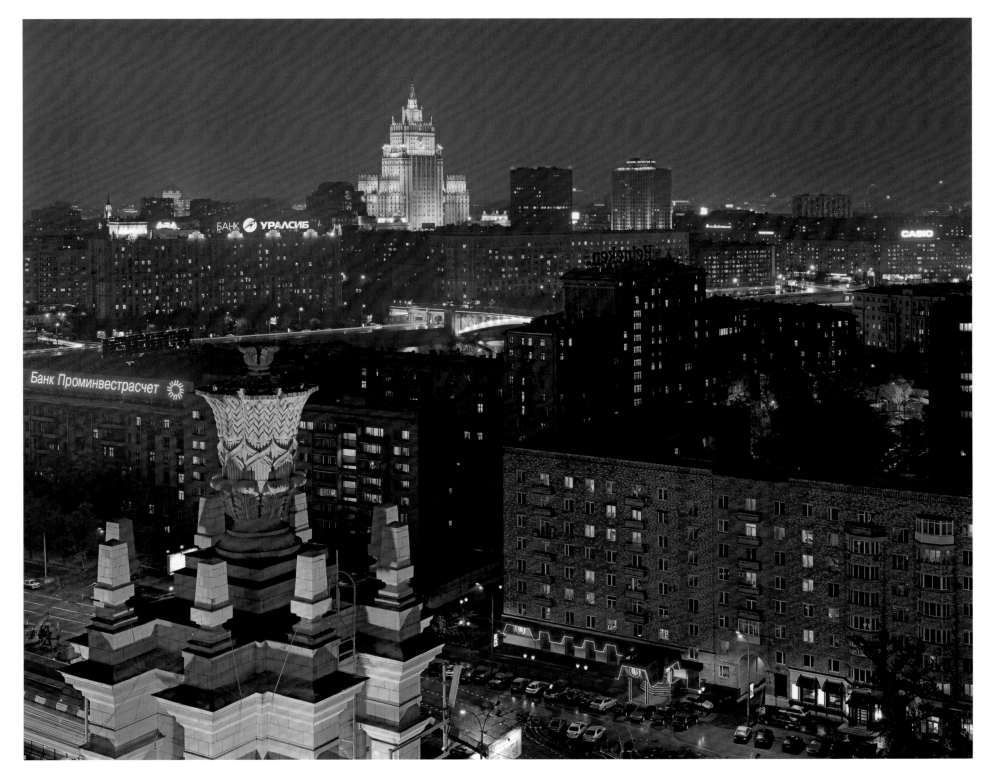

plate 5I **MOSCOW EVENING,** MOSCOW

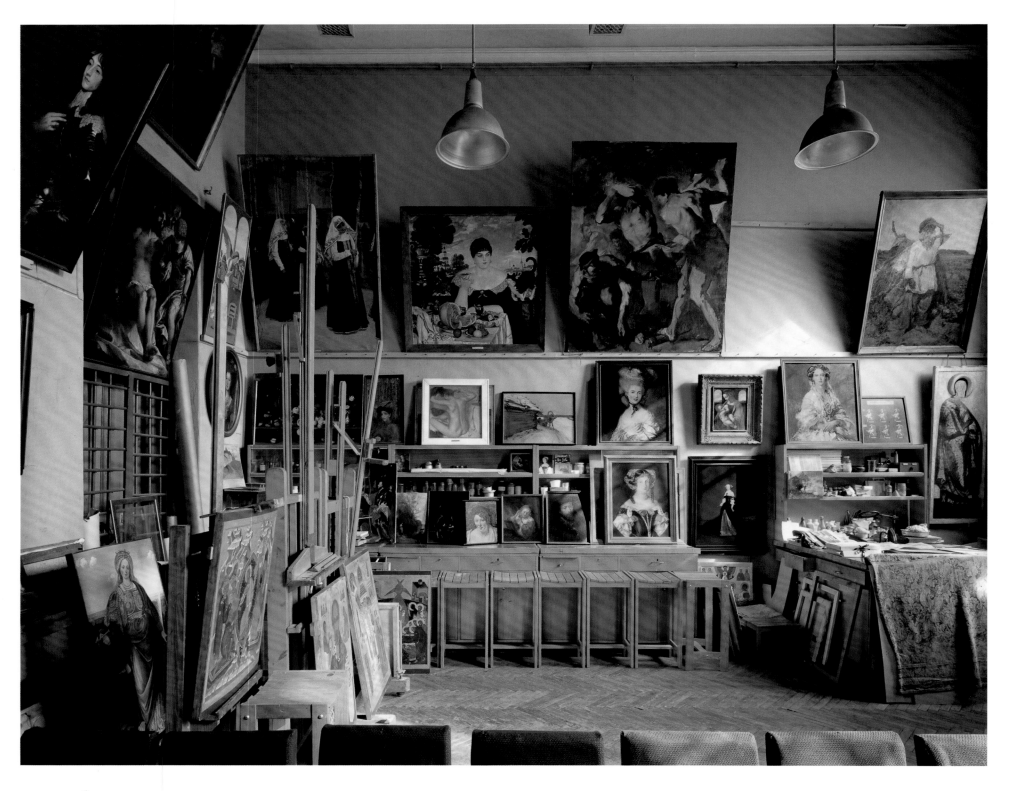

plate 52 **RESTORATION ROOM**, ST. PETERSBURG

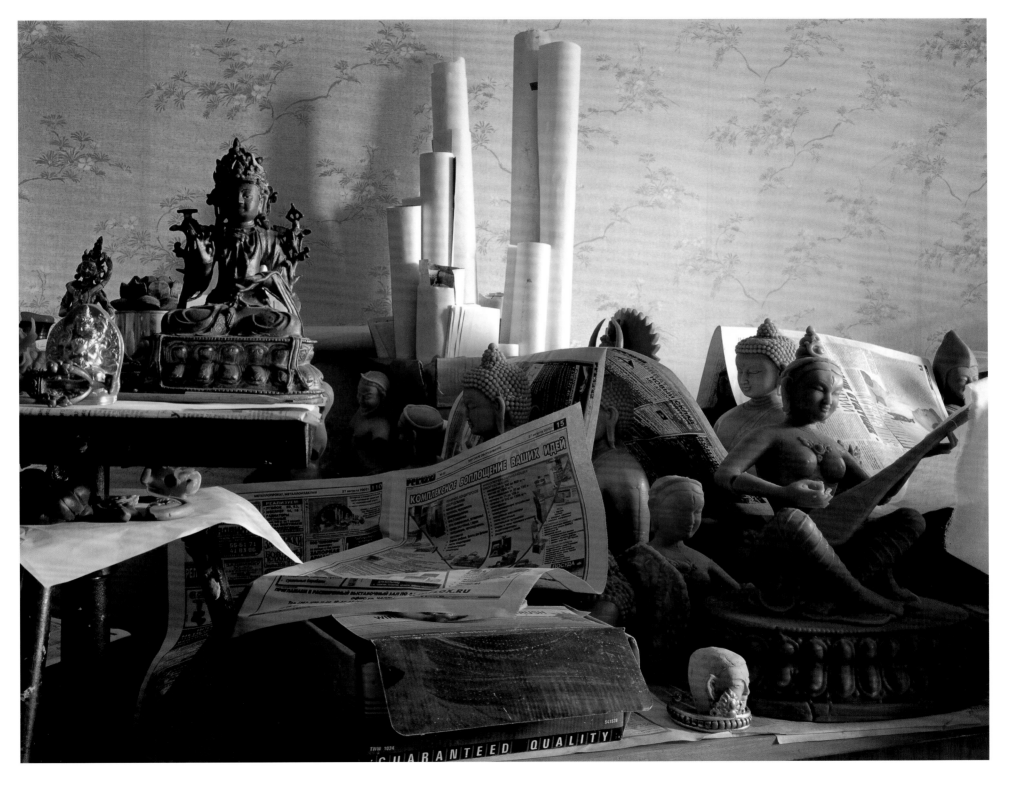

plate 53 WAX MODELS FOR CASTING, ULAN UDE

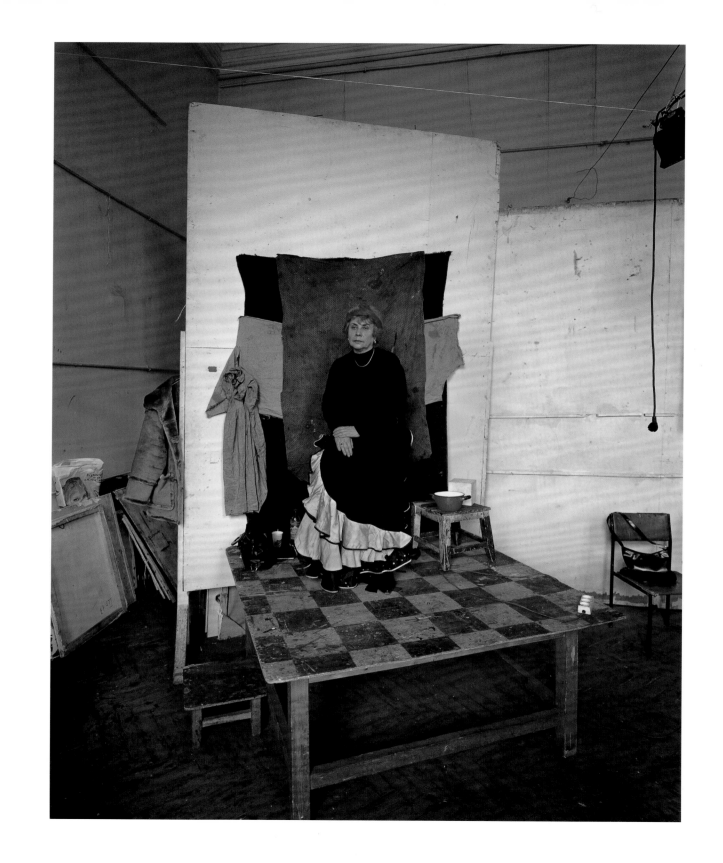

plate 54 **AKADEMY MODEL,** ST. PETERSBURG

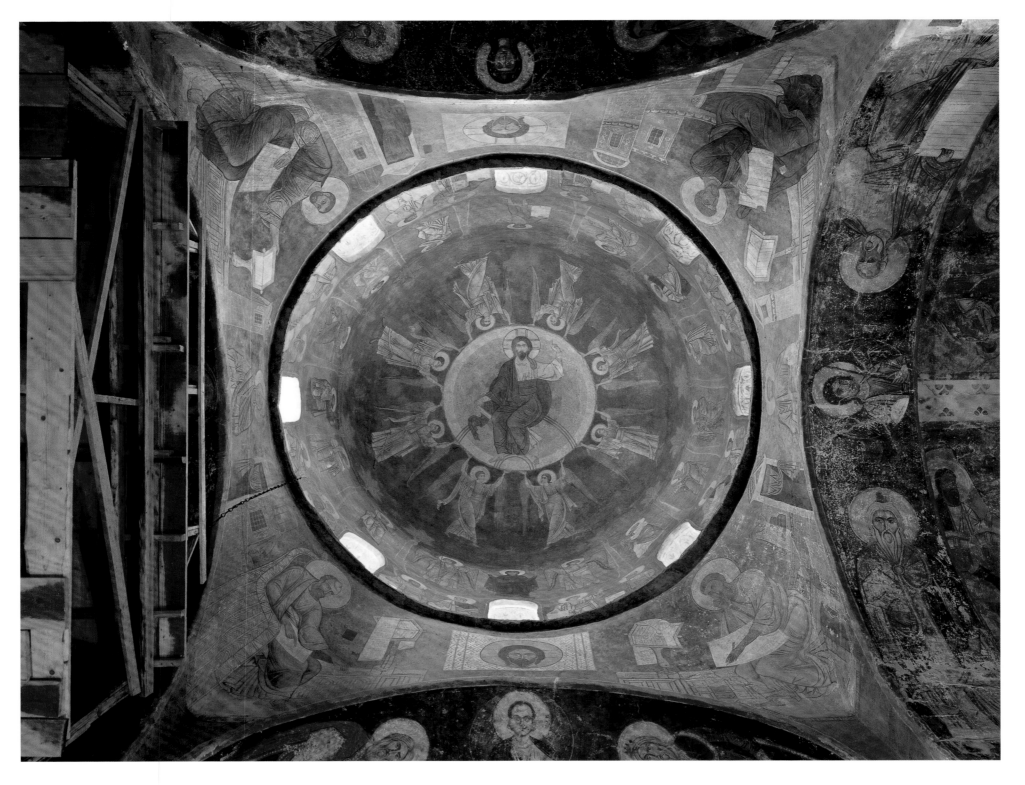

plate 55 **DOME**, MIROZHSKY MONASTERY, PSKOV

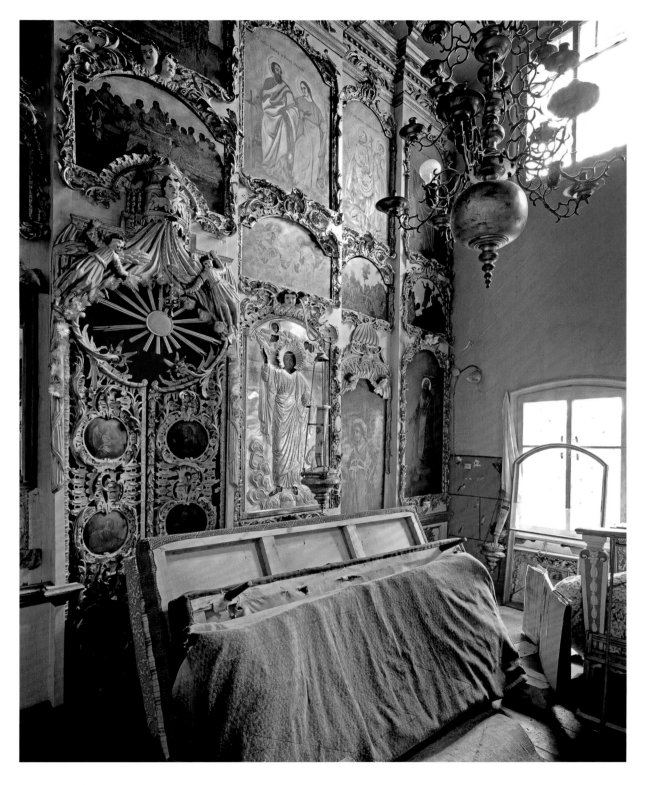

plate 56 **ICONOSTASIS WITH BEDS,** RESURRECTION CHURCH, TEREBENI

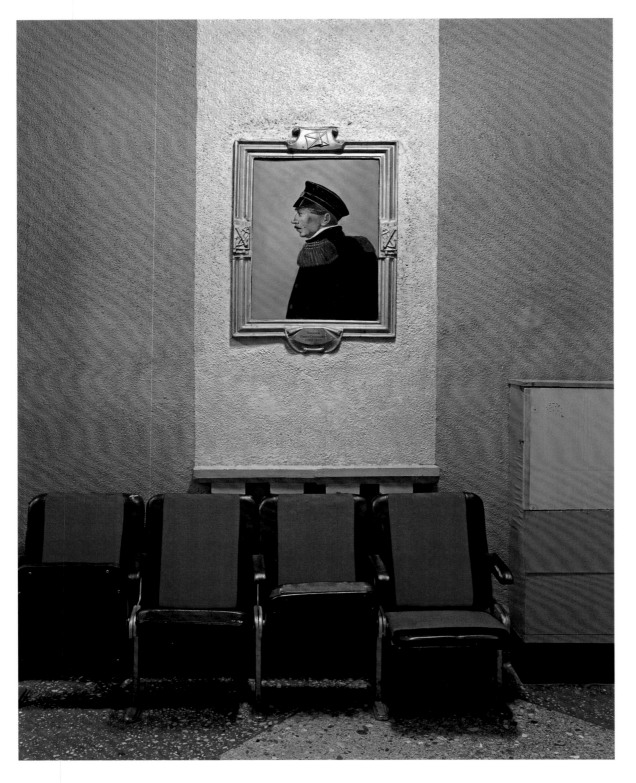

plate 57 **NAVAL CLUB,** VLADIVOSTOK

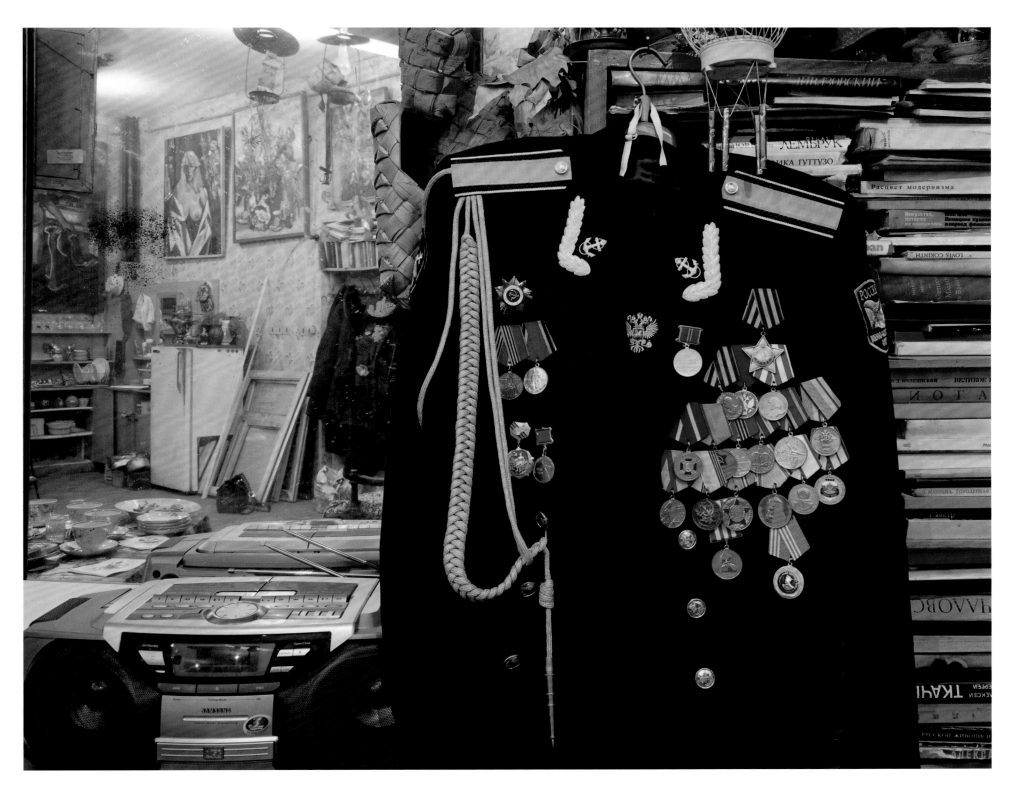

plate 58 **KORBAKOV'S UNIFORM,** VOLOGDA

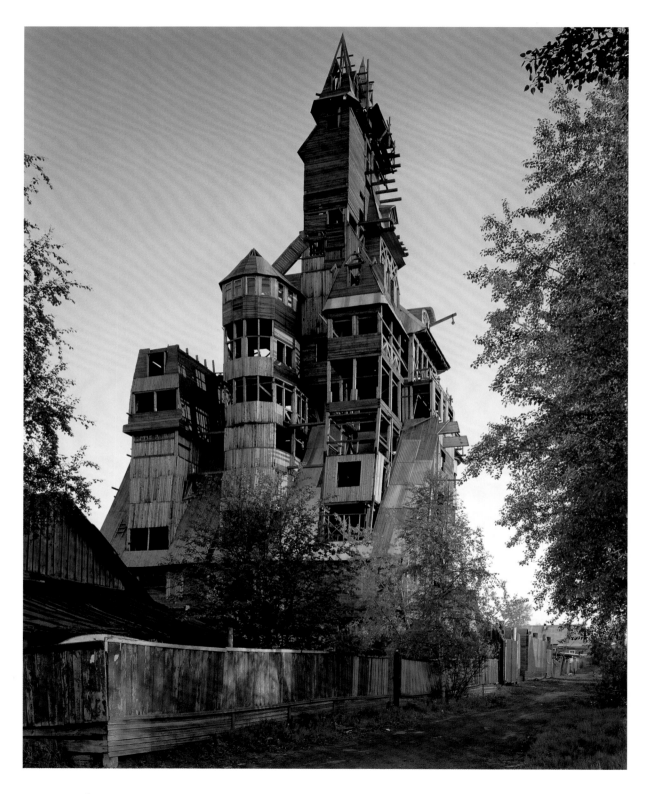

plate 59 **THIRTEEN-STORY WOOD HOUSE,** ARKHANGEL'SK

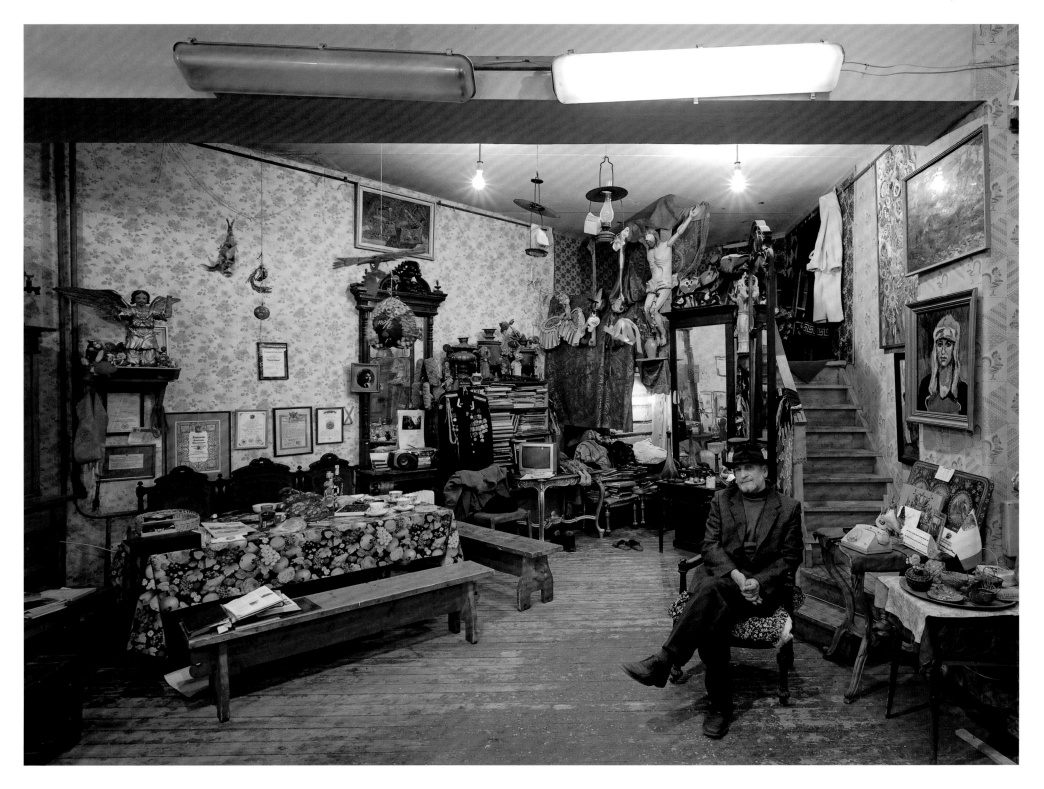

plate 60 **VLADIMIR KORBAKOV IN HIS STUDIO,** VOLOGDA

plate 61 **PETER THE GREAT AND BMW**, ST. PETERSBURG

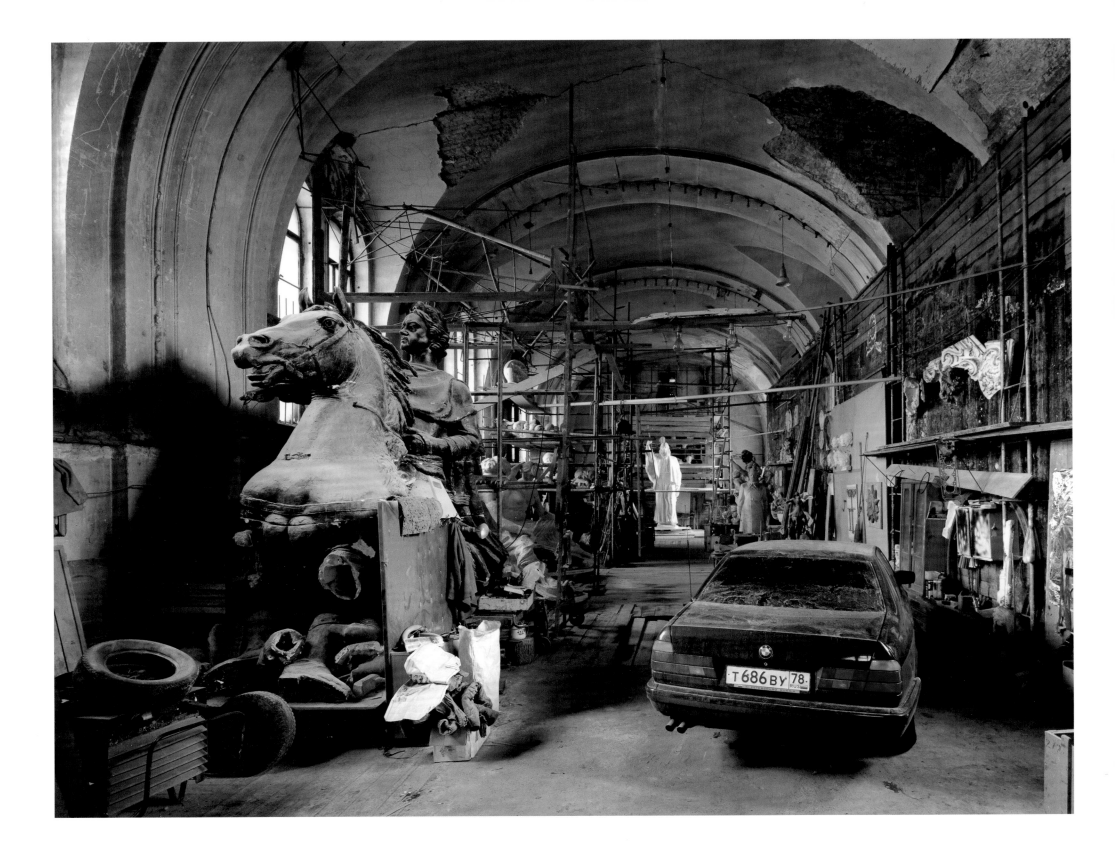

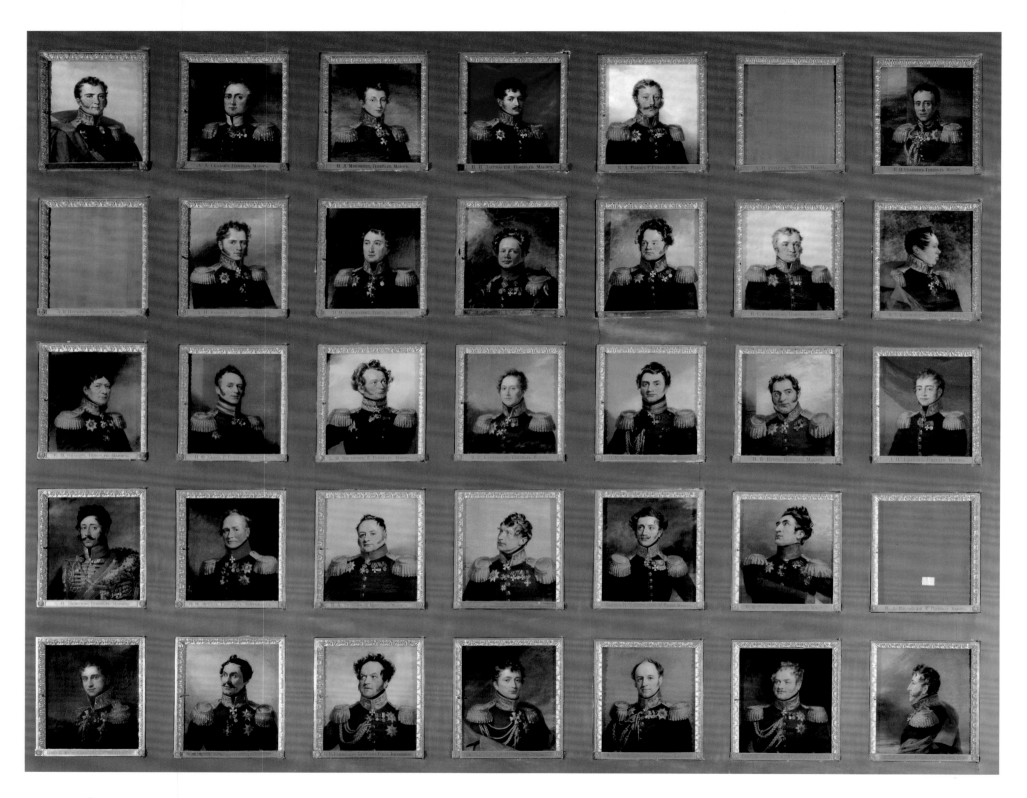

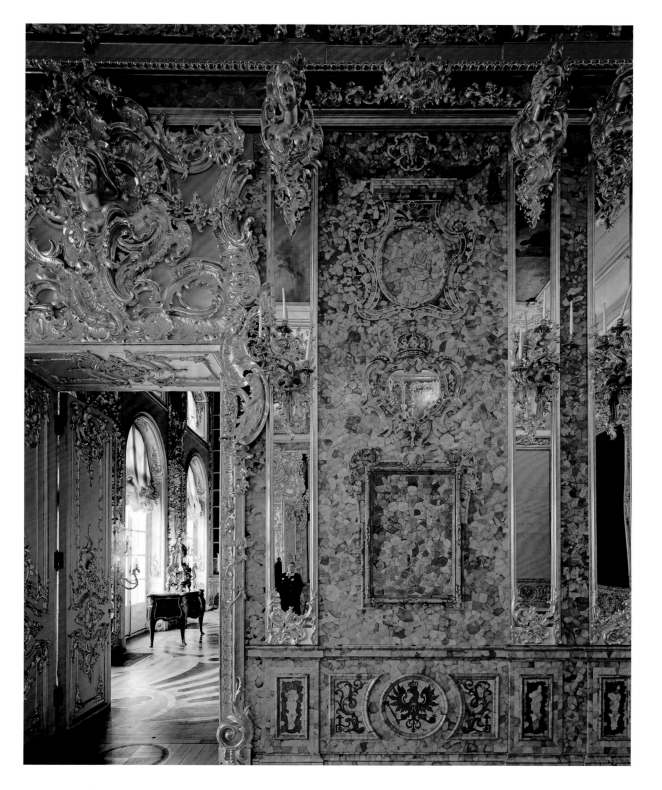

plate 63 **AMBER ROOM,** TSARSKOE SELO

plate 64 **OFFICERS' CLUB,** KRASNOYARSK

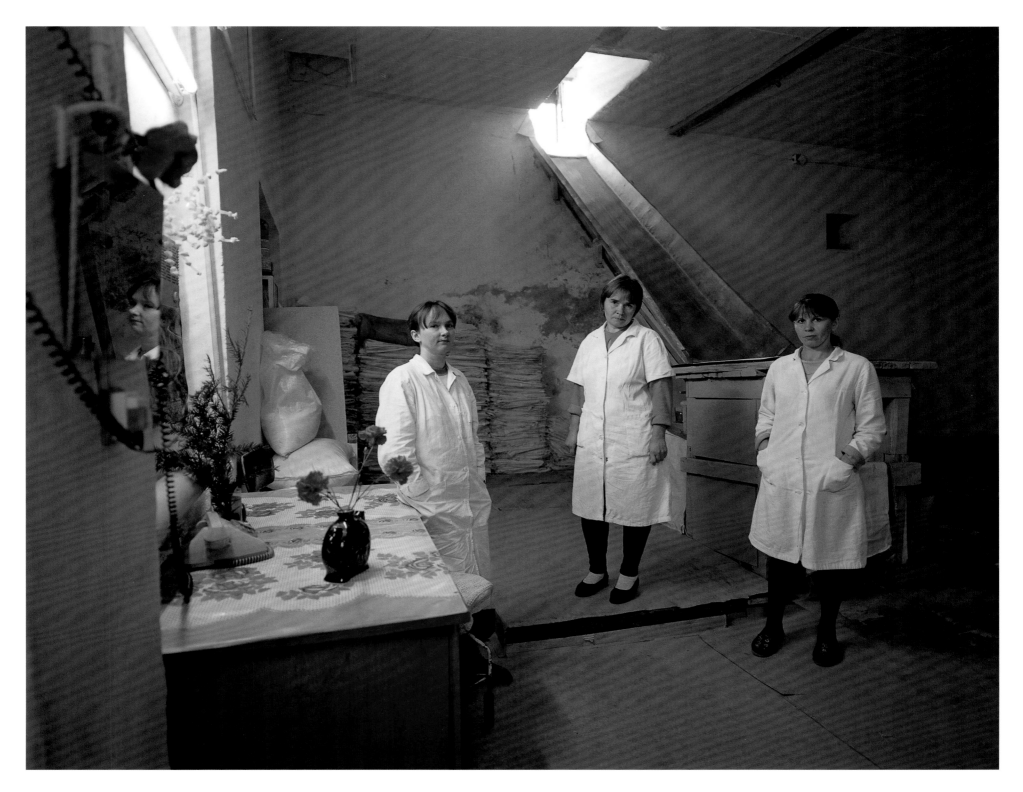

plate 65 **SUGAR WOMEN,** FACTORY OF CHAMPAGNE WINES, YALTA

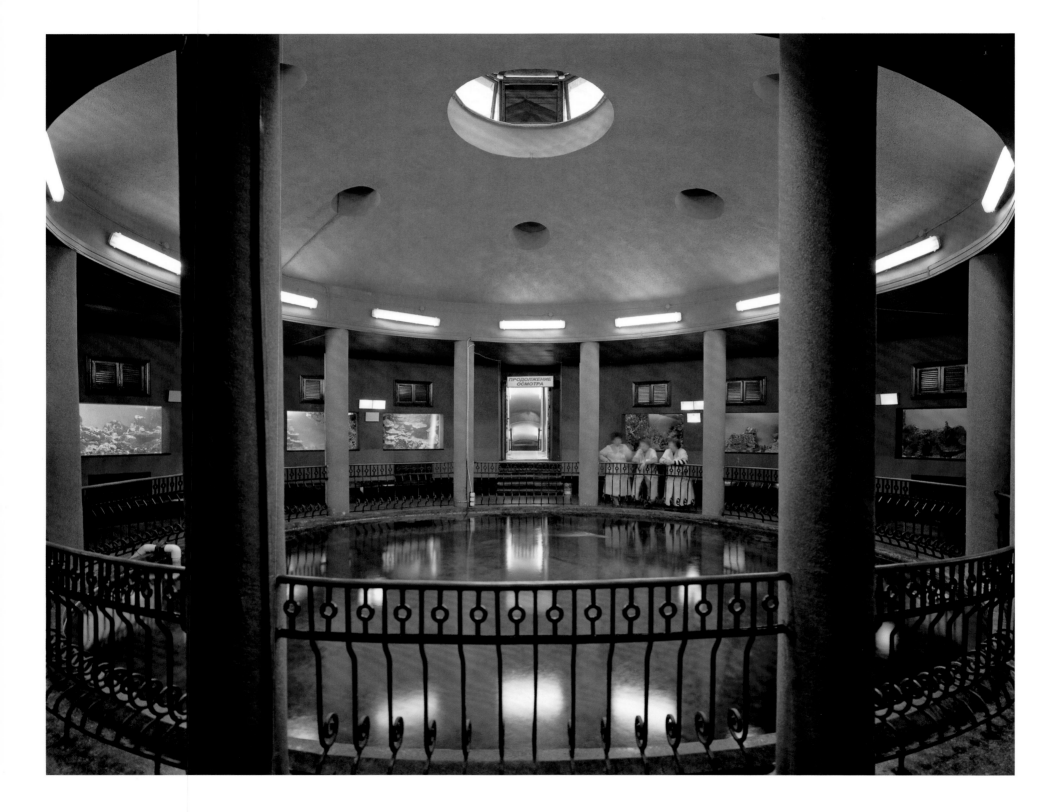

plate 66 **AQUARIUM,** SEVASTOPOL

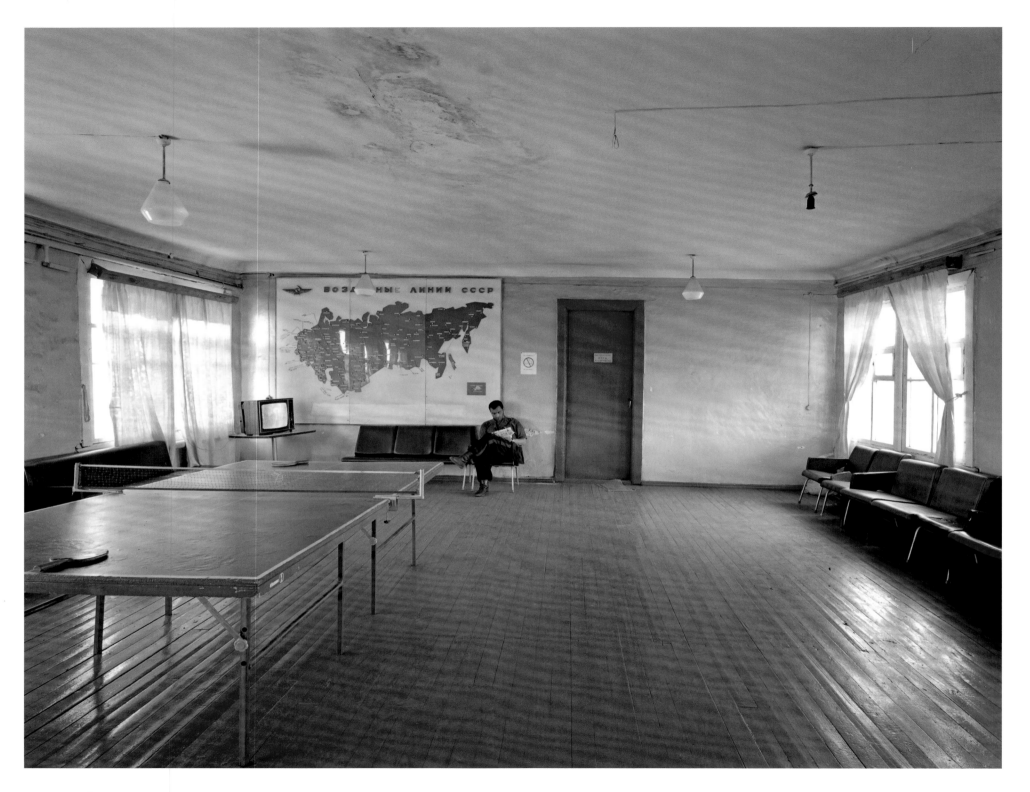

plate 67 **WAITING ROOM,** SOLOVKI AIRPORT, SOLOVKI

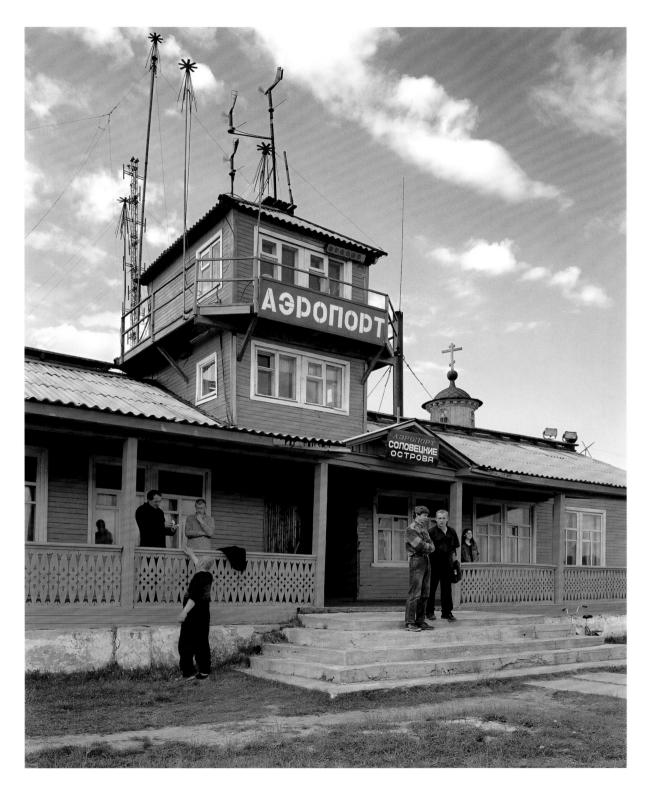

plate 68 **AIRPORT**, SOLOVKI

plate 69 **ROSE PAVILION,** PAVLOVSK

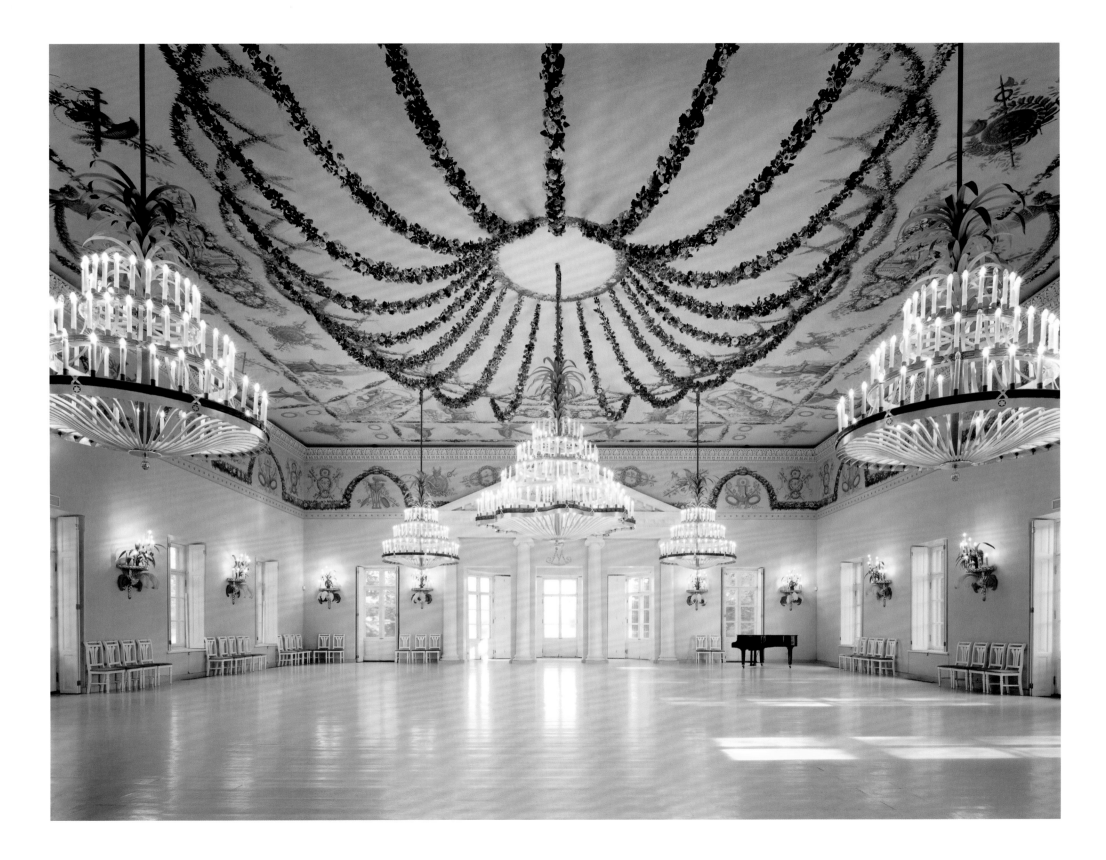

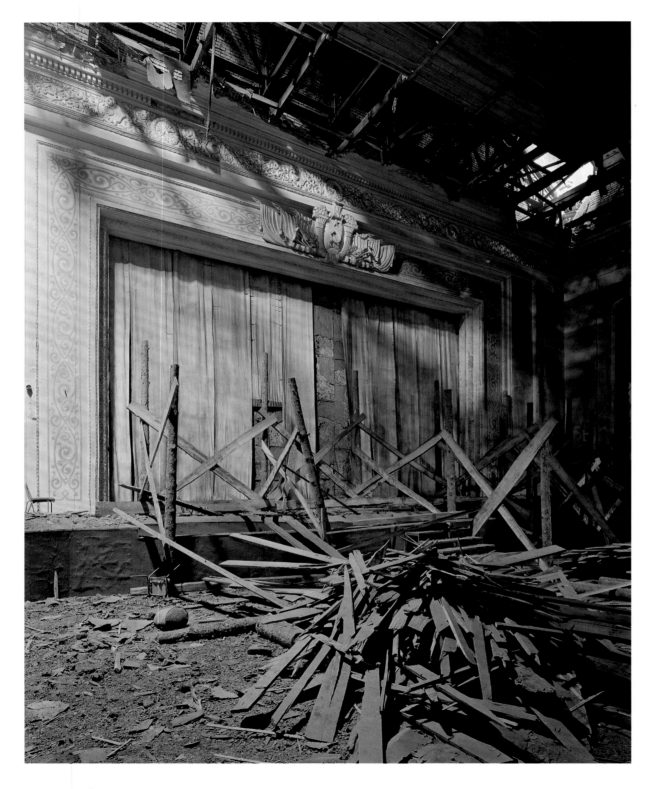

plate 70 **LOCOMOTIVE WORKERS' THEATRE,** ULAN UDE

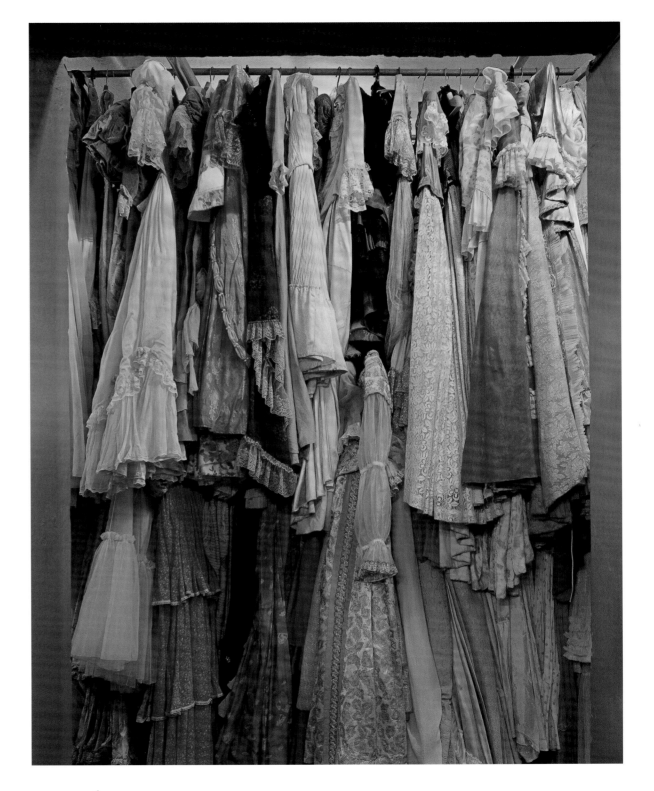

plate 71 **WARDROBE DEPARTMENT**, LENFILM, ST. PETERSBURG

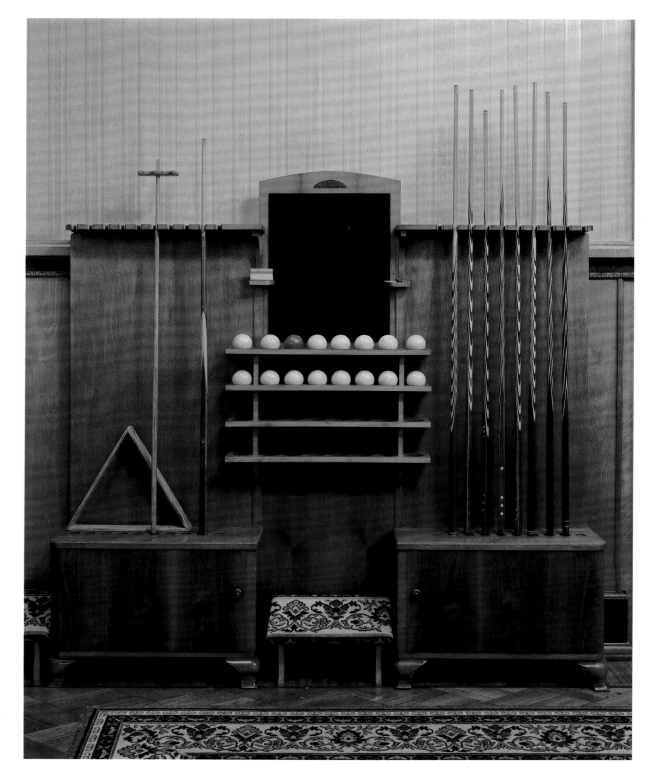

plate 72 **STALIN'S BILLIARDS,** YUSUPOV PALACE, YALTA

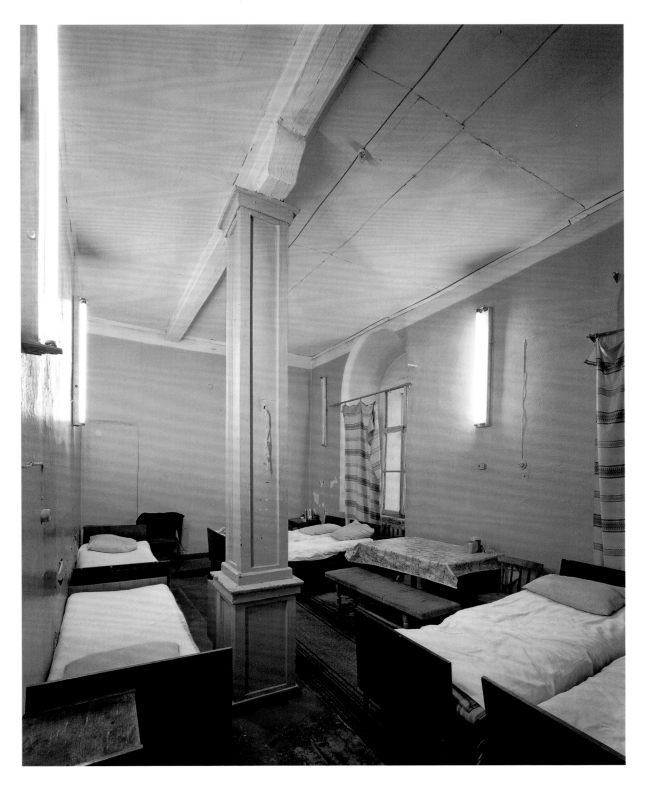

plate 73 **DORMITORY IN FORMER CHURCH,** VOLOGDA

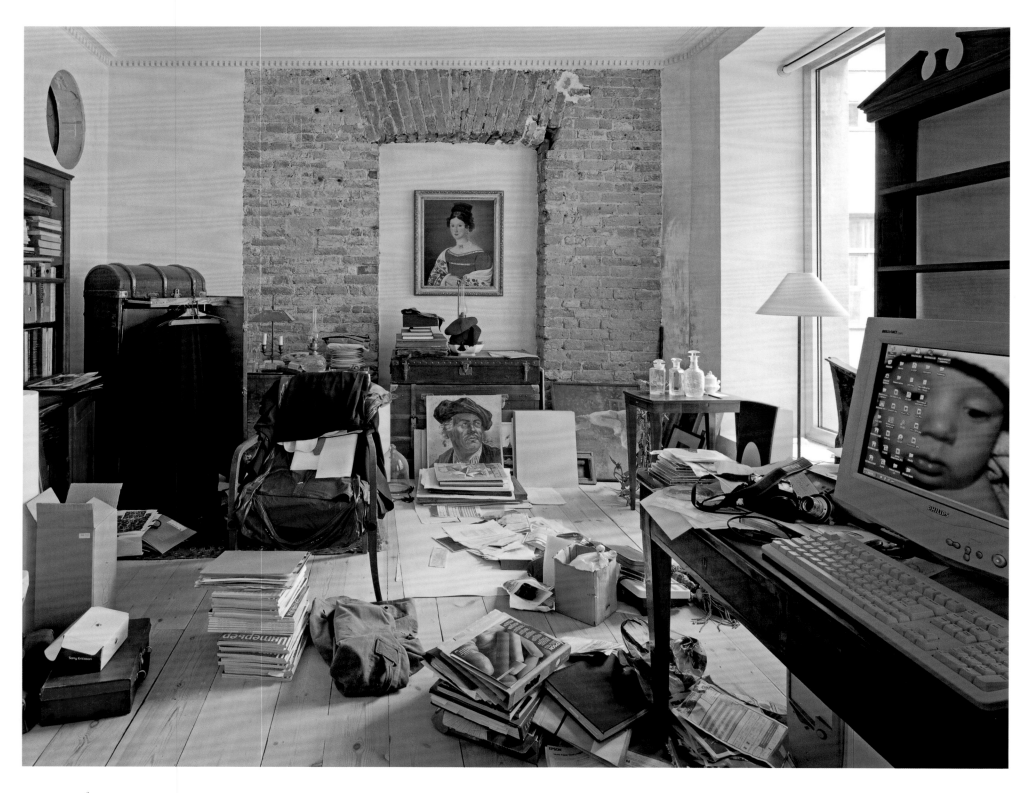

plate 74 **ARCHITECT'S HOME,** ST. PETERSBURG

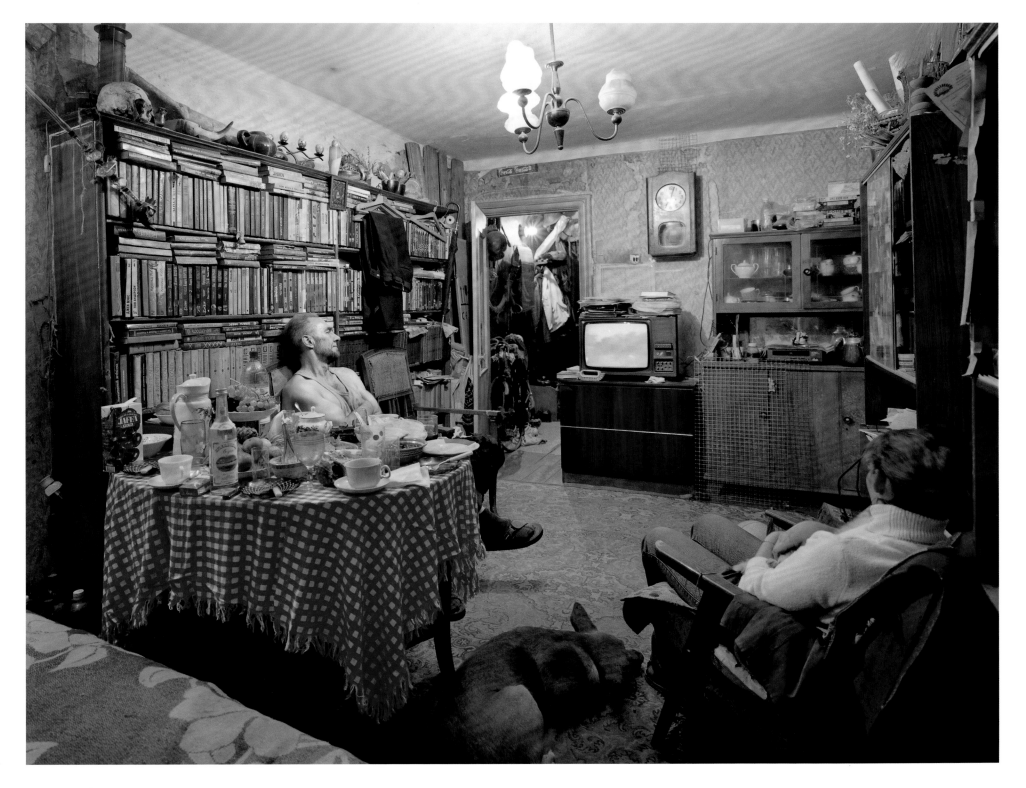

plate 75 **VOLODYA, WIFE LARISA, AND DOG,** SIMFEROPOL

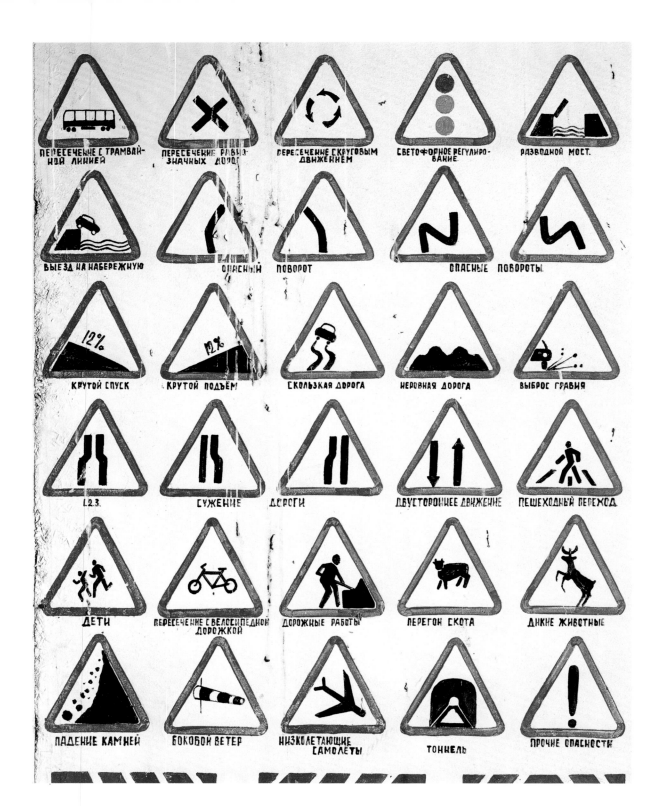

plate 76 "OTHER DANGERS," CRIMEA

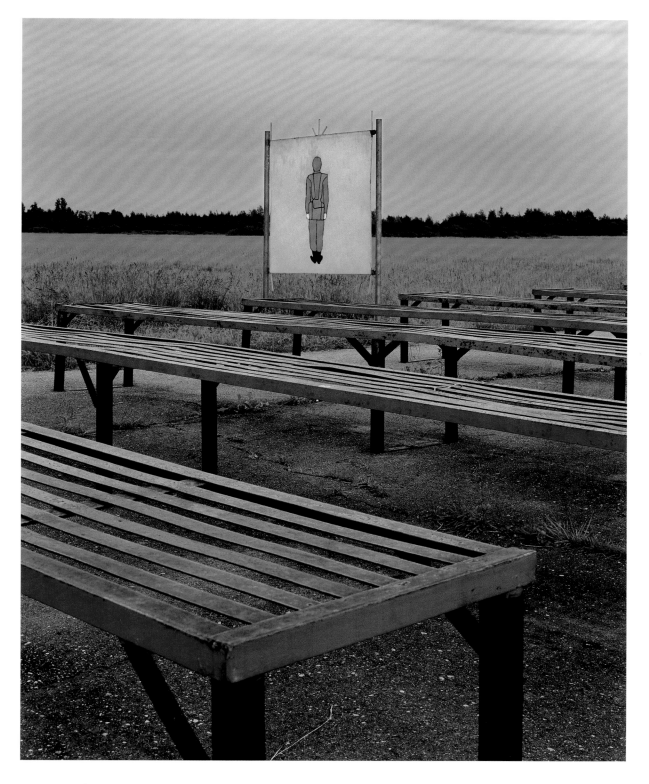

plate 77 **PARATROOPER TRAINING GROUNDS**, PSKOV

plate 78 **GREEN TRUCKS, WHITE NIGHTS,** SOLOVKI

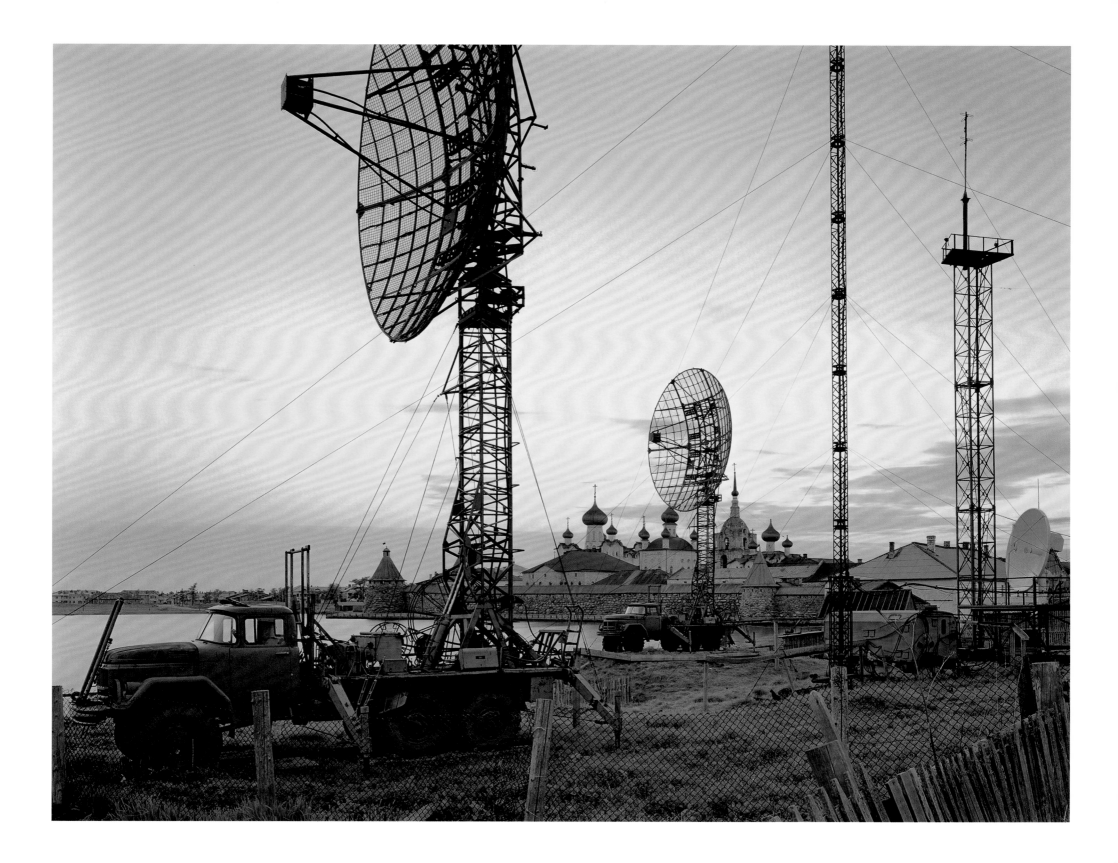

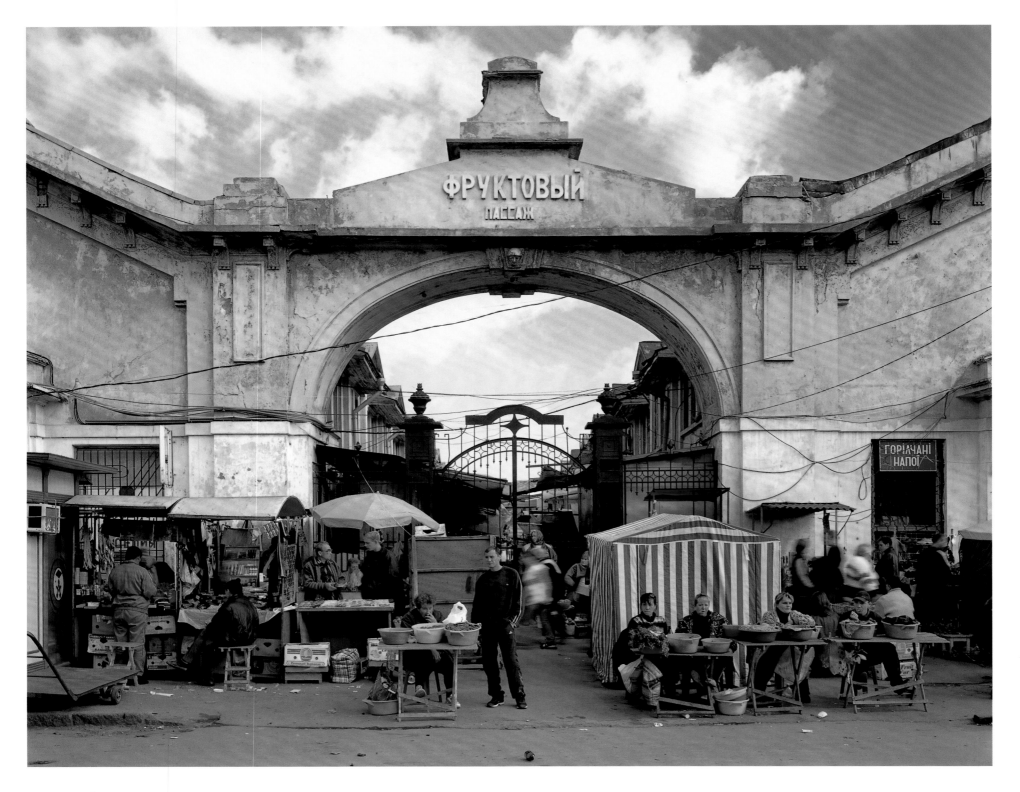

plate 79 **PRIVOZ FRUIT MARKET,** ODESSA

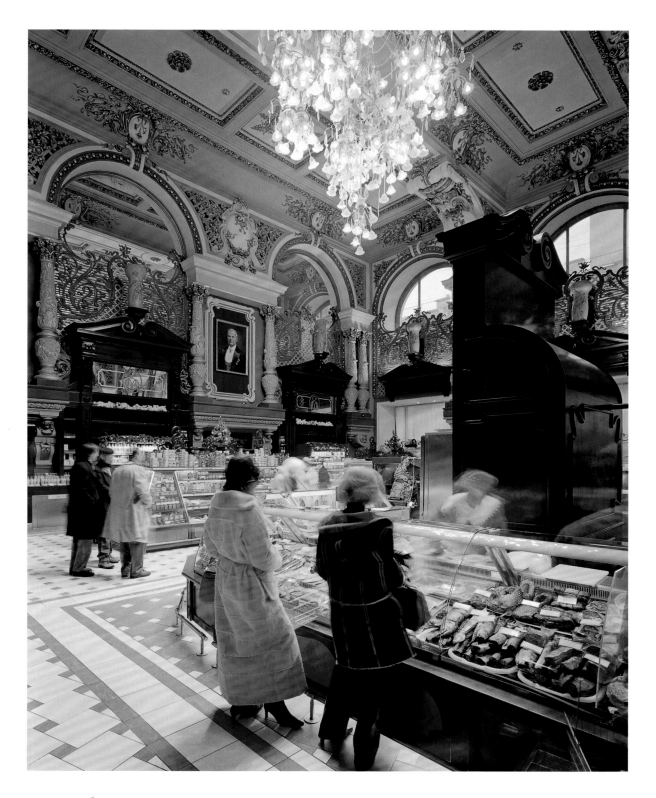

plate 80 YELISEYEVSKY FOOD STORE, MOSCOW

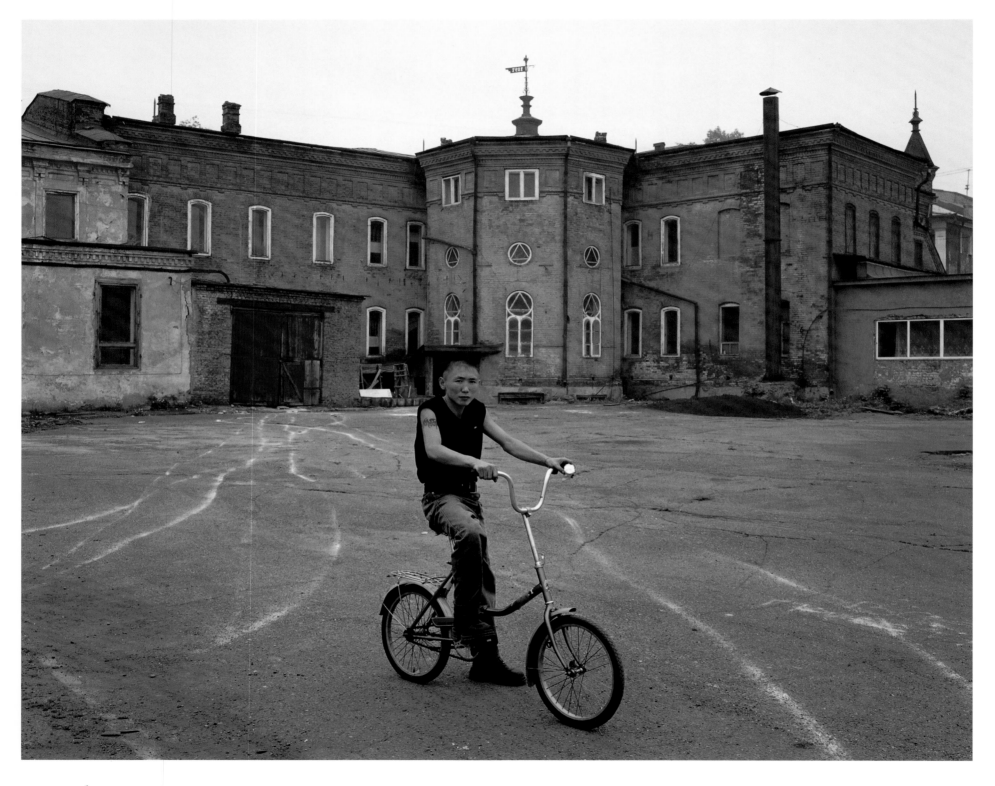

plate 81 **BOY WITH BIKE,** IRKUTSK

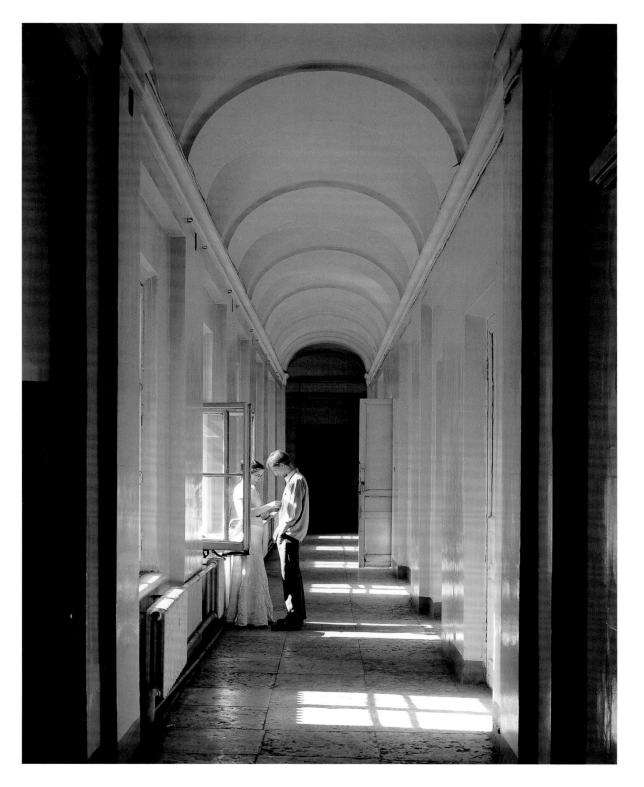

plate 82 **WHITE-NIGHT INTERIOR,** ST. PETERSBURG

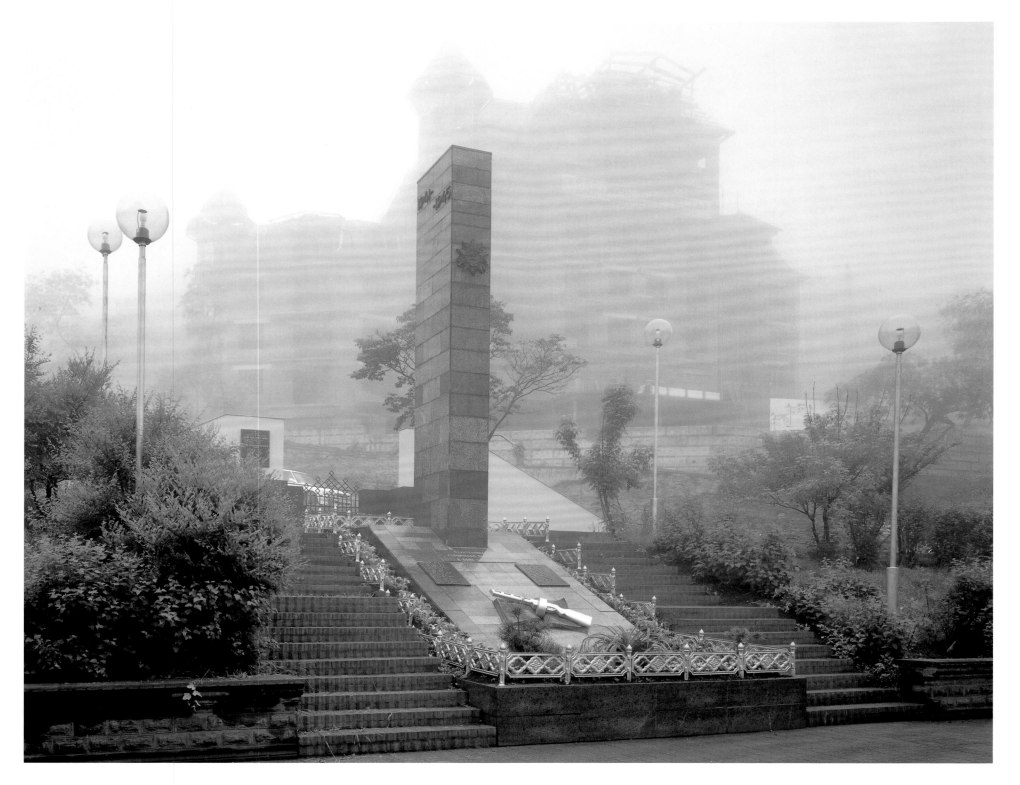

plate 83 **WAR MEMORIAL IN FOG,** VLADIVOSTOK

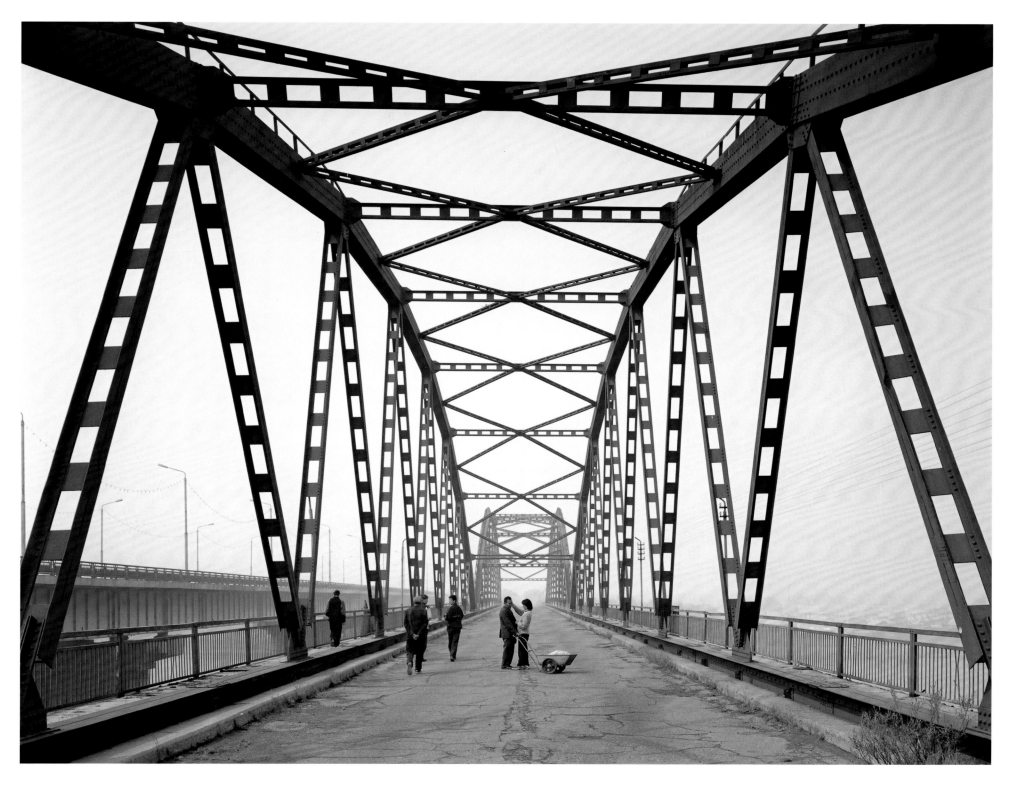

plate 84 **COUPLE ON BRIDGE,** ULAN UDE

plate 85 **TCHAIKOVSKY'S BROTHER'S GRAVE,** NOVODEVICHY CEMETERY, MOSCOW

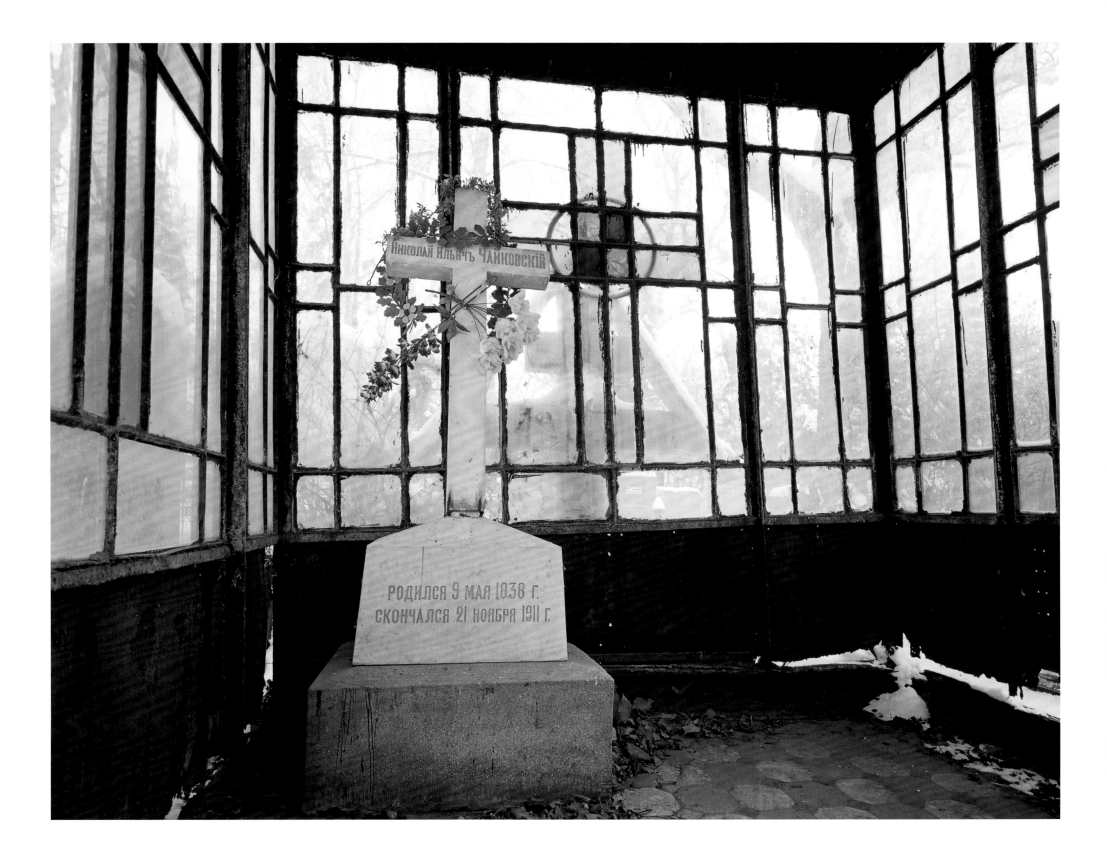

plate 86 EMBANKMENT, ARKHANGEL'SK

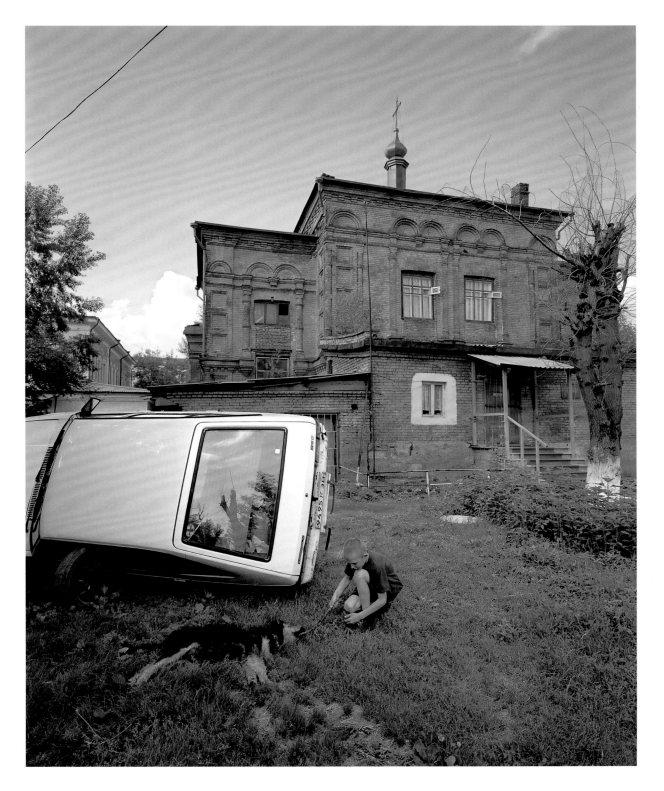

plate 87 **BOY WITH DOG,** KRASNOYARSK

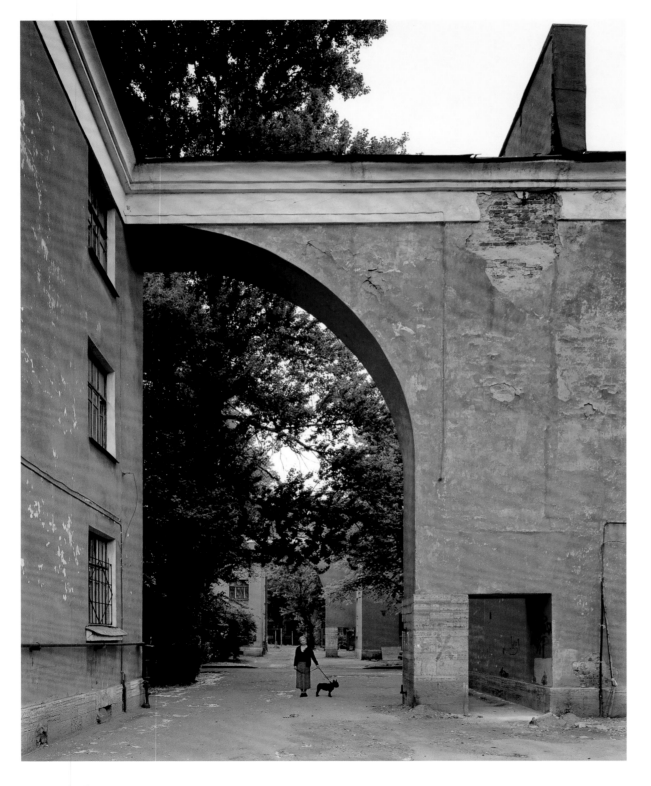

plate 88 **TRACTOR STREET**, ST. PETERSBURG

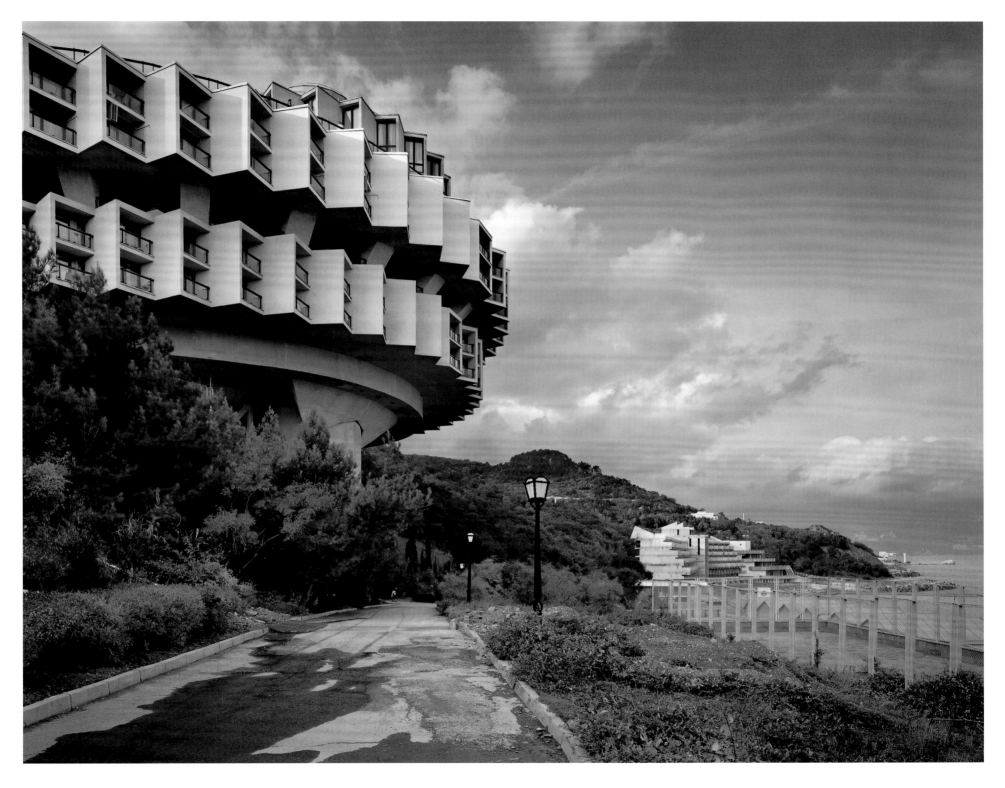

plate 89 **FRIENDSHIP SANATORIUM,** CRIMEA

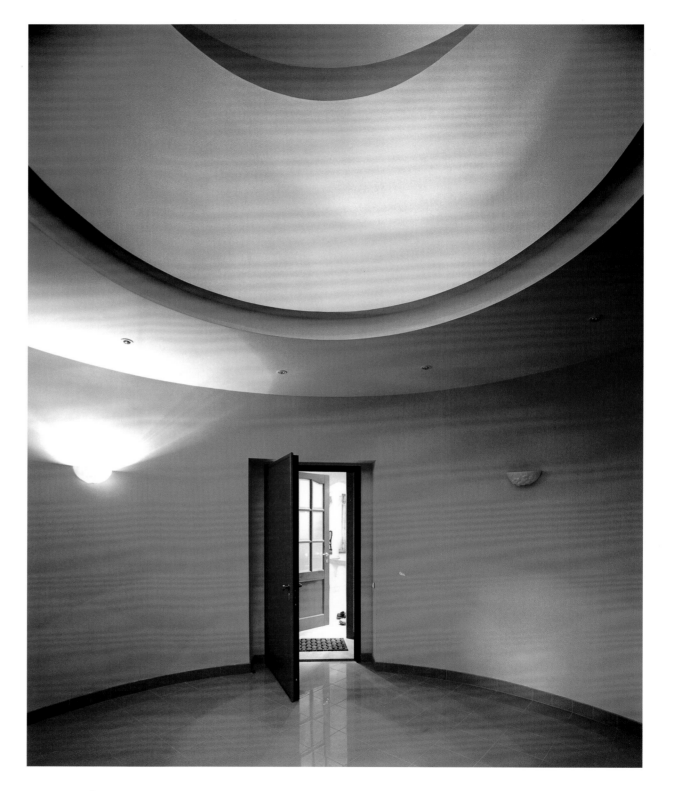

plate 90 **APARTMENT ENTRANCE**, ST. PETERSBURG

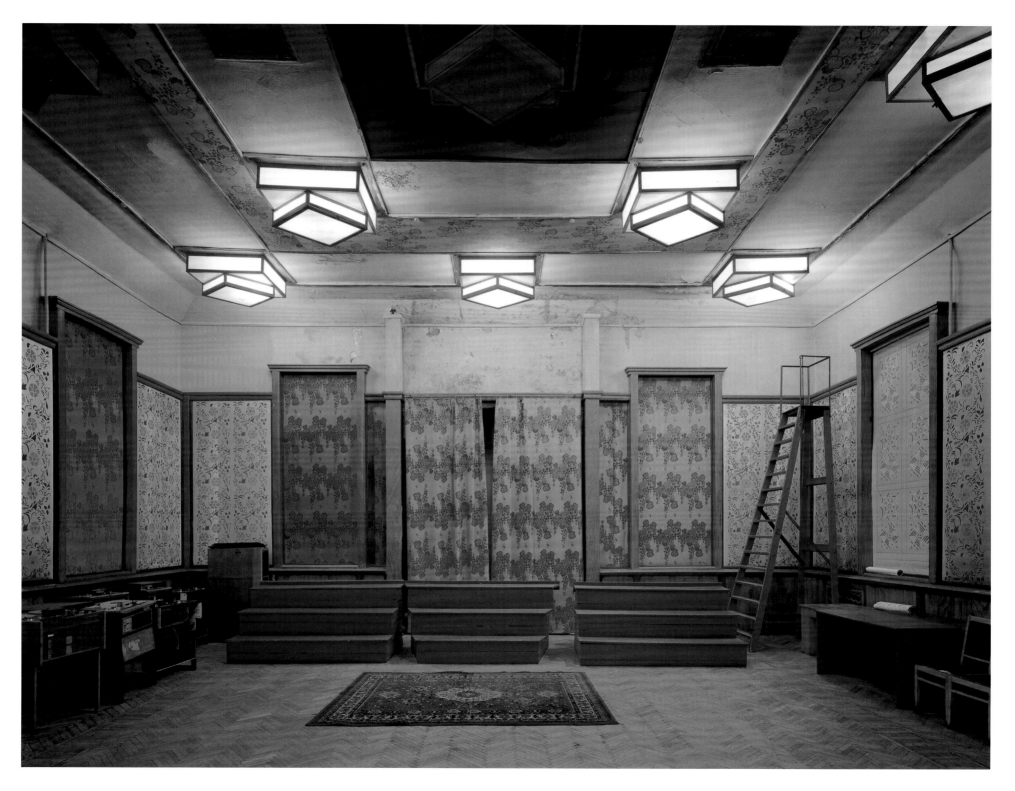

plate 91 **RECORDING STUDIO,** SIMFEROPOL

plate 92 **MOVIE THEATER,** ODESSA

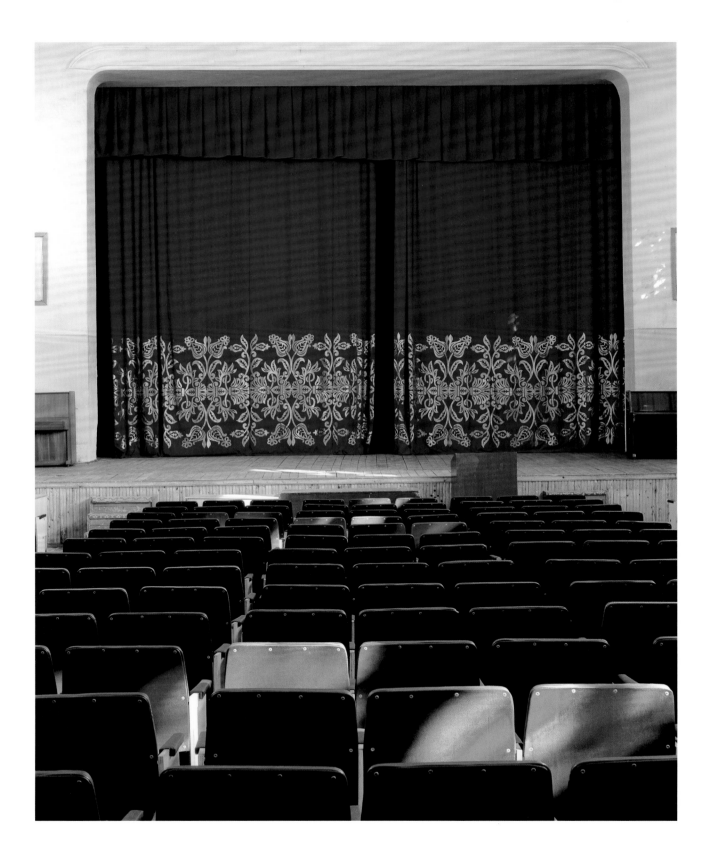

plate 93 **ARMORY,** LENFILM, ST. PETERSBURG

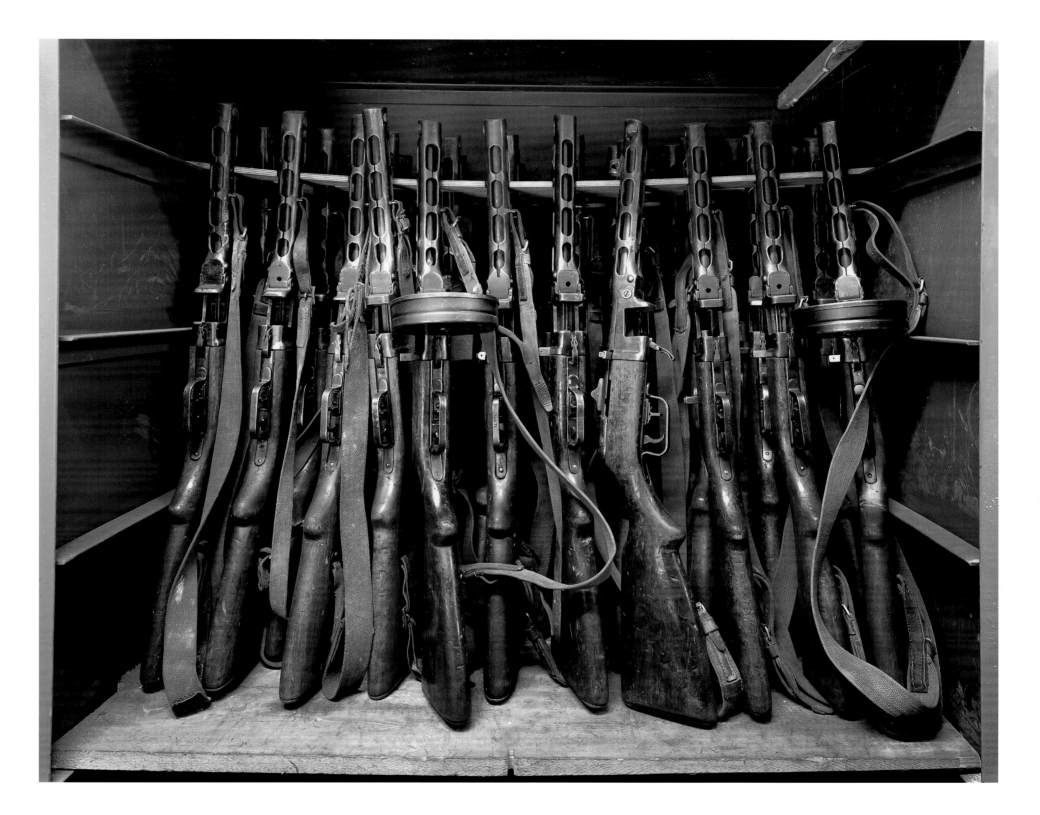

plate 94　**RED PIANO,** PIONEER CAMP, ARTEK, YALTA

plate 95 **ATTACK SUBMARINE IN FOG,** VLADIVOSTOK

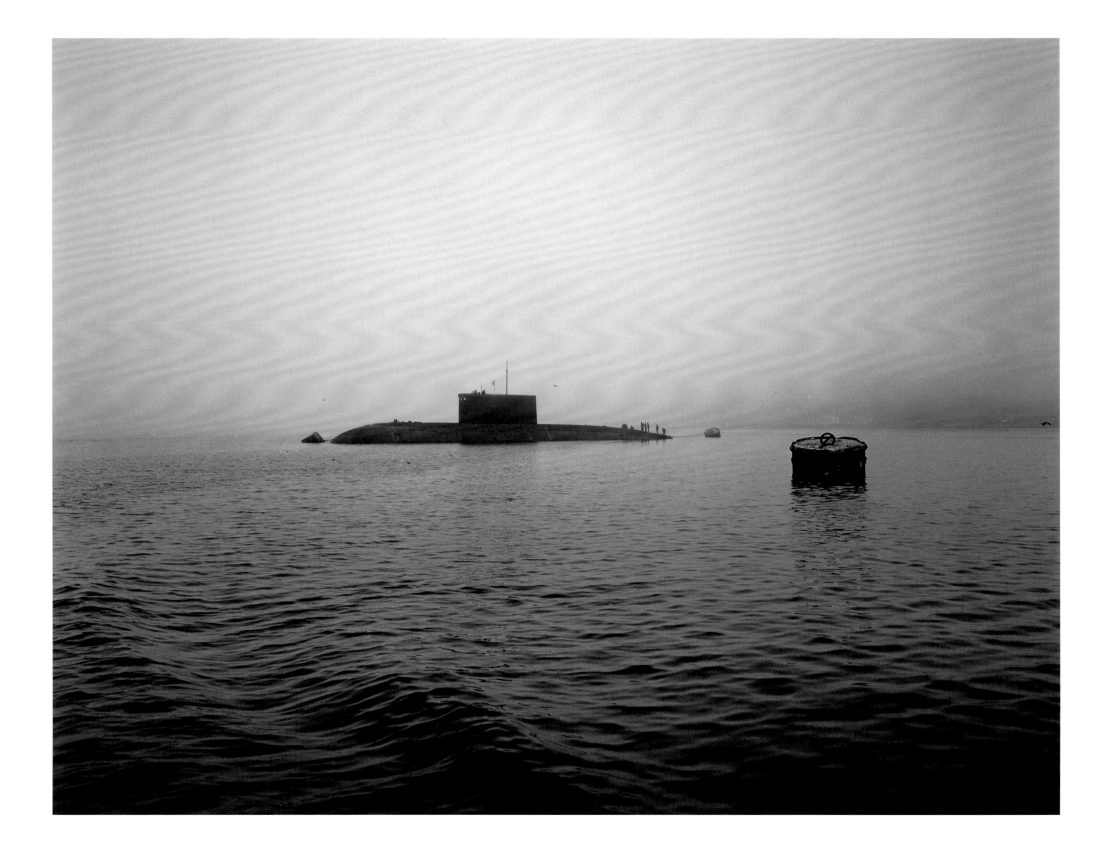

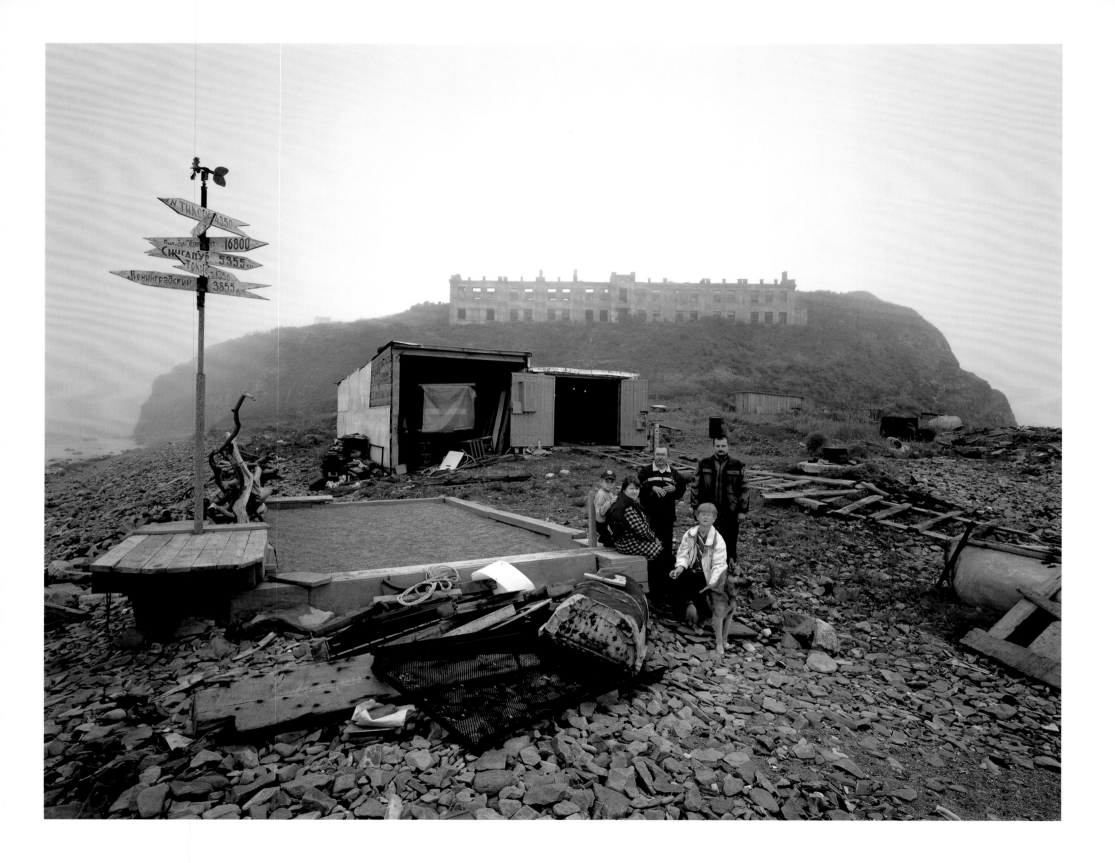

plate 96 **ABANDONED MISSILE BASE,** SKRIPLEVA'S ISLAND

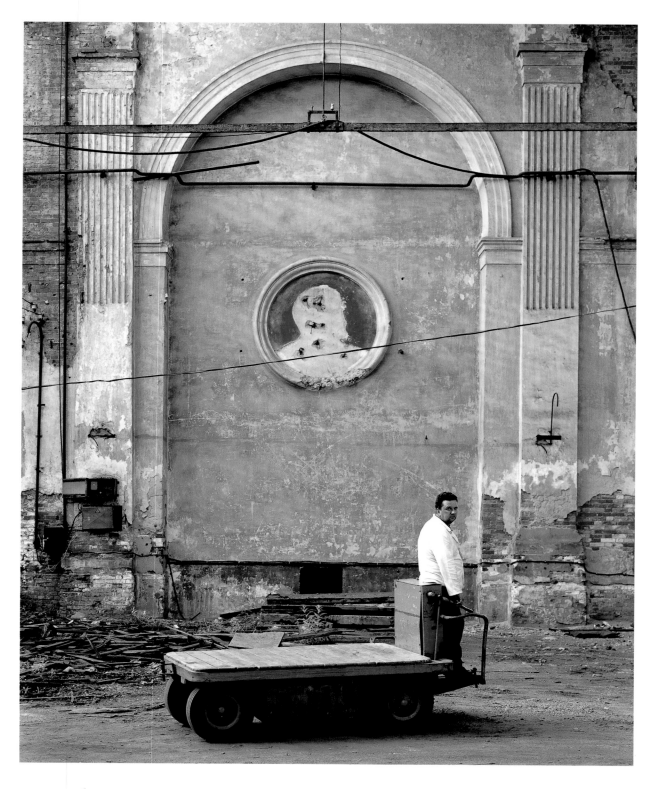

plate 97 **WARSAW STATION**, ST. PETERSBURG

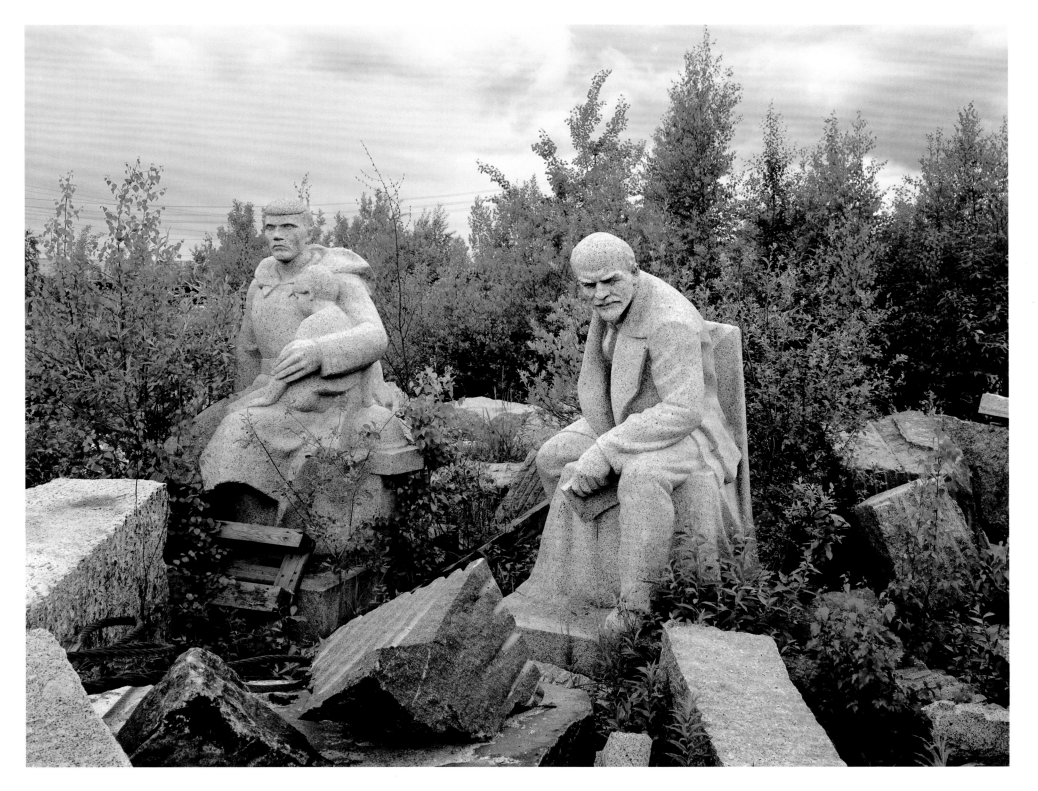

plate 98 **UNDELIVERED LENIN,** ST. PETERSBURG

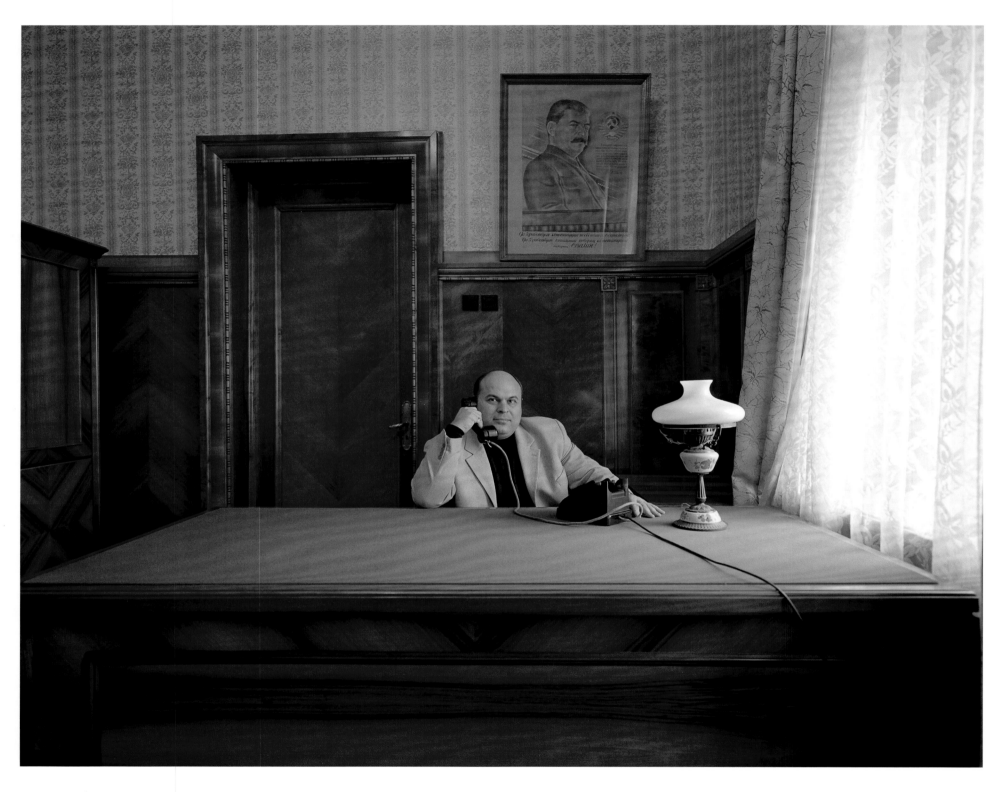

plate 99 **STALIN'S OFFICE,** YUSUPOV PALACE, CRIMEA

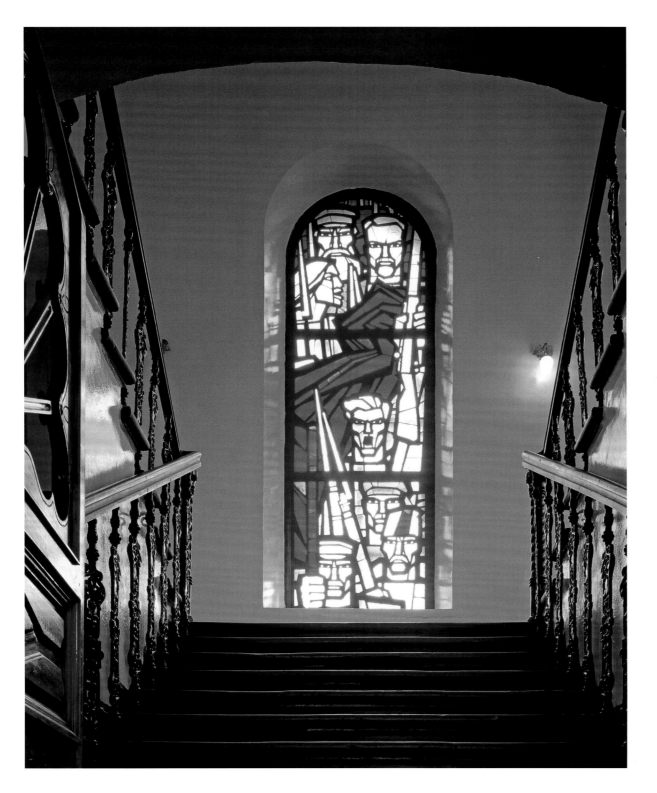

plate 100 **REVOLUTION STAINED GLASS**, IRKUTSK

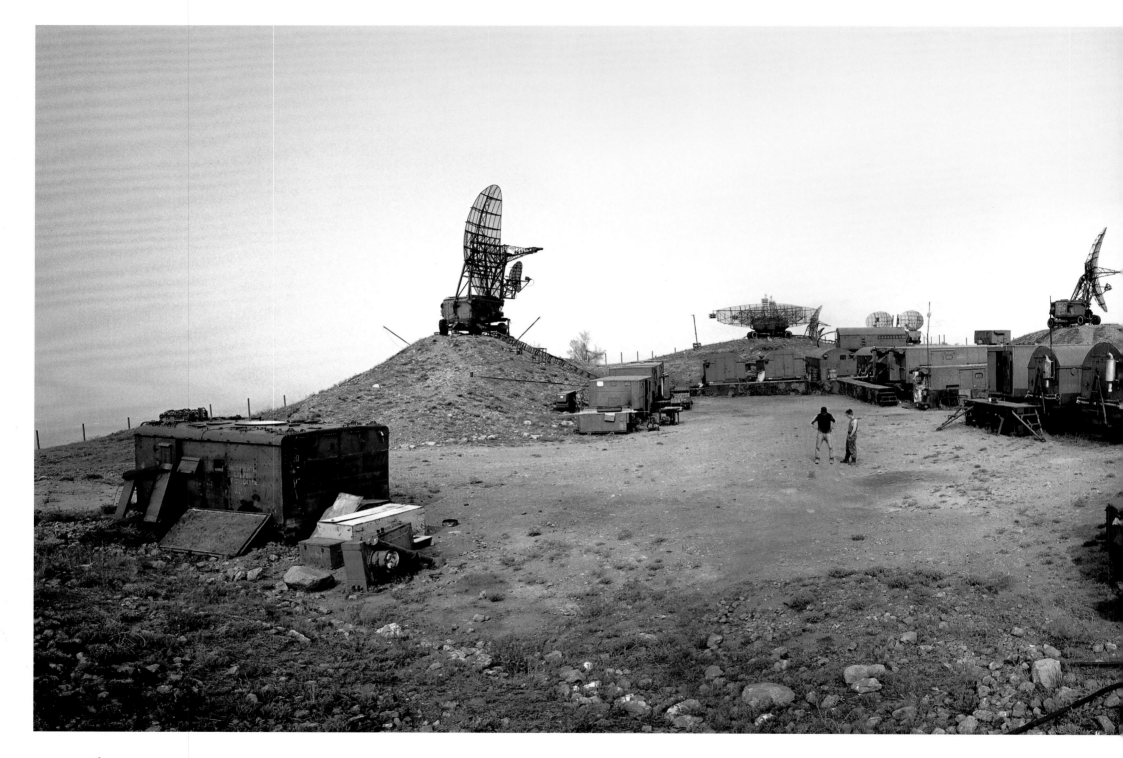

plate 101 **MOUNTAINTOP RADAR BASE,** MONGOLIAN BORDER

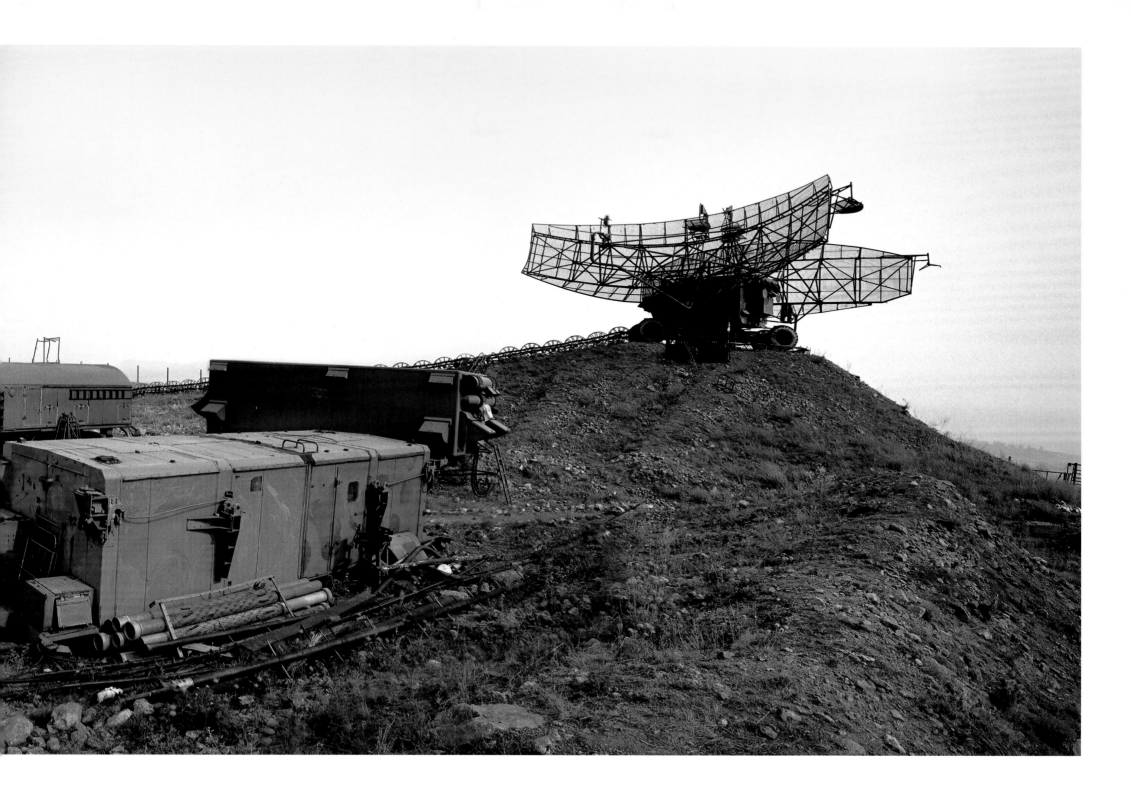

plate 102 **TUTUS,** MARIINSKY THEATRE, ST. PETERSBURG

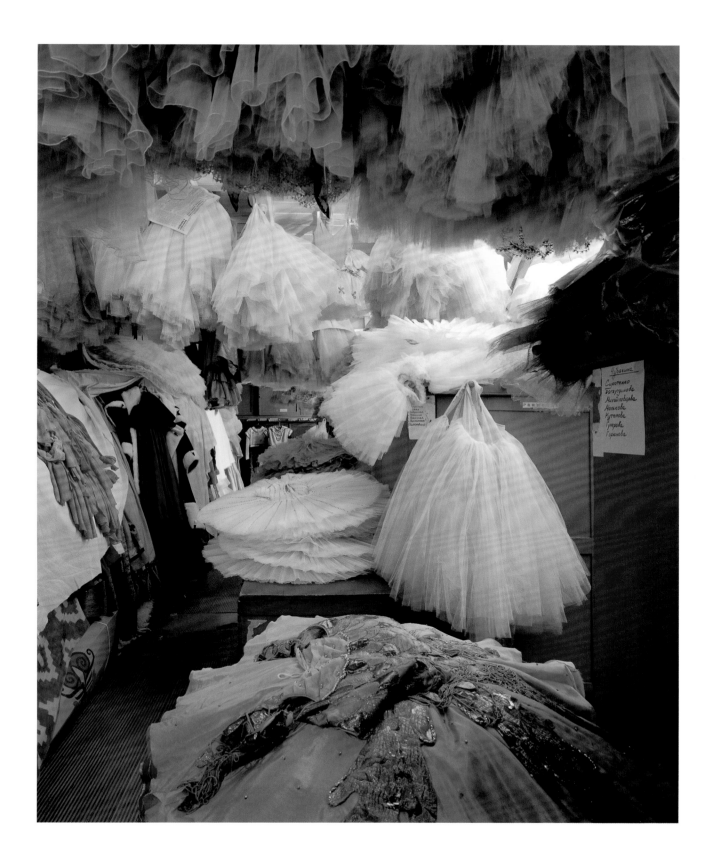

plate 103 **REHEARSAL STUDIO,** PALACE OF COAL MINERS, ARTEM

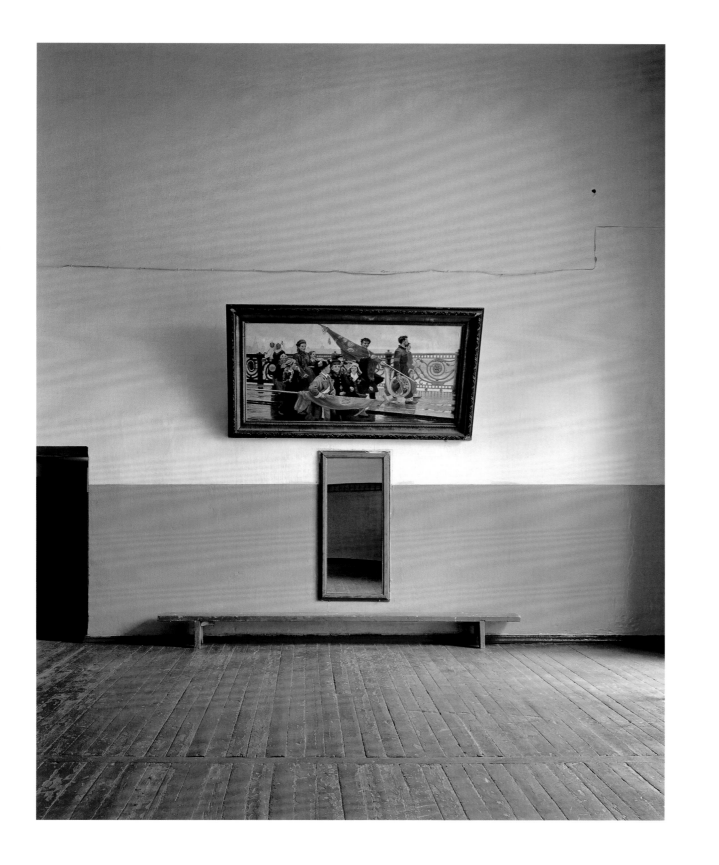

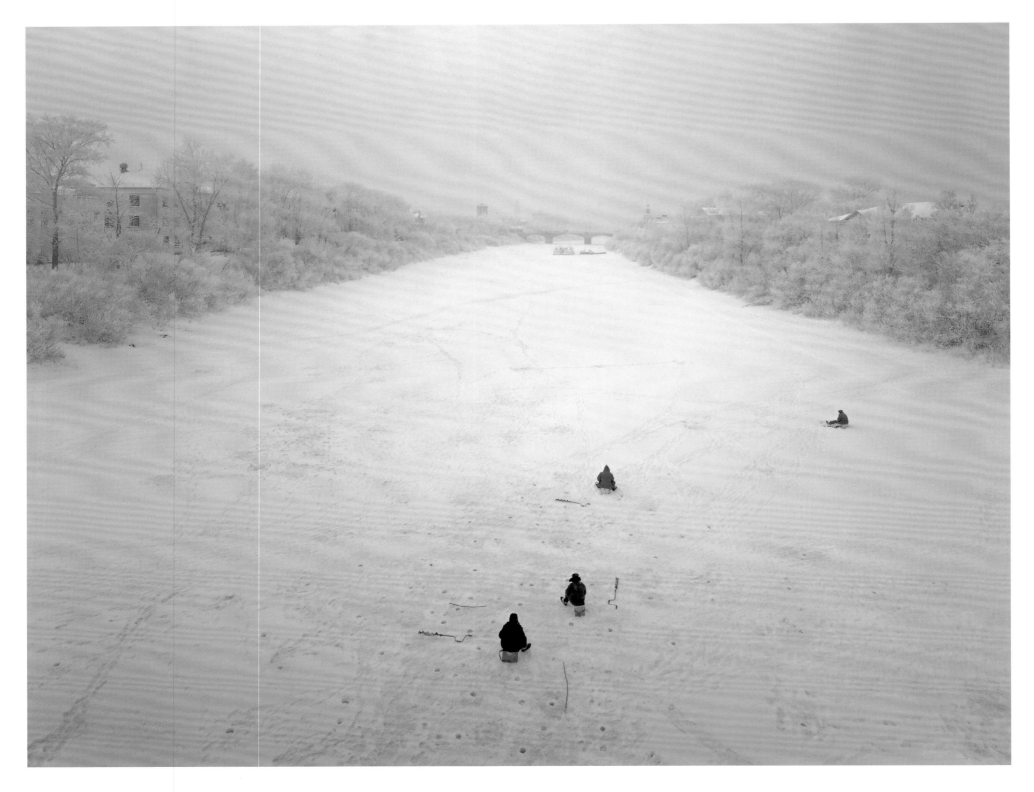

plate 104 **ICE FISHING,** VOLOGDA

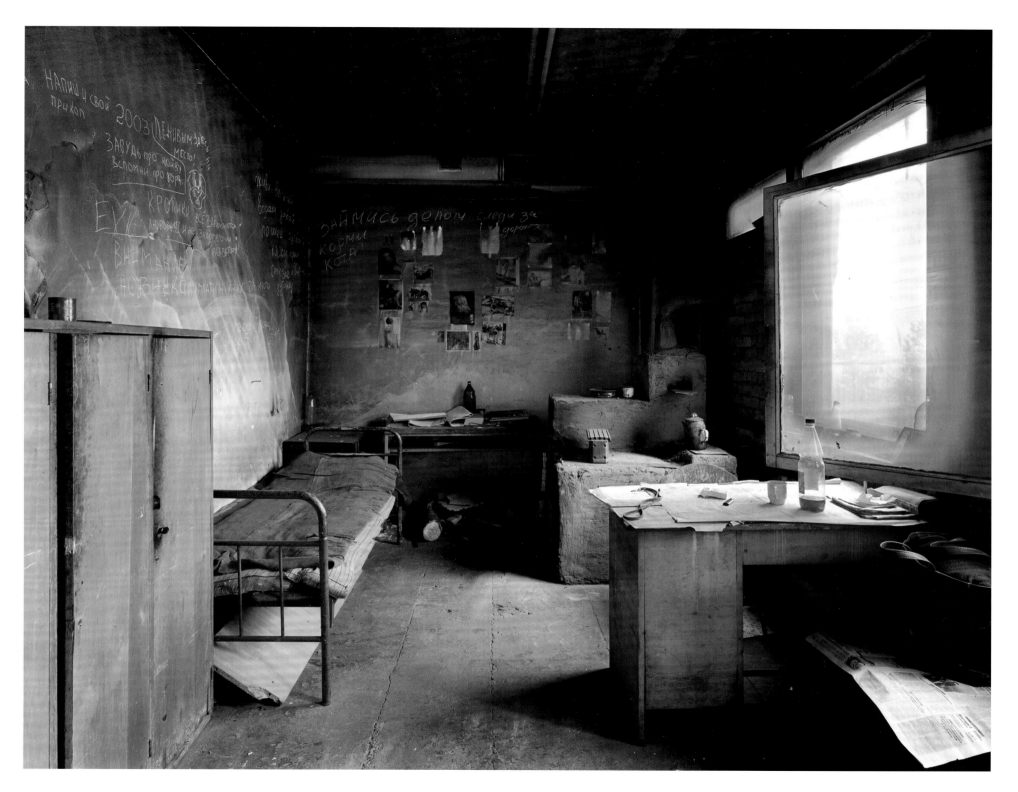

plate 105 **WATCHMAN'S ROOM,** SIBERIA

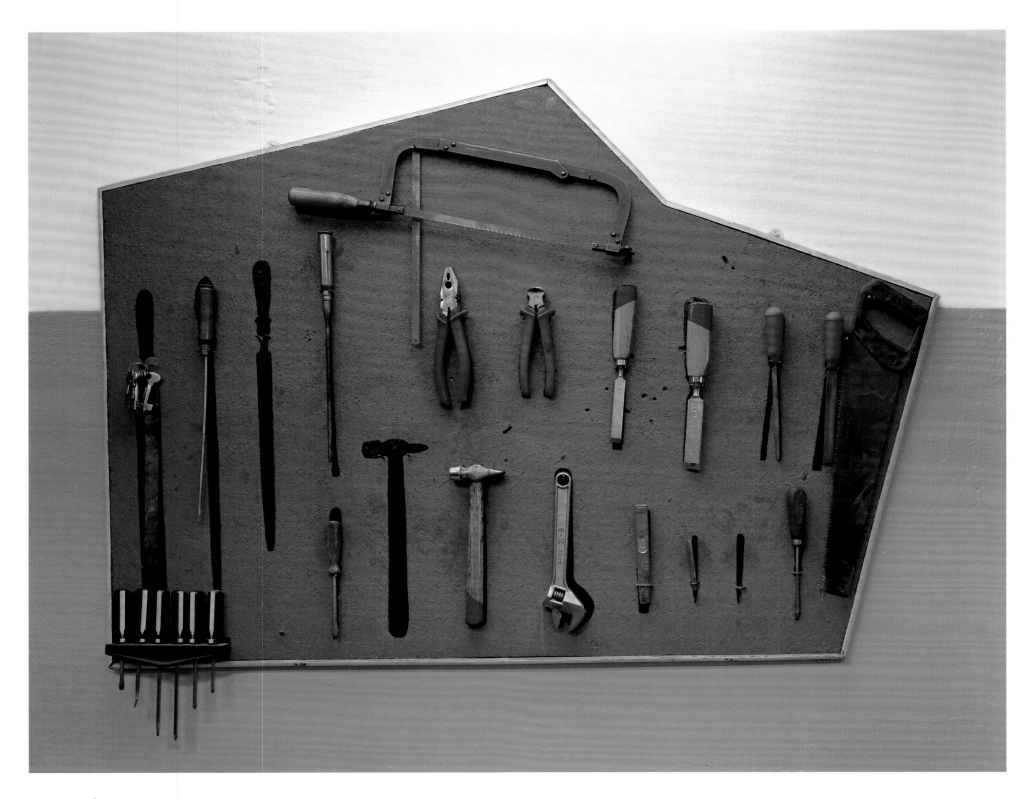

plate 106 **WORKSHOP TOOLS,** LENFILM, ST. PETERSBURG

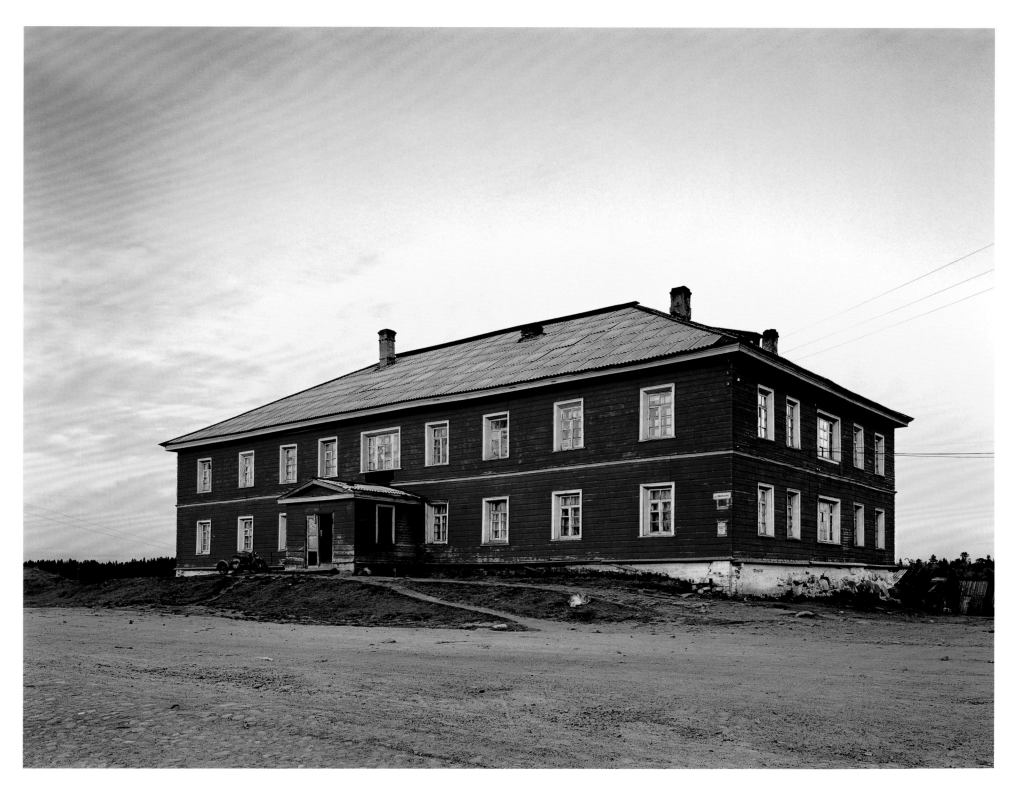

plate 107 **RED HOUSE, WHITE SEA,** SOLOVKI

plate 108 **INSTRUCTOR'S PLATFORM,** PSKOV

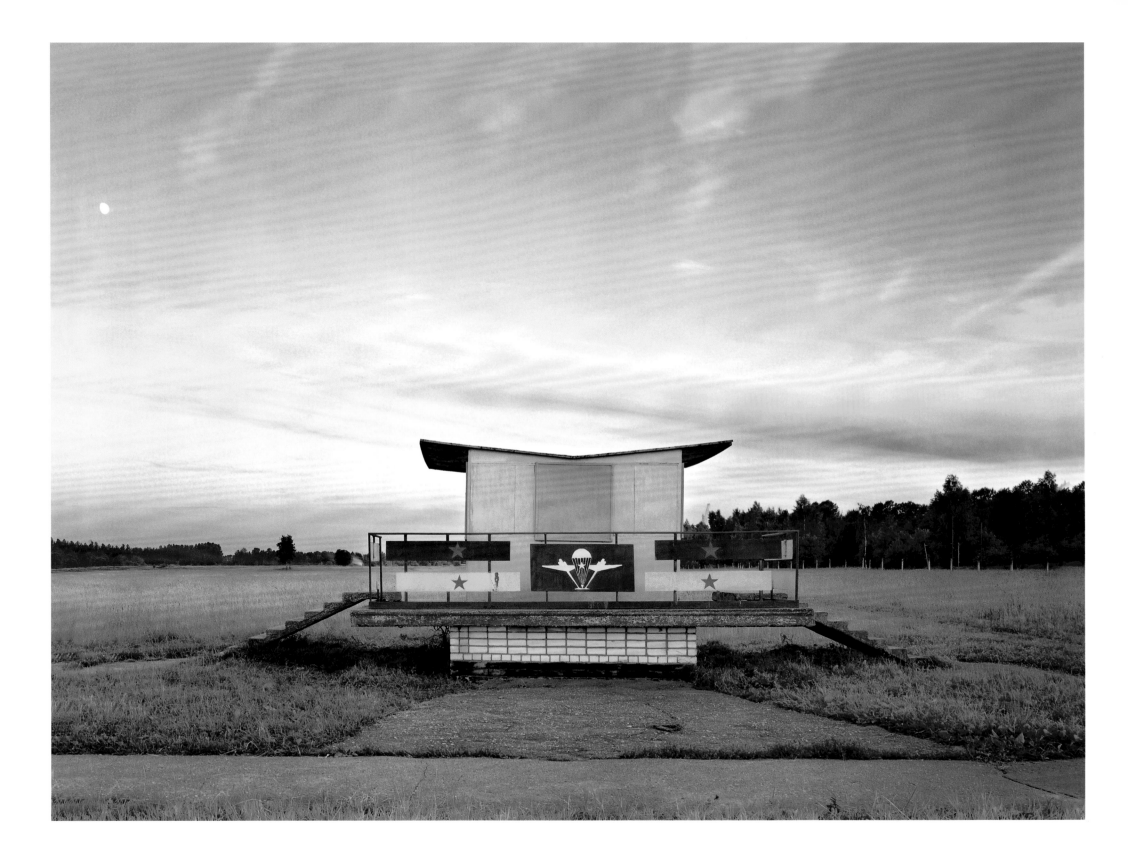

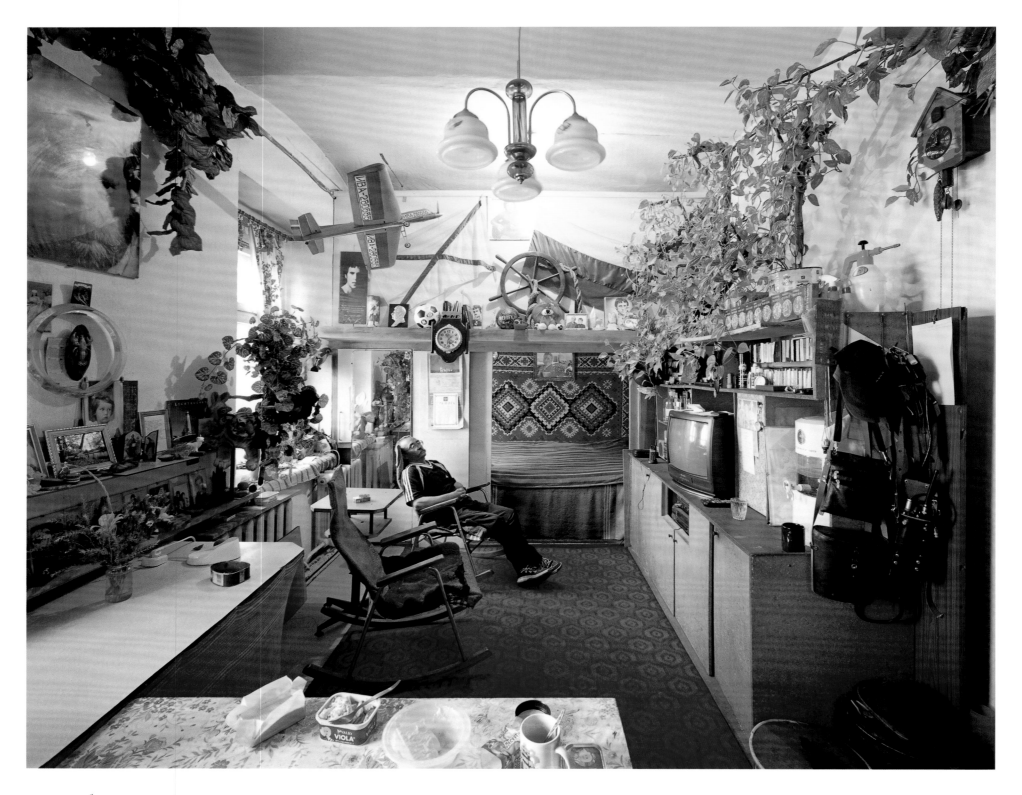

plate 109 **LIGHTHOUSE KEEPER'S QUARTERS,** SKRIPLEVA'S ISLAND

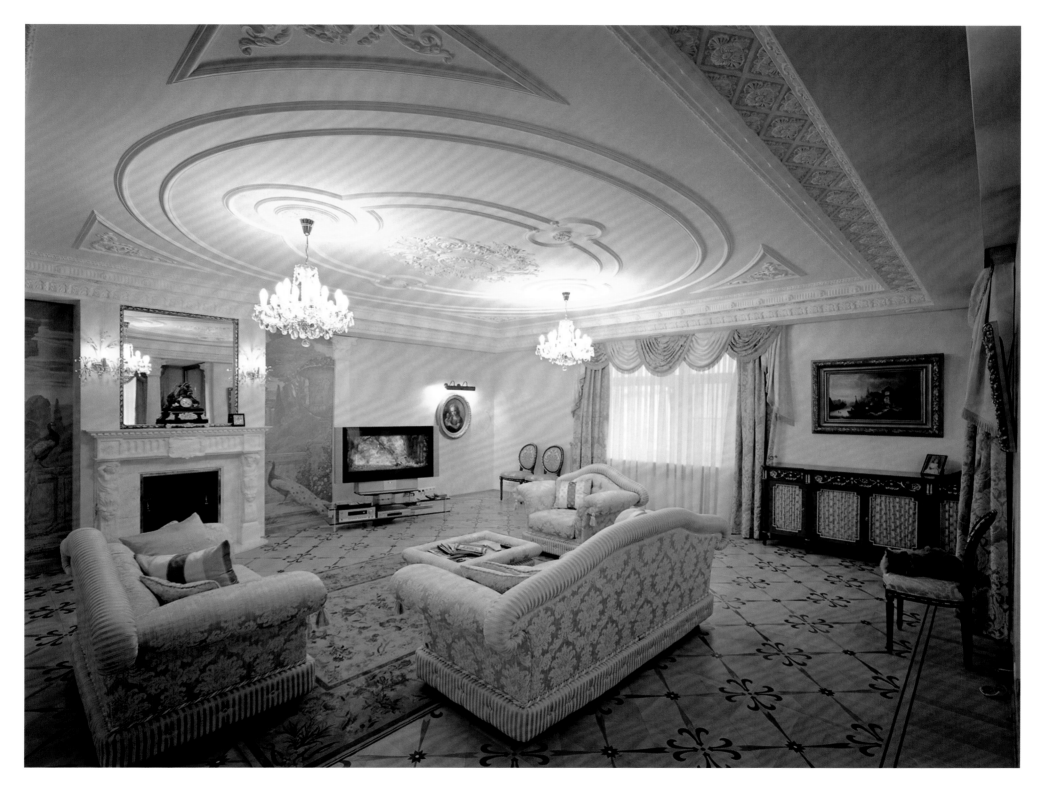

plate 110 **LIVING ROOM**, ST. PETERSBURG

plate III **PORT OF OKHA,** SAKHALIN ISLAND

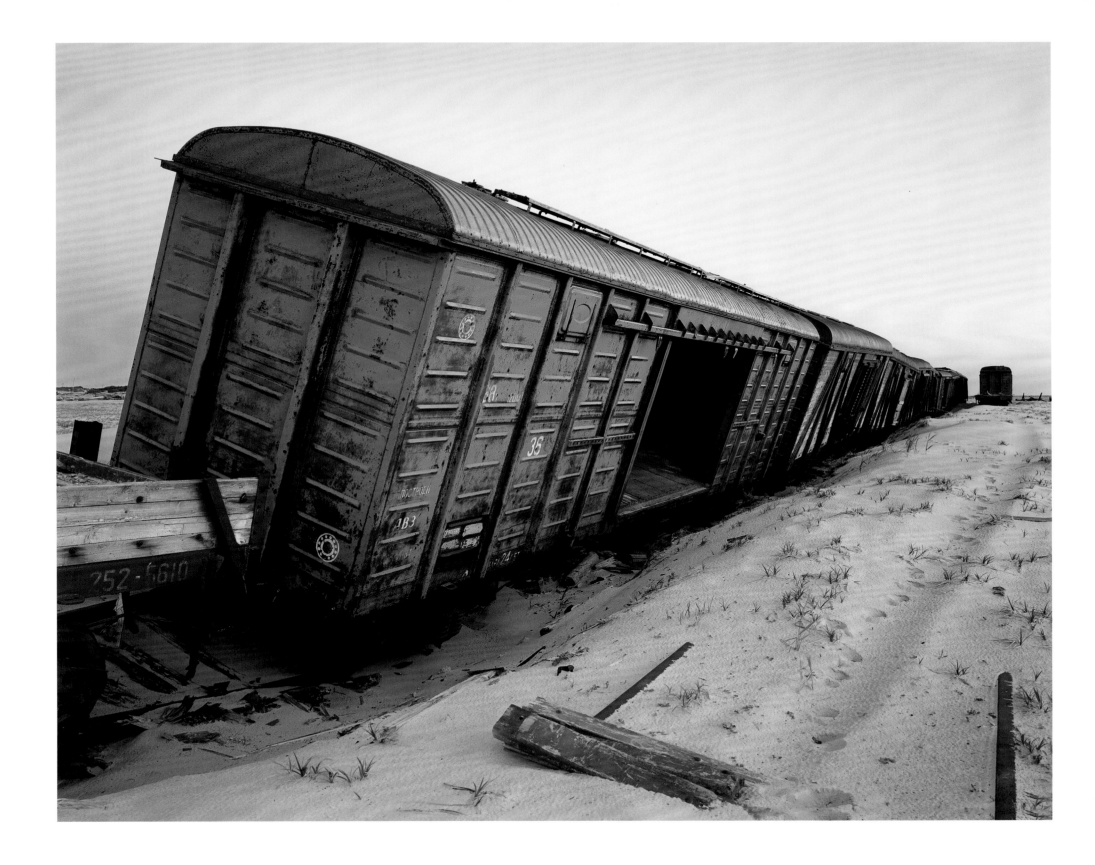

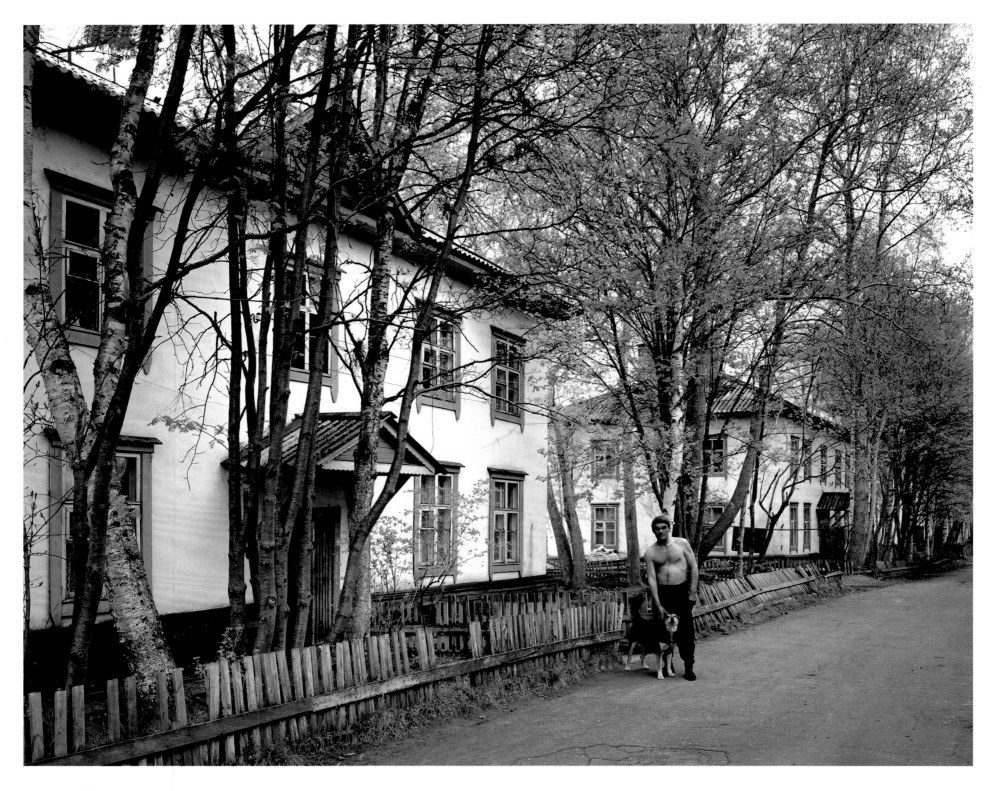

plate 112 **MAN WITH HIS DOG,** WHITE SEA

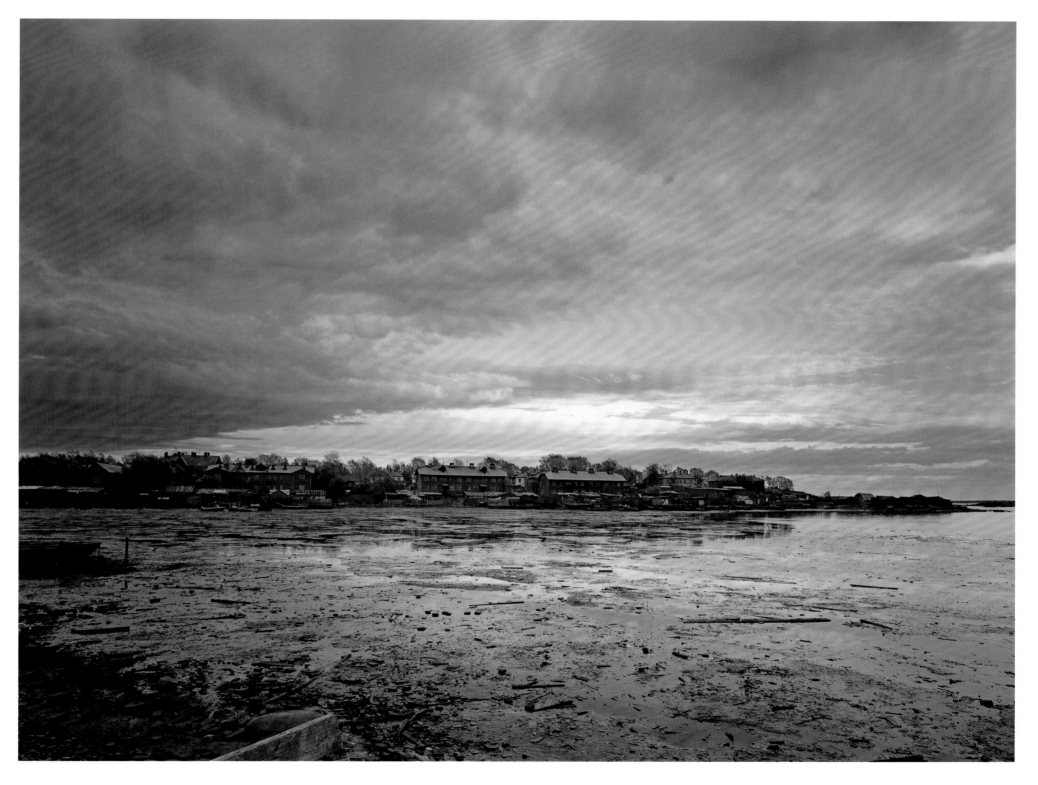

plate 113 **FISHING VILLAGE,** WHITE SEA

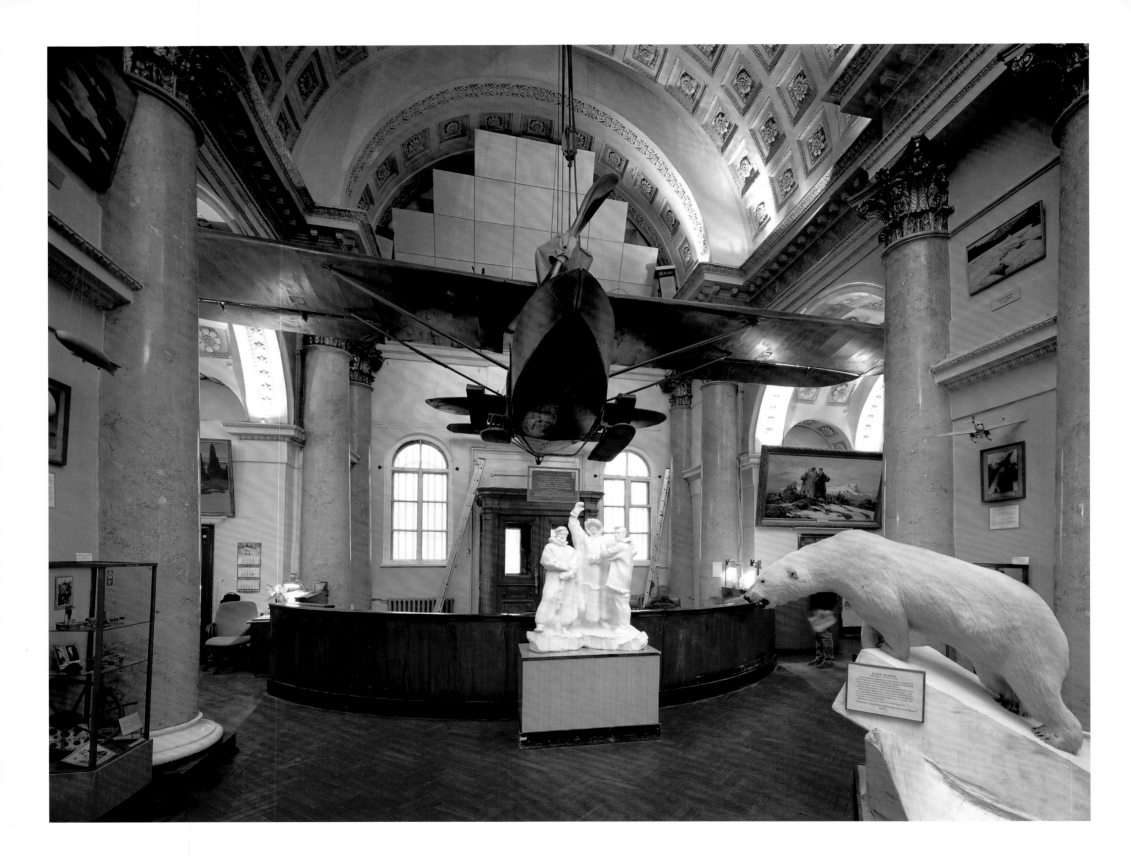

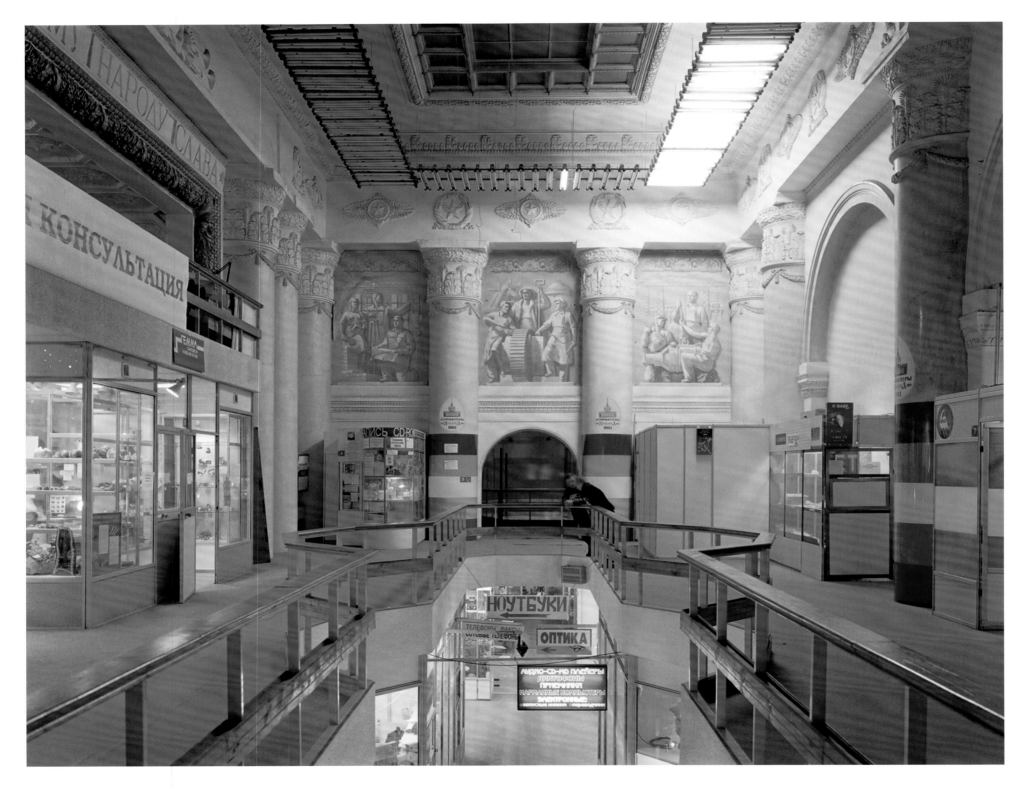

plate 115 **CENTRAL PAVILION,** VDNKH, MOSCOW

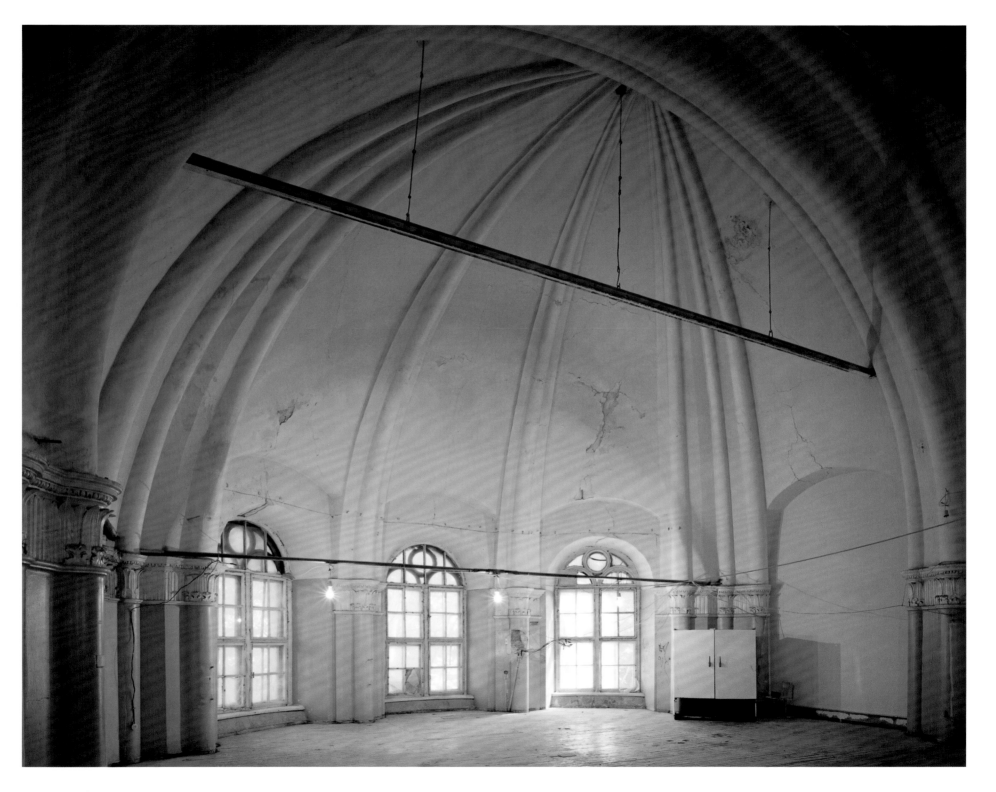

plate 116 **CENTRAL SYNAGOGUE**, ODESSA

plate 117　**AMARYLLIS**, VOLOGDA

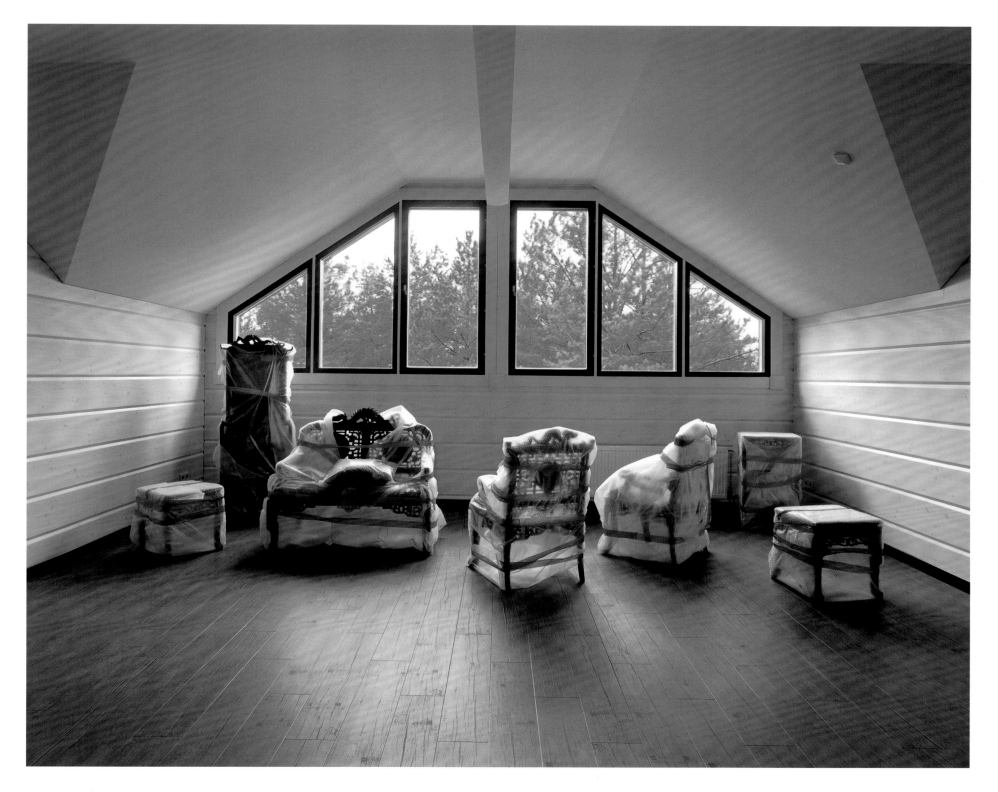

plate 118 **MODERN DACHA**, DUNI

plate 119 **LIVADIA PALACE**, YALTA

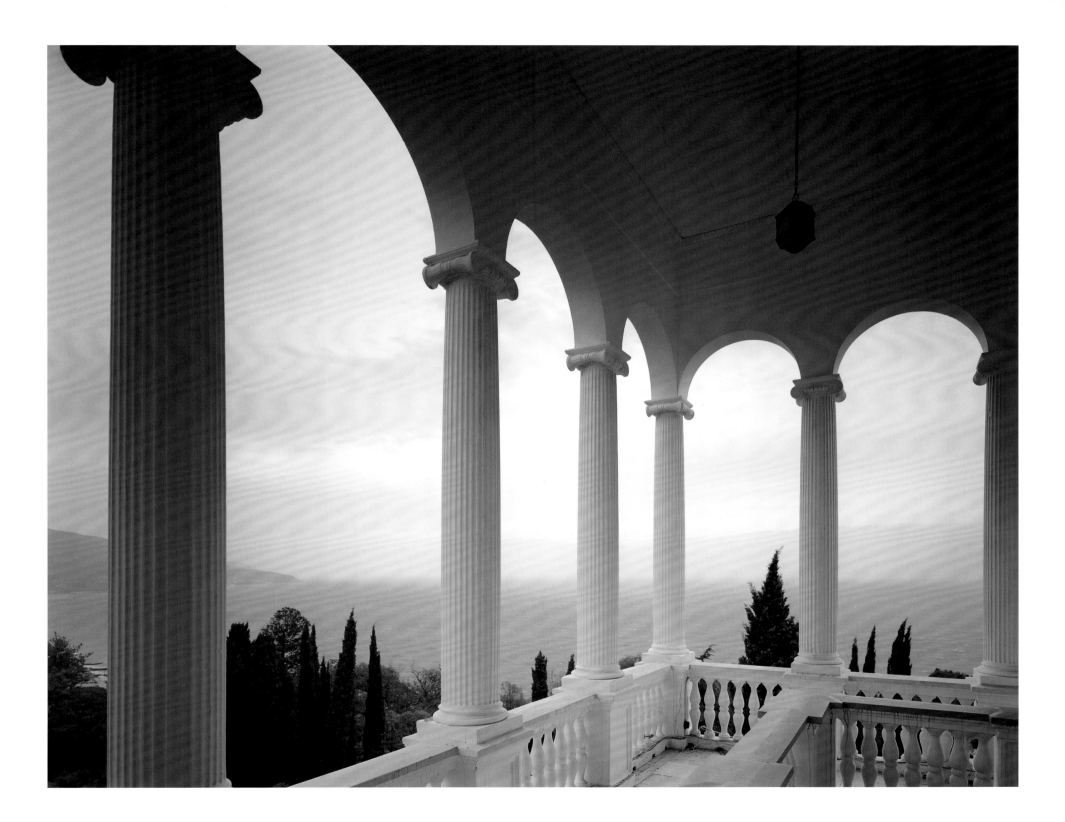

End Notes

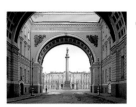

plate 1
PALACE SQUARE
ST. PETERSBURG, 2000

Designed by the Italian architect Bartolomeo Rastrelli, the General Staff Arch has a view that perfectly incorporates Alexander's Column and the Winter Palace. Although one of Russia's most beautiful and articulate public spaces, the square has been the setting for such violence as 1905's Bloody Sunday—when a worker protest for improved labor conditions was violently suppressed, touching off the 1905 Revolution—and the Bolshevik coup of 1917.

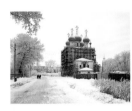

plate 2
ICEBREAKER
KANONERSKY SHIP-REPAIR YARD, ST. PETERSBURG, 2002

An icebreaker emerges from the shipyard with a fresh coat of bright orange paint, for heightened visibility in the Arctic gloom.

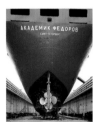

plate 3
ABANDONED CHURCH
VOLOGDA, 2004

Vologda is a night train's ride northeast of Moscow, just outside the much-traveled Golden Ring, a chain of historic Russian cities around Moscow. It remained undamaged in the many wars that ravaged cities farther west. As a result, much of its wooden architecture has been preserved.

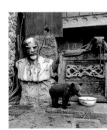

plate 4
MISHA AND VLADIMIR
LAKE BAIKAL, 2003

This private zoo began when its owners found two bears left on their doorstep.

plate 5
RADIO STATION
SIMFEROPOL, 2003

This former synagogue was converted into a radio station in the early 1930s.

plate 6
SPACE MUSEUM
PIONEER CAMP ARTEK, YALTA, 2003

This suit was worn in space by one of Russia's early cosmonauts. The museum is part of an elite camp for Russian and foreign Young Pioneers, members of a youth organization for Communists, in Yalta, a Black Sea resort town.

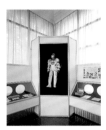

plate 7
COSMOS PAVILION DOME
MOSCOW, 2004

The VDNKh (Exhibition of the People's Economic Achievements) is a sprawling complex of Stalinist-era architecture. Originally a monument to Soviet advances in mechanization, this building became the Cosmos Pavilion after the satellite *Sputnik* was launched in 1957.

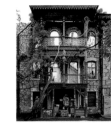

plate 8
CHICKEN-LEGS BUILDING
IRKUTSK, 2003

Locals call this unfinished Duma (parliament) building for the Irkutsk region of Siberia the "chicken-legs building." The nickname refers to a well-known Russian folktale about an old hag who lives in the woods in a shack that stands on chicken legs.

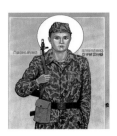

plate 9
WARRIOR-MARTYR
ST. PETERSBURG, 2003

This portrait of Yevgeny Rodionov, a Russian soldier murdered by Chechen terrorists for refusing to convert to Islam, was added to the iconostasis (a partition that holds icons) of a small chapel on the outskirts of St. Petersburg after the building's renovation.

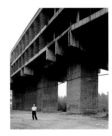

plate 10
STREET SCENE
IRKUTSK, 2003

Surplus camouflage doubles as construction netting in the city of Irkutsk.

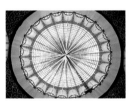

plate 11
CIGARETTE SELLERS
CHEKHOV STREET, YALTA, 2003

Many of the homes and palaces of this renowned Black Sea resort bear the influence of Ottoman architecture. Anton Chekhov's home—he lived out his final years in Yalta—is just down the street from this ruin.

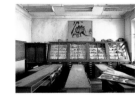

plate 12
FOSSIL ROOM
ST. PETERSBURG, 2002

Classroom of the paleontology chair, one of the oldest at the Department of Geology at St. Petersburg State University.

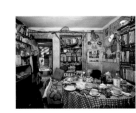

plate 13
VOLODYA'S APARTMENT
SIMFEROPOL, 2003

Vladimir Zovorodko, a legendary fibber, is known to friends as the Russian Baron von Münchhausen. (Though two bears did once live with him in this apartment.)

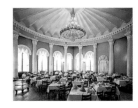

plate 14
DINING ROOM
UKRAINA SANATORIUM, YALTA, 2003

Constructed during the 1950s in the prevailing socialist-realist style, the Ukraina was the last of the lavish sanatoriums built in Yalta, a mecca for young Soviet vacationers and ailing senior citizens alike. The dining hall's design incorporates both Soviet and nautical motifs.

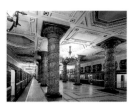

plate 15
AVTOVO METRO STATION
ST. PETERSBURG, 2002

Committed to investing architecture with ideological purpose and glorifying working-class industry, Stalin imagined metro stations as "people's palaces." Moscow's and St. Peterburg's stations—filled with marble, mosaics, sculptures, and chandeliers—feature some of the cities' most splendid architecture. During World War II, they served as air-raid shelters and sites for high-level political meetings. The Avtovo station was built in the mid-1950s; its glass columns are decorated with symbols of the Soviet state and were originally lit from inside.

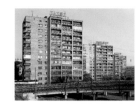

plate 18
UKRAINIAN PAVILION
VDNKH (EXHIBITION OF THE PEOPLE'S ECONOMIC ACHIEVEMENTS),
MOSCOW, 2002

A theme park for Soviet socialism, the exhibition included monuments to Soviet science, plus fountains and amusement-park rides, as well as national pavilions for the Soviet republics. This pavilion, whose exterior is covered in multicolored tiles and gold leaf, celebrates the agricultural fertility of the Ukraine. Today, most of the original exhibits have been removed and replaced with commercial outlets. Recently, the name of the park was changed to VVC, an abbreviation for All-Russia Exhibition Center.

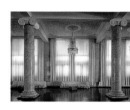

plate 21
GLORY TO THE WORKING CLASS
KHABAROVSK, 2003

These Soviet-era signs glorifying the socialist enterprise ("Glory to the Working Class," this series announces) have virtually disappeared from the crowns of high rises, typically replaced by equally monumental paeans to electronics retailers and insurance companies.

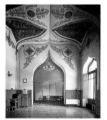

plate 16
TURKISH ENVOY'S ROOM
VORONTSOV'S PALACE, ODESSA,
2003

This room in the Ukrainian port city of Odessa was built by Count Vorontsov, a prominent nobleman, to receive visitors from the Ottoman court. The Soviets converted it into a children's center. Presently it is used as a hip-hop rehearsal studio.

plate 19
REPAIR SHOP
ST. PETERSBURG, 2003

Lunchtime in a mechanical-repair shop in St. Petersburg. The hanging pennant is an award for "best worker" from the Communist Collective of Labor.

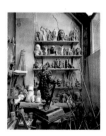

plate 22
DISCOTHEQUE
KRASNOYARSK, 2003

A former culture palace converted into a nightclub in Krasnoyarsk.

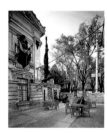

plate 17
NAVAL-MUSEUM CAFÉ
SEVASTOPOL, 2003

During the Soviet period, Sevastopol, located at the southern tip of the Ukraine, was called the White City, following an extensive reconstruction by Joseph Stalin after World War II. Today, the Russian and Ukrainian navies share its port.

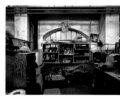

plate 20
EXECUTIVE OFFICES
IZVESTIA BUILDING, MOSCOW,
2003

Built in the early years of the Soviet Union, the Izvestia building's stark constructivist facade stood out against the highly ornamented Imperial-era buildings of Pushkin Square, boldly announcing the Soviet intention to "make it new." Formerly the home of the Communist Party mouthpiece, the building is still connected to the existing respected Izvestia newspaper, and belongs to one of the biggest Russian media corporations.

plate 23
YOUNG SCULPTOR'S STUDIO
ST. PETERSBURG, 2002

Studio of Pavel Ignatiev, a young sculptor in St. Petersburg. The clay figure, a model for a large public sculpture for an Italian city, is of Domenico Trezzini, a Swiss-born and Rome-trained architect for Peter the Great who built the St. Peter and Paul Fortress, as well as the third incarnation of the Winter Palace. (The building that stands today is the fifth.) The sculpture on the shelf in the rear is by Pavel's father, who formerly occupied this studio.

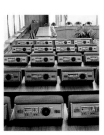

plate 24
VOTING MACHINES
SIMFEROPOL, 2003

An assembly room in the Crimean regional Rada, or parliament.

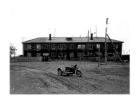

plate 25
APARTMENT HOUSE NEAR SEA OF OKHOTSK
FAR EAST, 2003

Even in Russia's vast Far East, where there is more space than the mind can contemplate, communal living, as in this apartment house, is the norm. The Sea of Okhotsk, off Russia's eastern flank, begins just behind the building.

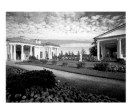

plate 26
CAMERON GALLERY
TSARSKOE SELO, 2000

Scottish architect Charles Cameron built this Ionic gallery in the late eighteenth century at the invitation of Catherine the Great. It is said to have been her favorite spot within the great imperial palace of Tsarskoe Selo, just south of St. Petersburg.

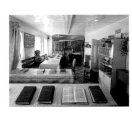

plate 27
RABBI DOV AND WIFE NINA
BIROBIDZHAN, 2003

One-room synagogue in the main city of the former Jewish Autonomous Region (JAR), created by Stalin in Russia's Far East in 1928 as a "homeland" for Soviet Jews. By the early 1930s, 41,000 Jews lived in Birobidzhan; about 3,000 remain today.

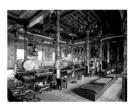

plate 28
BUDDHIST MONASTERY INTERIOR
DATSAN, 2003

Datsan, the center of Buddhism in Russia, survived relatively unscathed despite the official atheism of the Soviet Union, perhaps because of its isolated location just north of the Mongolian border.

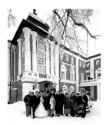

plate 29
WINTER WEDDING
VOLOGDA, 2004

The wedding palace is located in a converted wing of a monastery complex.

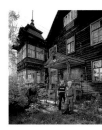

plate 30
KAMINKER AND KOLIBADA
ST. PETERSBURG, 2000

Dmitry Kaminker, a sculptor well-known for his whimsical public projects, lives in Shuvalovo-Ozerki, a neighborhood of artist homes outside of St. Petersburg built by Finns in the late nineteenth century.

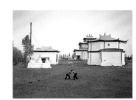

plate 31
NOVICES WRESTLING
DATSAN, 2003

(same location as plate #28)

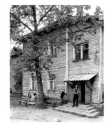

plate 32
REHAB CENTER
PETROZAVODSK, 2002

Located on the shore of Lake Onega, the second-largest lake in Europe, Petrozavodsk is the capital of the region of Karelia, which borders Finland and is famed for its natural beauty. (It's also where Russian president Vladimir Putin likes to fish.)

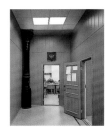

plate 33
SOLDIER TAKING EXAM
VLADIVOSTOK, 2003

Vladivostok, Russia's major port on the Pacific Ocean, near China and North Korea, is home to the Far Eastern State Technical University. The city was founded by Yuli Bryner, whose grandson Yul Brynner would become a Hollywood star.

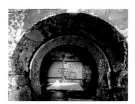

plate 34
ENTRANCE GATE
SOLOVKI, 2002

Entrance to the sixteenth-century monastery in Solovki, an island chain on the White Sea, in Russia's north. In 1924, the first Soviet labor camps were built here; later, they were incorporated into the GULag (Glavnoe Upravlenie Lagerei, or Main Administration of Labor Camps), a chain of corrective facilities mainly in Siberia and the Far North memorialized in Aleksandr Solzhenitsyn's masterpiece *The Gulag Archipelago*.

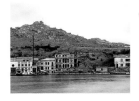

plate 35
BALAKLAVA
CRIMEA, 2003

During the Crimean War, Balaklava was the Black Sea supply port of the allied British, French, and Turkish forces. In an epic 1854 battle, the Russian side failed to capture the port, but the Brits suffered heavy casualties, inspiring the poem "The Charge of the Light Brigade," by Alfred, Lord Tennyson.

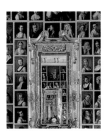

plate 36
ROTARI'S GALLERY
PETERHOF, 2000

Pietro Rotari, a popular eighteenth-century Italian court painter, was commissioned by Catherine the Great to fill this picture gallery in Peterhof, the summer palace of Peter the Great. He supposedly used only six women as models for the gallery's 384 portraits.

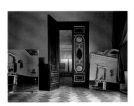

plate 37
CHILDREN'S THEATER
VORONTSOV'S PALACE, ODESSA,
2003

The doors and mantel come from the
room in the Mikhailovsky Castle, in
St. Petersburg, where Tsar Paul I was
assassinated by mutinous civil and
military officials at the behest of his
son, who became Tsar Alexander I. The
Romanov family sold the blood-stained
mantel to the Vorontsovs to expunge
the memory of the murder. (Though the
blood is no longer visible, the mantel-
piece remains chipped—Paul's head was
bashed against it—today.)

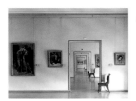

plate 38
ROOM 348
THE STATE HERMITAGE MUSEUM,
ST. PETERSBURG, 2000

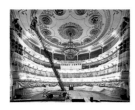

plate 39
OPERA HOUSE
IRKUTSK, 2003

Although the journey to Irkutsk from
St. Petersburg took many months,
those exiled there, including many who
took part in the Decembrist uprising
of 1825—staged by military aristocrats
inspired by the liberal ideals of the
French Revolution—managed to turn
this provincial capital into "the Paris
of Siberia."

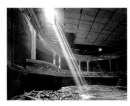

plate 40
LOCOMOTIVE WORKERS' THEATRE
ULAN UDE, 2003

Interior of a 1,100-seat theater built in
the 1930s for the workers of the neigh-
boring locomotive factory in Ulan Ude,
near the Mongolian border. The pres-
ent condition is the result of the factory
closing in the early 1990s.

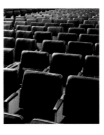

plate 41
BLACK CHAIRS
ODESSA, 2003

(same location as plate #92)

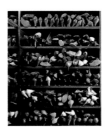

plate 42
SHOES
LENFILM, ST. PETERSBURG, 2002

Lenfilm (Leningrad Film Studio), one
of Russia's two premier film studios,
was founded in 1918 and was known to
produce more venturesome fare than
was palatable to central authorities
in Moscow. Its flagship symbol of the
Bronze Horseman statue, lit by flood-
lights, is an icon of Soviet cinema.

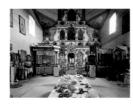

plate 43
DAY OF THE TRINITY
TEREBENI, NEAR PSKOV, 2002

Resurrection Church on the Day of the
Trinity, when members of the congrega-
tion bring food and eat atop the graves
of their late relatives. Pskov is in the
northwestern corner of Russia, near the
border with Estonia.

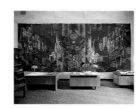

plate 44
RECEPTION OFFICE
PIONEER CAMP ARTEK, YALTA,
2003

(same location as plate #6)

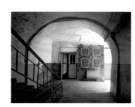

plate 45
KREMLIN INTERIOR
SOLOVKI, 2002

Leaning against the wall is a remnant
of an iconostasis, presumably recovered
by the monks who have reoccupied this
monastery—a labor camp in the 1920s
and 1930s—since 1991. Part of the mon-
astery is now used as a museum.

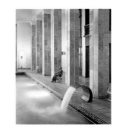

plate 46
ARIANDA SANATORIUM
YALTA, 2003

One of the most luxurious spas in
the Crimea.

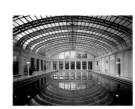

plate 47
SWIMMING POOL
UKRAINA SANATORIUM, YALTA,
2003

(same location as plate #14)

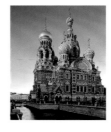

plate 48
**CHURCH OF OUR SAVIOR ON
THE SPILLED BLOOD**
ST. PETERSBURG, 2000

The Romanovian fantasy was built
on the site of Tsar Alexander II's
assassination.

plate 49
FOUR TREES
NEAR FERAPONTOVO MONASTERY,
FERAPONTOVO, 2004

The Church of the Nativity of the
Virgin of Ferapontovo, near Vologda,
has frescoes by Dionisys, painted in
the late fifteenth and early sixteenth
centuries.

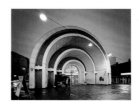

plate 50
KRASNYE VOROTA STATION
MOSCOW, 2003

The Krasnye Vorota (Red Gates) built
in 1935, is one of the most fully real-
ized examples of constructivism. Chief
engineer I. D. Goceridze's wrote, "[It]
is covered with the red marble brought
from the far-away, lost-in-mountains
Georgian village Shrosha. This village
is my motherland."

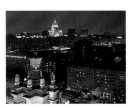

plate 51
MOSCOW EVENING
MOSCOW, 2003

View from the Hotel Ukraina, one of seven Gothic, tiered skyscrapers built in Moscow at Stalin's direction in the late 1940s and early 1950s to compete with Western construction. Another one of these towers, the home of the Ministry of Foreign Affairs, can be seen in the distance.

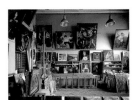

plate 52
RESTORATION ROOM
V.I. REPIN ACADEMY OF FINE ARTS, ST. PETERSBURG, 2002

Studio used by the painting department for instruction in restoration and conservation techniques.

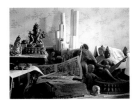

plate 53
WAX MODELS FOR CASTING
ULAN UDE, 2003

Apartment studio of Siberian artist Dmitry Budashabe. An advertisement in one of the draped newspapers promises a "comprehensive realization of your ideas."

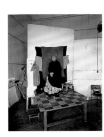

plate 54
AKADEMY MODEL
V.I. REPIN ACADEMY OF FINE ARTS, ST. PETERSBURG, 2002

Model in the advanced painting classes at the academy, founded in 1757.

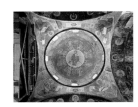

plate 55
DOME
MIROZHSKY MONASTERY, PSKOV, 2002

Only fresco showing the full cycle of Christ Pantocrator to escape destruction by the Mongol Horde in the thirteenth through fifteenth centuries. The fresco was painted by a Greek artist soon after the domed church of the monastery was constructed, in 1156.

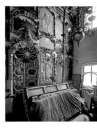

plate 56
ICONOSTASIS WITH BEDS
RESURRECTION CHURCH TEREBENI, NEAR PSKOV, 2002

Guests of Father George often sleep in this unused chapel. The parents of Mikhail Kutuzov, the legendary general who defeated Napoleon in 1812, are buried in the basement.

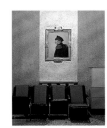

plate 57
NAVAL CLUB
VLADIVOSTOK, 2003

A portrait of Crimean War hero Admiral Pavel Nakhimov. An intrepid and ingenious commander, he destroyed a numerically superior Turkish fleet at the Battle of Sinope in 1853 and intentionally sunk his own ships a year later to prevent the French and English from entering the port of Sevastopol.

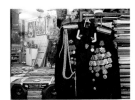

plate 58
KORBAKOV'S UNIFORM
VOLOGDA, 2004

World War II naval uniform of Vladimir Korbakov, 82, Vologda's best-known artist and poet.

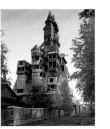

plate 59
THIRTEEN-STORY WOOD HOUSE
ARKHANGEL'SK, 2002

The tallest building in Arkhangel'sk, this skyscraper was built by Nikolai Sutyagin, the owner of a local lumber yard and construction company. For fire-safety reasons, Arkhangel'sk's municipal laws forbid wooden construction above two stories. Sutyagin cleverly evaded the statute—his construction is technically two floors; the roof, which is exempt from regulations, claims the remaining eleven floors. Though the Arkhangel'sk city government nevertheless ordered Sutyagin to tear the structure down, it remains standing, and he lives inside with his family.

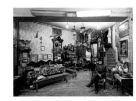

plate 60
VLADIMIR KORBAKOV IN HIS STUDIO
VOLOGDA, 2004

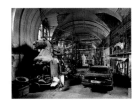

plate 61
PETER THE GREAT AND BMW
ST. PETERSBURG, 2002

The same sculptor has occupied this studio for more than fifty years. The equestrian statue is a replica of the famed Bronze Horseman on St. Petersburg's Decembrist Square, designed by French sculptor Etienne-Maurice Falconet in 1782 as a monument to Peter the Great.

plate 62
HALL OF 1812
THE STATE HERMITAGE MUSEUM, ST. PETERSBURG, 2000

At the invitation of Tsar Alexander I, English painter George Dawe made 400 portraits of the Russian generals who defeated Napoleon. The empty frames honor those whose pictures were never completed.

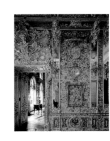

plate 63
AMBER ROOM
TSARSKOE SELO, 2000

This room was built in the early eighteenth century for Friedrich Wilhelm I, the king of Prussia, who gave it as a gift to Tsar Peter I soon after. During World War II, the Nazis looted and dismantled the room, and it has never been recovered; the whereabouts of its walls and furnishings remains the subject of much controversy. The current incarnation is a reconstruction, completed in 2003 after 25 years of labor by Russian craftsmen.

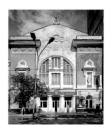

plate 64

OFFICERS' CLUB
KRASNOYARSK, 2003

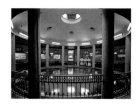

plate 65

SUGAR WOMEN
FACTORY OF CHAMPAGNE WINES,
YALTA, 2003

Staff of the sugar-delivery room of a
large winery near Yalta. The Crimea is
famed for its sweet wine.

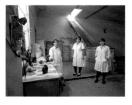

plate 66

AQUARIUM
SEVASTOPOL, 2003

Built in the late nineteenth century, this
aquarium is Ukraine's oldest.

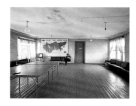

plate 67

WAITING ROOM
SOLOVKI AIRPORT,
SOLOVKI, 2002

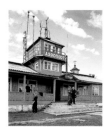

plate 68

AIRPORT
SOLOVKI, 2002

(same location as plate #67)

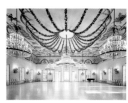

plate 69

ROSE PAVILION
PAVLOVSK, 2000

The ballroom attached to the Rose
Pavilion (so named because it is sur-
rounded by rose gardens) in Pavlovsk
Park, near St. Petersburg, was designed
by Italian architect Carlo Rossi for
Tsarina Maria Feodorovna to celebrate
the future tsar Alexander I's trium-
phant return from the war against
Napoleon. (The pavilion itself was
destroyed during World War II but was
restored in the mid-1990s with private
funds.)

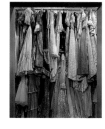

plate 70

LOCOMOTIVE WORKERS' THEATRE
ULAN UDE, 2003

(same location as plate #40)

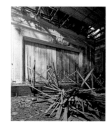

plate 71

WARDROBE DEPARTMENT
LENFILM, ST. PETERSBURG, 2002

(same location as plates #42, #93, and
#106)

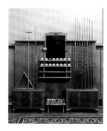

plate 72

STALIN'S BILLIARDS
YUSUPOV PALACE, YALTA, 2003

The unrestored billiards room of
Stalin's residence during the Yalta
conference of 1945.

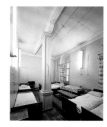

plate 73

DORMITORY IN FORMER CHURCH
VOLOGDA, 2004

This former church is in use as a youth
hostel.

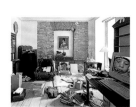

plate 74

ARCHITECT'S HOME
ST. PETERSBURG, 2003

The home of one of Russia's best-
known young designers, Andrei
Dmitriev, this apartment fuses post-
modern design strategies with the
aesthetic of Soviet communal living.

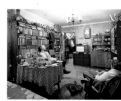
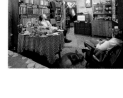

plate 75

VOLODYA, WIFE LARISA, AND DOG
SIMFEROPOL, 2003

(same location as plate #13)

plate 76

"OTHER DANGERS"
CRIMEA, 2003

This legend of road signs concludes, in
the lower right-hand corner, with the
generic "Other Dangers," encompass-
ing all road warnings not covered by
the other signs.

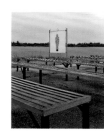

plate 77

**PARATROOPER TRAINING
GROUNDS**
PSKOV, 2002

The long benches are used to store
parachutes after landing.

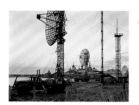

plate 78

GREEN TRUCKS, WHITE NIGHTS
SOLOVKI, 2002

This photograph was taken at 2 A.M., the dimmest point of the night.

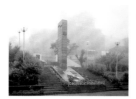

plate 83

WAR MEMORIAL IN FOG
VLADIVOSTOK, 2004

Nikita Khrushchev planned to transform the Far Eastern city of Vladivostok into the Russian San Francisco. Although similarly ensconced in fog in the summer months, this port city is only now undergoing extensive redevelopment.

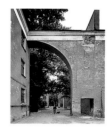

plate 88

TRACTOR STREET
KIROV DISTRICT,
ST. PETERSBURG, 2002

Built during the Soviet Union's early years, when architectural experimentation was tolerated, this constructivist apartment house was built for workers from the nearby tractor factory.

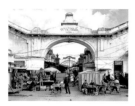

plate 79

PRIVOZ FRUIT MARKET
ODESSA, 2003

Privoz, or Harvest, is Odessa's most famous farmers' market.

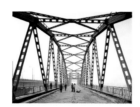

plate 84

COUPLE ON BRIDGE
ULAN UDE, 2003

After the construction of a newer bridge nearby, this span is now used as a footpath.

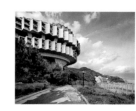

plate 89

FRIENDSHIP SANATORIUM
CRIMEA, 2003

Built in the 1970s to celebrate the solidarity of the Soviet Union and Czechoslovakia, Friendship continues to operate today.

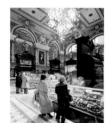

plate 80

YELISEYEVSKY FOOD STORE
MOSCOW, 2004

Formerly Food Store No. 1, this opulent gourmet grocery store, housed inside a late eighteenth-century classical mansion, now disdains any pretense of numerical anonymity. The interior gleams with chandeliers, stained glass, and gilt wall decorations.

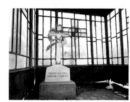

plate 85

**TCHAIKOVSKY'S
BROTHER'S GRAVE**
NOVODEVICHY CEMETERY,
MOSCOW, 2004

Novodevichy is the final resting place for some of Russia's greatest artists, scientists, and political dignitaries. Nikolay Gogol is buried here, as is Andrei Tupolev and the wives of Joseph Stalin and Mikhail Gorbachev.

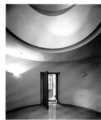

plate 90

APARTMENT ENTRANCE
ST. PETERSBURG, 2002

Apartment house occupied by several New Russian families.

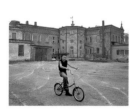

plate 81

BOY WITH BIKE
IRKUTSK, 2003

Deep in Siberia, Irkutsk is a showcase of Russia's ethnic diversity.

plate 86

EMBANKMENT
ARKHANGEL'SK, 2002

Wooden sidewalks—easier to clean than asphalt during muddy winters—are common in this older, poorer district. The Northern Dvina River, on which Arkhangel'sk stands, gleams in the distance, as do the crowns of buildings built from sturdier material.

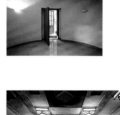

plate 91

RECORDING STUDIO
SIMFEROPOL, 2003

(same location as plate #5)

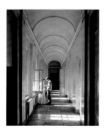

plate 82

WHITE-NIGHT INTERIOR
V.I. REPIN ACADEMY OF FINE ARTS,
ST. PETERSBURG, 2002

The hallway of the academy.

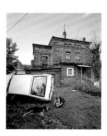

plate 87

BOY WITH DOG
KRASNOYARSK, 2003

On the grounds of a nursing home, part of which previously served as a church.

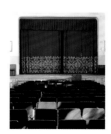

plate 92

MOVIE THEATER
ODESSA, 2003

Stained-glass windows create the colored light on the seats.

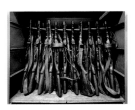

plate 93
ARMORY
LENFILM, ST. PETERSBURG, 2002

Collection of World War II-era sub-
machine guns used in the making of
war movies.

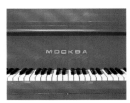

plate 94
RED PIANO
PIONEER CAMP ARTEK, YALTA,
2003

Although a few keys stick, this grand
piano has a lovely tone.

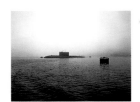

plate 95
ATTACK SUBMARINE IN FOG
VLADIVOSTOK, 2003

Kilo-class diesel submarine being
resupplied.

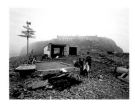

plate 96
ABANDONED MISSILE BASE
SKRIPLEVA'S ISLAND, FAR EAST, 2003

A lighthouse keeper and his fam-
ily. Previously, the island housed a
nuclear-missile silo attended by an
all-female military staff. Legend has it
that residents were told the base was a
mental hospital. Tokyo appears to be
the nearest sizable destination, 1,350
kilometers away.

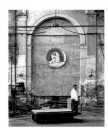

plate 97
WARSAW STATION
ST. PETERSBURG, 2002

St. Petersburg trains to Warsaw
departed from this station. Like the
great leader—now reduced to a silhou-
ette—whose image once oversaw all
arrivals and departures, it no longer
operates.

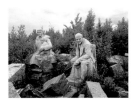

plate 98
UNDELIVERED LENIN
ST. PETERSBURG, 2002

In a stone-cutting yard, amidst
headstones hurried for the recently
deceased, lie the monuments of an
undelivered future.

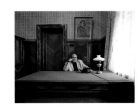

plate 99
STALIN'S OFFICE
YUSUPOV PALACE, CRIMEA, 2003

A visitor on a tour of Stalin's head-
quarters for the Yalta conference of
1945.

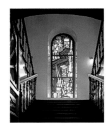

plate 100
REVOLUTION STAINED GLASS
IRKUTSK, 2003

The engraved glass panel in Irkutsk's
Museum of Regional Studies neatly
channels Russia's multilayered history:
The material evokes piety and worship,
the iconography commemorates
Communist struggle, and the construc-
tivist style recalls the aeshetic experi-
ments of the avant-garde in the early
part of the twentieth century.

plate 101
MOUNTAINTOP RADAR BASE
MONGOLIAN BORDER, 2003

Local Buddhists consider this mountain-
top a sacred site. The radar base con-
tinues to survey China, the source of
anxiety for many Russian doomsayers
convinced it will one day invade Siberia.

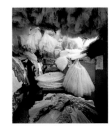

plate 102
TUTUS
MARIINSKY THEATRE,
ST. PETERSBURG, 2000

The Mariinsky is home to the Kirov
Ballet. Its basement stores costumes
from hundreds of productions.

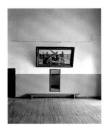

plate 103
REHEARSAL STUDIO
PALACE OF COAL MINERS,
ARTEM, FAR EAST, 2003

Just outside Vladivostok, the coal-
mining town of Artem is named for the
alias of a ruthless Communist revo-
lutionary, F. A. Sergeyev, who fled to
Australia after the failed revolution of
1905 but returned in 1917 and died in a
train crash four years later.

plate 104
ICE FISHING
VOLOGDA, 2004

Familiar with, and even fond of, their
fierce winters—which, despite Arctic
temperatures, are often crisp and wind
free—many Russians who fish in winter
prefer to stay outdoors rather than in
shacks.

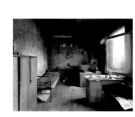

plate 105
WATCHMAN'S ROOM
SIBERIA, 2003

Guard's room in an abandoned glass
factory near Ulan Ude. Though the
factory shut down some time ago, the
watchman continues to live there with
his wife, subsisting on the occasional
odd job and the goodwill of others.
"Get to work—feed the cat," the black-
board says.

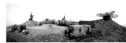

plate 106
WORKSHOP TOOLS
LENFILM, ST. PETERSBURG, 2003

(Same location as plates #42, #71, and
#93)

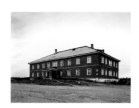

plate 107

RED HOUSE, WHITE SEA
SOLOVKI, 2003

House on Main Street, Solovki. As the light of the white nights makes sleep difficult, families and friends often stay up, paying visits, eating, drinking, and singing. This photograph was taken at 1 A.M.

plate 112

MAN WITH HIS DOG
WHITE SEA, 2002

The village of Rabochestrovsk, near Murmansk, in Russia's Far North.

plate 117

AMARYLLIS
VOLOGDA, 2004

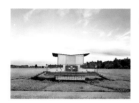

plate 108

INSTRUCTOR'S PLATFORM
PSKOV, 2002

Although photography of Russian military sites is ostensibly prohibited, the prevailing guideline seems to be the old Russian saying, "What is not permitted is not always forbidden."

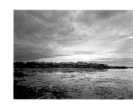

plate 113

FISHING VILLAGE
WHITE SEA, 2002

(same location as plate #112)

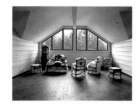

plate 118

MODERN DACHA
DUNI, 2002

New purchases waiting to be unwrapped. Duni is near Vyborg, which borders the Gulf of Finland, northwest of St. Petersburg.

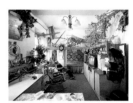

plate 109

**LIGHTHOUSE
KEEPER'S QUARTERS**
SKRIPLEVA'S ISLAND, FAR EAST, 2003

Home of Vladimir Petrovich Samoilov. The Samoilovs subsist on seafood illegally poached by local fisherman.

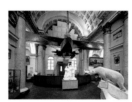

plate 114

**MUSEUM OF THE
ARCTIC AND ANTARCTIC**
ST. PETERSBURG, 2002

This museum occupies the former Church of St. Nicholas.

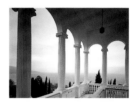

plate 119

LIVADIA PALACE
YALTA, 2003

Built as a summer residence for Tsar Nicholas II—the view here is from Tsarina Alexandra's private balcony—the Livadia served as the site of the Yalta conference (as well as FDR's home for the duration of the talks). The famous photograph of the Big Three was taken in the Livadia's courtyard.

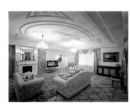

plate 110

LIVING ROOM
ST. PETERSBURG, 2002

Home of a New Russian executive.

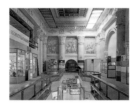

plate 115

CENTRAL PAVILION
VDNKH, MOSCOW, 2002

(same location as plate #7)

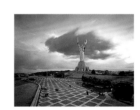

plate 120

MOTHERLAND
KIEV, 2003

This titanium statue, 100 meters high, was built by order of Russian president Leonid Brezhnev in the early 1980s. It is called Rodina Mat (The Homeland Is Mother), and it faces toward Moscow.

plate 111

PORT OF OKHA
SAKHALIN ISLAND, 2003

In the Imperial period, Sakhalin Island, north of Japan, was the site of several notorious prisons. In 1890, Anton Chekhov traveled there for nearly a year to document living conditions. Oil was first discovered in Russia at Okha, on the island's northern tip, in 1907.

plate 116

CENTRAL SYNAGOGUE
ODESSA, 2003

In Soviet times, this former synagogue was divided into two levels; the upper floor was used as a volleyball court. The court is unused today, while the lower story once again serves as a synagogue.

AFTERWORD *by* ANDREW MOORE

One house, no doubt because of its peculiar appearance, began to attract his attention from a distance, and the prince remembered afterwards saying to himself: "That must certainly be the house." He drew near to verify his conjecture with a feeling of immense curiosity; he felt that for some reason, he would be particularly upset if he had guessed right. It was a large, gloomy, three-storeyed house, of a dirty green colour and of no particular architectural interest Without as well as within, the house looks drab and inhospitable, somehow; everything in it seems to be hiding away in some dark corner, and it is difficult to explain why one should get such an impression from the mere exterior of the house. Architectural lines have, of course, a secret of their own.

FYODOR DOSTOYEVSKY
*THE IDIOT**

Born in the year of *Sputnik,* the Red Star, I grew up dreading the moonless night when descending Soviet paratroopers, armed with grimaces and machine guns, would enslave my hometown. Convinced of their bottomless stealth, I asked my parents whether the Russians weren't somehow behind the tragedy of *Apollo 1.* At school, my social studies workbook included graphs depicting the many years of labor it took a Soviet worker to buy a refrigerator, further confirmation of the grim post-occupation future awaiting a generation raised on TV dinners.

Despite the scare tactics of those anonymous textbook authors, there was much more entertaining and effective propaganda at work in those early years of the Cold War. James Bond hit the screen at my most impressionable age, and it was in those early films that I saw the cruel and calculating Slavic brow at its most menacing. Though Bond's nemesis was an international syndicate called SPECTRE, its leaders' penchant for chess, white Chianti, and poison-tipped spikes nevertheless betrayed them as graduates of the KGB training school.

In the intervening years, however, this animus yielded readily to wonder before the audacious angularity of Rodchenko's photographs and to awe at the omnipotent realism of Tolstoy's novels. But some of those early fears resurfaced during the early '80s, when I traveled through eastern Europe, particularly in what was then Czechoslovakia. Stories and jokes, told by the Czechs with the darkest of humor, both despaired of and ridiculed their occupiers. In the corner of a rural beer hall, a mute man pantomimed for me the meaning of CCCP, the Cyrillic acronym for the Union of Soviet Socialist Republics: The first *C* was a handcuff on the right wrist, the second *C* went around the left one, the third *C* gripped the neck, and the *P* was a hammer blow on the head.

Other Czechs rued the loss of their precisely tooled subway cars, which had been carted off for service in the metros of their "best friends," only to be replaced with inferior Soviet versions. Indeed, the shutter of the Russian camera I purchased not only fired with clanging metallic recoil but was also held in its case by crudely fashioned wood blocks. On the streets of Prague, I watched a Soviet

officer reach into his briefcase; expecting to see him pull out some secret device, I looked on as he furtively withdrew his highly prized possession, a lone banana.

My experiences in the Eastern Bloc revealed the disjuncture between the projected power and menace of the almighty Soviet state and a much paltrier reality. What I was not prepared for, when I first went to Russia in 2000, was the strangeness and aesthetic oddity of this world apart. I had expected the drab and monumental, the dour and suspicious, but I had not anticipated a visual world so independent of my previous experiences. There was something of a dark dream about it, illogical and tragic, yet lit by the defiant spark of the unexpected. For example, on the gargantuan fields of untended grasses that set monotone housing blocks apart, tiny footpaths crisscrossed every which way, inroads of humanity incised on indifference. This type of contradiction, the inflated idea versus the most humble reality, the world of officialdom versus the ragged individual, was one of the qualities that continually piqued my interest and imagination.

This quality of extreme contradiction revealed itself to me directly when I started taking pictures. As with any large-format camera, the lens projects an aerial image (upside down) onto a piece of ground glass at the rear of the camera. Often, a very faint grid has been etched into this glass, making it easier to check the overall level and straightness of the image. In the photography of architectural spaces, the grid lines are invaluable in organizing the proportions of the space, as one needs to look at the picture overall as well as composing in sections.

In Russia, on more occasions than I can remember, I simply had to abandon this type of formal organization of the picture. Where wall met ceiling, no right angle ever formed. If I straightened the picture plane to the ceiling, the floor appeared crooked. If I used one wall as a parallel line, then, certainly, the opposing wall went askew. When I mentioned this phenomenon to my Russian friends, they merely laughed at me: Who cares whether the walls are a little crooked? Ideas are what really matter. As one of them quipped, "The history of Russia is the search for the right angle."

Visual symmetry, or the lack thereof, leads naturally to two corollary aspects of the Russian visual aesthetic: scale and repetition. Living most of my adult life in New York City, I am accustomed to an overpowering sense of scale in architecture. Yet the use of scale in Russia had an effect opposite to my native experience; whereas the vertical climb of buildings in New York proposes to uplift and inspire, the elephantine spaces in Russia produce an antithetical feeling, as if they purposely mean to reduce and overwhelm the individual. The open spaces set against the repetitive and identical apartment blocks appear as voids meant to expose rather than embrace. It was difficult to understand the planning that went into this arrangement, although many Russians I met feel it was a purposeful scheme meant to make everyday life as difficult as possible and to distract people's minds from notions dangerous to the state.

This aggrandizement of urban space at the expense of the individual is a well-known phenomenon of Russian architecture; I was more interested in looking at the related phenomena of scale with regard to private or domestic spaces. One aspect that particularly fascinated me was the large communal wooden homes. Somehow, they reminded me of the Iroquois longhouses I had read about as a child. Like a simple box enlarged to the dimensions of a barn, with rooflines pitched at indeterminate angles and facades stamped with enormous numerals, these living quarters possessed what I can only call an unlovely beauty.

Often, this strange sense of scale was created by the mere repetition of a motif. The endless facades and corridors in the city of St. Petersburg seem to pursue the elongation of space way beyond practical purpose. The picture gallery at Peterhof, painted by Rotari,

has a like effect, albeit one much at home in the modern world of serial repetitions. Another example of this reiteration can be found in the four hundred portraits that fill up the Hall of 1812 in the Hermitage, although here the voids left by the unpainted heroes trip up the seamless facade.

Certainly, the most important visual tradition in Russia remains the icon. Incorporating techniques of reverse perspective devised by the Byzantines, these pictures act as portals to a spiritual dimension wholly unattainable to the normal senses. Soviet iconography shrewdly played on this tradition by carefully attuning the images of the nation's leaders, with their resolute and unvexed features, to the relentless message of the Soviet state: that the future would bring a better life to its citizens. When making images that contained these portraits and related symbols, I tried to play on the icon's inaccessibility by turning these propagandistic images into a closed door, in a sense transforming the threshold to utopia into a barricaded fork in history.

Gogol wrote, "Russia has two great problems: fools and roads." My difficulties more often lay with the latter. As Boris Fishman alludes in his foreword, I also shared in the ritual of making roadside repairs by the flame of a cigarette lighter, drifting in a smoking boat in the White Sea, or being grounded for days because of broken airport guidance systems and the haze of enormous forest fires. Rather than covering the entire country, surely the task of a lifetime, I visited its four points: east, west, south, and north. I offer no particular reason for this decision, except that it seems in keeping with the breadth of the land itself. Ultimately, I made six trips to Russia over the course of four years.

Between trips, I gathered the accumulated pictures in a growing binder. When I returned to Russia, wherever I went, I used this notebook as a passport for entrée to the places I wished to photograph. Nearly every institution has a doorkeeper, frequently an older woman seated at a desk with not much for company but a telephone and a small lamp. It was a great pleasure to see them turn the pages of the notebook slowly, commenting on this or that picture, their frown replaced with a smile and a story for their visitors.

I did at various moments have the sense of being a spy—perhaps an unavoidable feeling, given my early childhood experience with James Bond. Near the border of Mongolia, for example, having followed an unmarked road to the top of a small mountain, my friends and I ended up at the gates of an active radar station. The antennas of the numerous radar had particularized shapes, and, when they were active, each pivoted with a singular and odd motion: one enormous piece fluttered and spun with such violence that it seemed like a giant moth about to take flight. I am very grateful to the lone soldier who was so accommodating to us, and even more grateful that his commander was having an extra-long lunch at the base below.

On several occasions in the Russian Far East, where many areas had once been closed military zones, I was told that it was better that I not speak any English. (If questioned, I was to say, in Russian, that I was from Estonia.) On these occasions, we would arrive at a certain place, and my friend Sasha would be announced by the doorwoman with all the ceremony befitting a photographer from far-off St. Petersburg. He would chat with the director of the institution, while I, the mute assistant, would proceed to set up the camera. When I had figured out the picture, I would nod to Sasha, who would come over and offer his "approval," after which I would finish making the photograph. I don't know how well this ruse worked, but at least it avoided, for everyone, the issue of a foreigner photographing in a restricted zone.

Perhaps the greatest satisfaction I derived from this project has been the response of the various Russians to the photographs. As one said to me, "I used to look around and only see a landscape filled with junk. Now, when I look, I see the potential for beauty in

my own country." Afterward, I realized something similar had transpired within my own empathy for the people of this country. On a deeply cold January night, while I was sharing an improvised meal of smoked fish and vodka with an artist in his studio, there came a knock at the door, and in burst a costumed troupe that immediately swept us from the table into the midst of their dancing and singing revelry. The men wore wigs and bulging dresses and the women sported penciled mustaches and cigars, while a young girl, attired as a princess, held out a small basket for gifts for the midwinter celebrants. Their spontaneity not only vanquished any gloom of that chilly evening but also reminded me of the warmth and humor I encountered in the people of Russia while making this book, an experience that finally put to rest those earlier years of bias and antipathy.

I want to particularly thank two individuals who accompanied me on these travels. Xenia Nikolskaya, who I originally met through Danish architect and photographer Andreas Morch, was my original contact in St. Petersburg. As an accomplished photographer in her own right, she inspired and cajoled me to get things just right, not to mention distracting security guards with pointless questions while I completed my exposures. The other is my aforementioned friend Alexander "Sasha" Predovsky, who was my constant companion through Siberia. His charm and good humor carried us past many difficult and tense moments. I often compared him to the golden retriever that animal trainers bring alongside a wild animal, such as a cheetah, in public appearances; as long as the good-natured dog enjoys himself before the crowd, so the wary cheetah remains unperturbed. As good a traveling companion that one could wish for, he told me, "Just keep your eye on me if you feel anxious. However, if you ever see me start to worry, it's time to consider shooting yourself." I appreciated his joke, but I was glad that moment never arrived.

Of the many people who helped along the way, I would like to especially thank the following individuals in Russia who so

generously lent their knowledge and assistance: Mikhail Lopatkin, curator at Solovki; Alexej Guzanov, curator at Pavlovsk; Mikhail Piotrovskij, director of the Hermitage; Xenia Nikolskaya Sr.; Tamara Mitina; Natalia Tkacheva, curator at the Pskov Museum; Professor Yuri Bobrov of the V.I. Repin Academy of Fine Arts; Vadim Znamenov, director of the Peterhof; Jacob Voloshin; Boris Makarichev; Svetlana Timohova; Pavel Dobrodeev; Anton Mikhailov; Ludmila Horoshilova; Ludmila Konovalova; Anna Buziyan; Valentin Zibcev; Sergey Danevich; and Yuri Nikich.

At home in New York I would like to thank the following individuals who have been of invaluable help: my wonderful studio assistant, Jamey Poole, who meticulously kept track of all the profligate details of this project, and my friends at Laumont Lab, including Phillipe Laumont, Albert Fung, Gerry Lucid, Sara Madsen, and especially Kylie Wright, whose artistry brought the images alive to the highest degree. My longtime dealer Yancey Richardson has consistently championed my newest ventures, as have members of her staff, especially Michael Foley and David Carmona.

I am also grateful for my other dealers, Craig Krull in Los Angeles and Anna Walker Skillman at Jackson Fine Art in Atlanta, for their continuing efforts on my behalf. I would also like to mention Richard Story of *Departures* magazine and Andrew Long for giving me the original opportunity to visit St. Petersburg. My friend Ondrej Kubicek was of great help as an assistant with the early pictures. Many thanks again to my agent (and photographer) Wendy Burtons Brouws.

I want to especially thank my editor at Chronicle Books, Leslie Jonath, for her passionate belief in this book, as well as designer Sara Schneider and production coordinator Tera Killip. Special thanks go to Boris Fishman of the *New Yorker* for all of his exceptional insights as well as a splendid foreword. Lastly I would like to thank my family and friends who put up with my long absences.

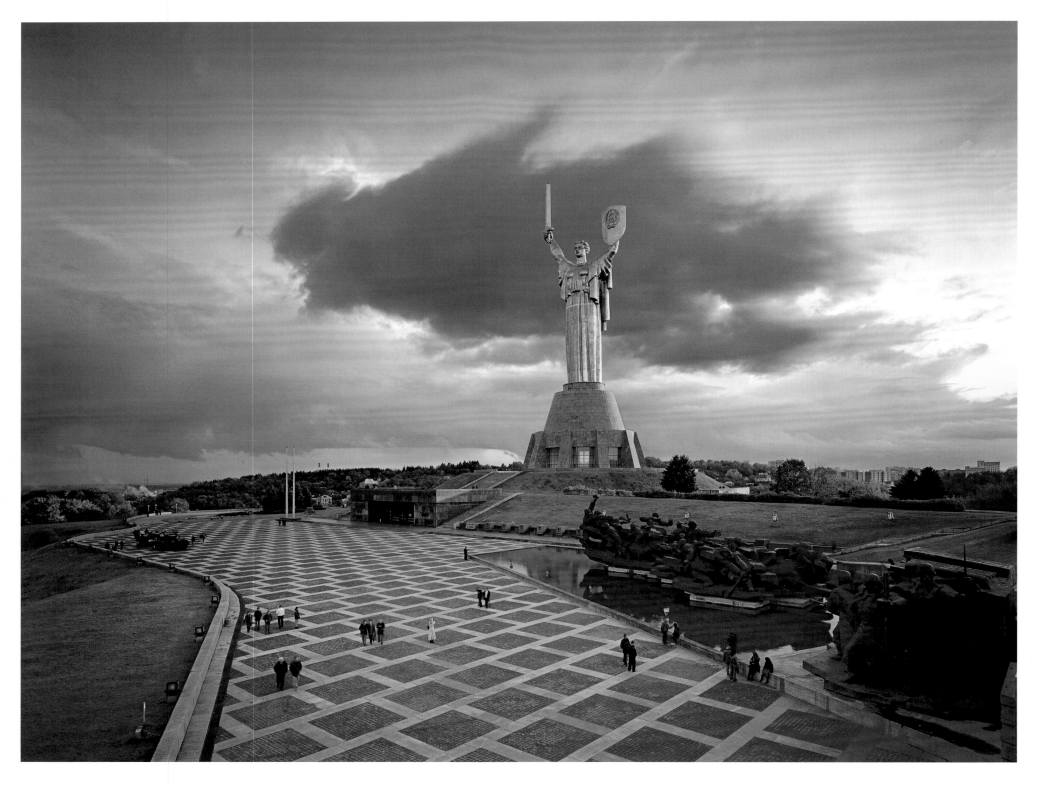

plate 120 **MOTHERLAND**, KIEV